SITES

OF

DECLINE

From the Editors

All cities are geological; you cannot take three steps without encountering ghosts bearing all the prestige of their legends. Certain shifting angles, certain receding perspectives, allow us to glimpse original conceptions of space, but this vision remains fragmentary. It must be sought in the magical locales of fairy tales and surrealist writings: castles, endless walls, little forgotten bars, mammoth caverns, casino mirrors.
- Ivan Chtcheglov

For the negative connotation that should accompany the phrase 'sites of decline,' one can't help but be taken aback at the polemical playfulness through which the subject is interpreted. The curation of Ampersand Volume Six thrusts 'decline first-responders' into one another, along with their stories, contexts, and agendas, concurrently reassessing the topic of decline, and detaching common tropes associated with it. Decline's siblings – degradation, disaster, abandonment, and contamination – all make cameos throughout the volume.

There are several legitimate arguments as to why decline is so pervasive as a design question. Rather than approach the topic with objectifying criticism, blinding conviction, or any one perspective in between, Sites of Decline positions these projects as a collection, eroding connotations and accepted methodologies that accompany the word. One need not look very far to identify the complementary relationship between urban abnormalities and the firing of polemical synapses within architecture.

If there is one common thread underlying the works collected, it would be the unabashed freedom of movement granted by open-ended contexts; constraints are voluntarily tightened as restraints are removed. Although history plays a crucial role, fantasy, fiction, and recreation are added to the design recipe in quantities that are perhaps less palatable in real, live, built environments. Abandonded remnants of the past are dug up from the ground at every opportunity; revealing unused toys, forgotten relics, distant memories, and outdated tools, many of which have since been ex-communicated from the contemporary, sanitized metropolis. There are however, momentary signs the culture of newness is swaying in the opposite direction – soon, visits to Fredrik Law Olmsted's "lungs for the city" will be surpassed by a much more mutant 2,200 acres of Fresh Kills; a remediated landfill where new ground sits atop society's discarded objects.

Maybe Ampersand's proximity to Detroit is what precipitated an audit of decline. Everyone who passes through Taubman College visits the city; we photograph it, we walk through it, we discuss it, and sometimes place fictitious buildings as a means to somehow contribute to larger questions of economies, ecologies, and urbanism. The resulting discourses, however, seldom create unified theorems. Instead, involved parties usually leave with stronger conviction of what to build, where to build, and how to build, which leaves us back where we started.

Thus, after what seems like eons of shocking imagery, documentaries, interventions, augmentations, and preservations, it appeared as though the topic had grown stale.

The expansive breath of responses [and not solutions] collected in Ampersand Volume Six: Sites of Decline suggests the topic can, and will yield work that is provocative, relevant, and fun.

Cheers,

David M de Cespedes
Nathan Mattson
Jessica Letaw
Mike Howard
Paul McBride

Table of Contents

1 **Preservation Detroit Experimental Branch**
Emily Kutil

7 **Geology and Restraint**
Jon Piasecki

13 **Locomotive City**
Justin Hui

21 **Ruin Porn as Collective Memory:
A Counter-Coverage of Detroit**
Valeria Federighi

29 **Mowing**
Pink Pony Express

31 **Rocce Rosse**
Luca Peralta, et al.

35 **& *Interview***
with Catie Newell

41 **Flat Broke**
Adamantios Tegkelidis

45 **Fog**
John Monnat

49 **Everybody Loves Action Figures**
Andrew Santa Lucia

55 **RIBA east:
Regeneration through catalytic insertions**
Sam Rose

57 **Shifting Properties:
New Directions for Spatial Development in
Resource-Dependent Regions**
Lauren Abrahams

65 **Downtown Wetlands: Atlanta**
M. Razvan Voroneanu

79 **Degradation is...**
Konstantinos Maroulas

83 **Sign City**
Ashley A. Reed

87 **Between Great and Lake:
Design for Great-ER Lakes Sub-culture**
Elizabeth George & Julia Sedlock

95 **St. Louis Metro Villages:
Re-greening and Concentrating the Shrinking City**
Marius Mueller

101 **The Experiential Helmet**
Nimet Anwar

103 *& Interview*
with Meredith Miller

109 **Field Trip to an Ephemeral, Unfulfilled Future**
Bert de Muynck & Mónica Carriço

111 **Water Tower Kinetic Machine**
Danae Manolesou

115 **Monument to Bruce**
Design With Company

121 **Popular Mutation**
Miro Sraka

125 **The Villa Simulacrum**
Salvatore Dellaria

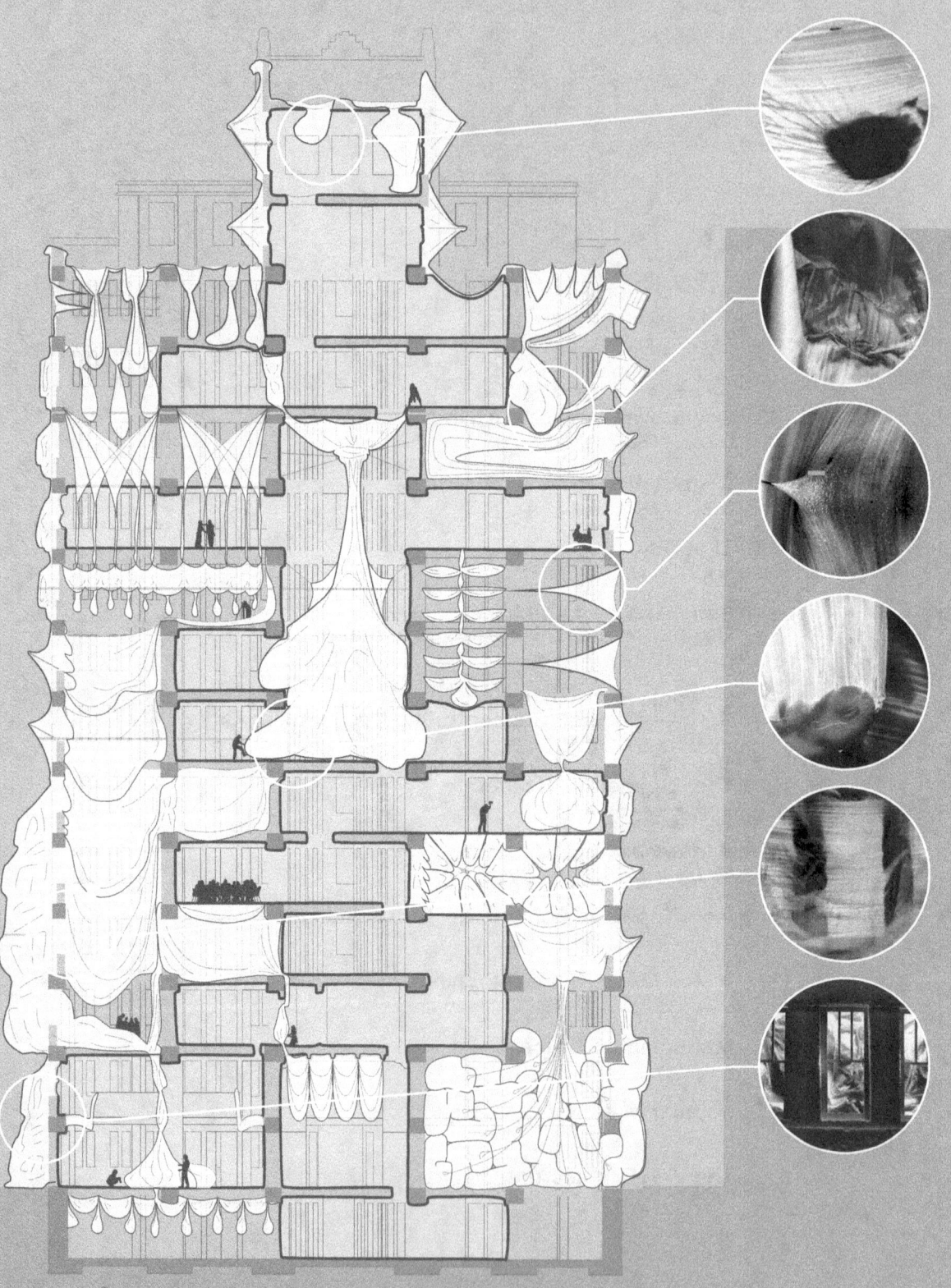

Preservation Detroit Experimental Branch

Preservation Detroit Experimental Branch

Emily Kutil

Preservation Detroit Experimental Branch is a proposed renovation to the Metropolitan Building in downtown Detroit. The Metropolitan was built in the 1920's and has been unoccupied since the 1970's for a variety of reasons, one of which involves the window detail. The Metropolitan's window frames have wide flanges that are laminated between the two courses of bricks in the walls. Now exposed to the elements, the flanges are causing those bricks to separate and fall from the building (see wall section). Replacing the windows would mean replacing almost all of the infill material in the exterior walls.

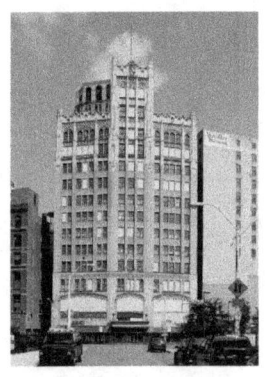

Above: Photograph of the Metropolitan Building from Farmer Street, Image credit http://detroiturbex.com

Opposite: Building Section

This proposal uses experimental techniques to find ways to reinhabit the building as a test site for a new research branch of Preservation Detroit. The building is lined with two membranes: one is a flexible, formally articulated latex membrane, and the other is a thicker, sturdier rubber that fits more tightly to the existing structure. The latex collects the materials that the building sloughs off over time, and those collected materials constantly change the shape of the membrane. The thicker rubber defines a more stable space for occupation by Preservation Detroit. The latex membranes expand the wall section from the thickness of the brick infill to a much larger dimension-- all of this space is dedicated to capturing and redirecting the building's materials.

The project was conceived not as a result of a larger set of ideas about preservation, or about Detroit, but about the potentials of flexible, formally articulated wall sections that are designed for "capture." Two case studies informed the work: the Commerzbank by Norman Foster and Partners, which compresses a highly articulated wall system within a flattened, normative curtain wall; and the Soft House by Kennedy Violich Architects, which uses photovoltaics woven within a moveable curtain to both capture solar energy and reconfigure space. The latex system is an effort to impart the articulation of the Commerzbank with the flexibility and expression of the Soft House.

The intervention aspires to promote an adaptive, participatory re-occupation of the building, and also to open a conversation about the role of the image of a "preserved" building in the city. Beyond freezing a building in time .

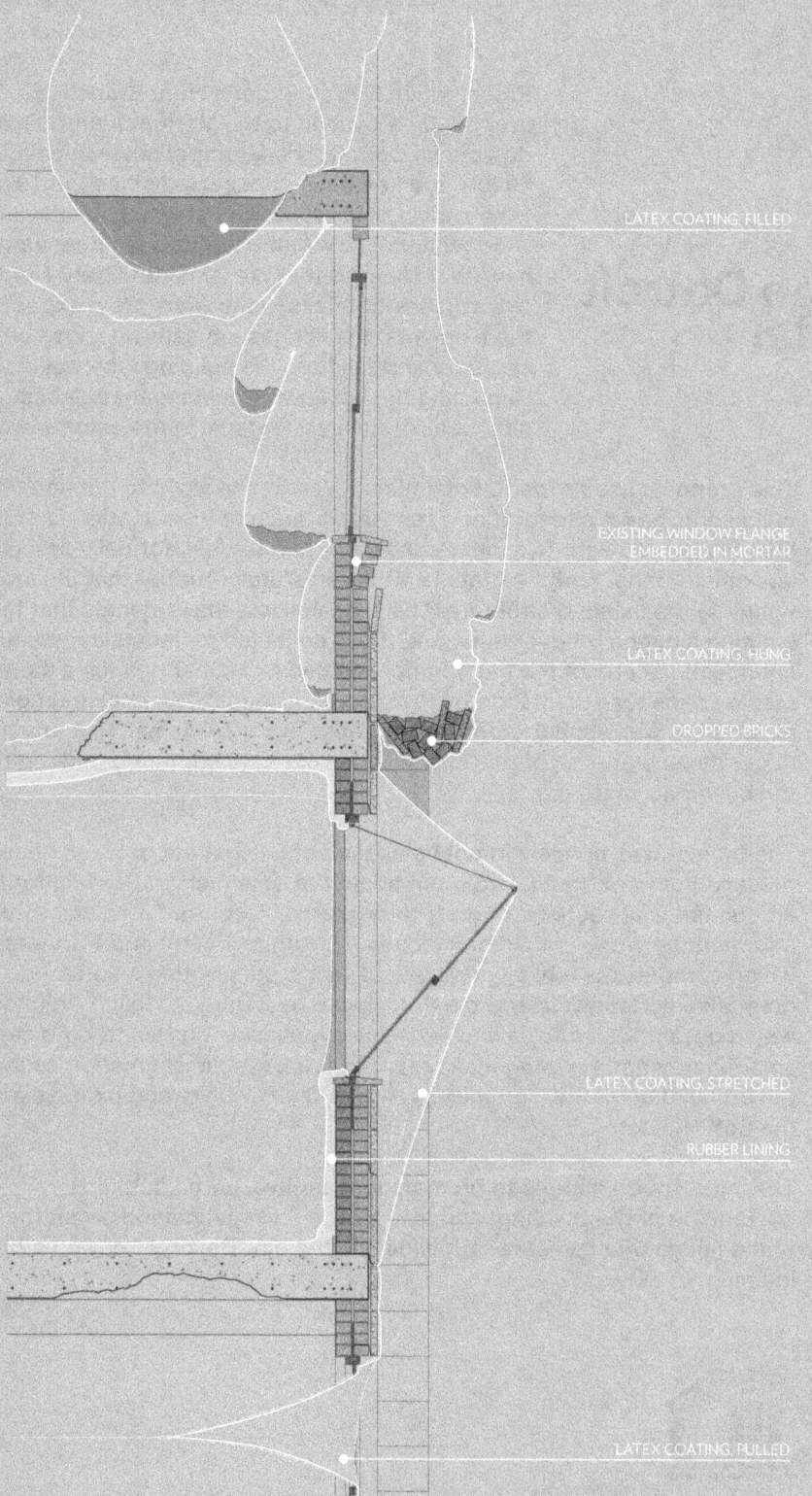

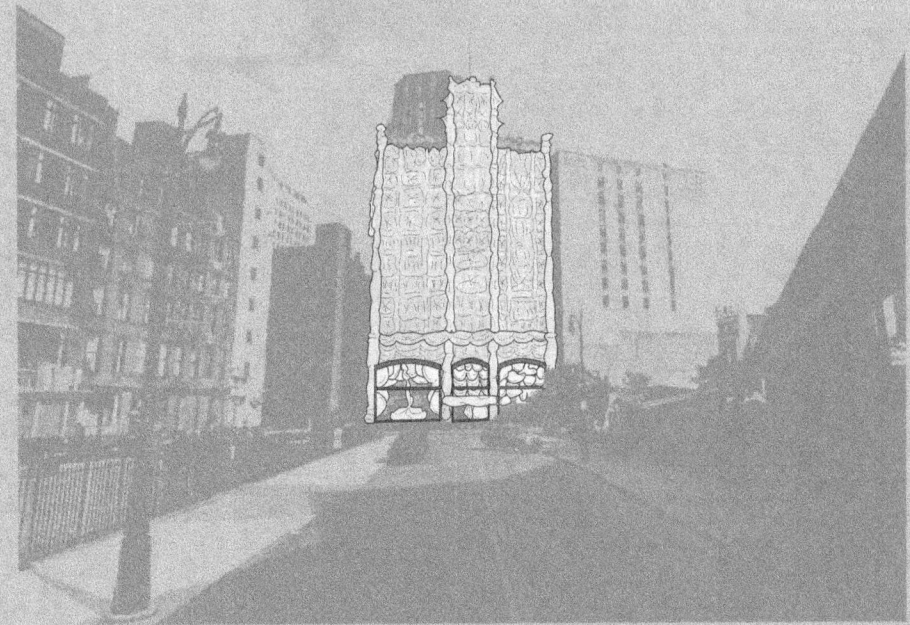

Above: Site plan.

Right: View from Farmer St.

Opposite: Wall section.

4 Preservation Detroit Experimental Branch

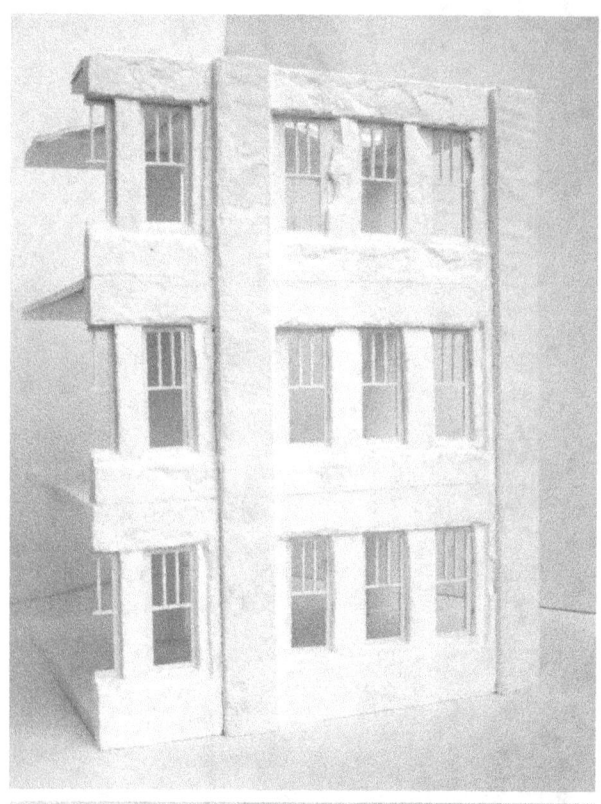

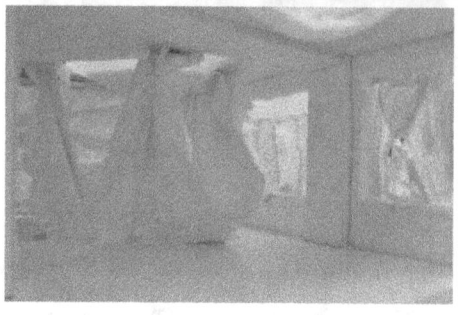

Above: Model interior after latex coating

Opposite: Early fabric manipulation tests, and model details

Left: Model before and after latex coating

Below: changes over time

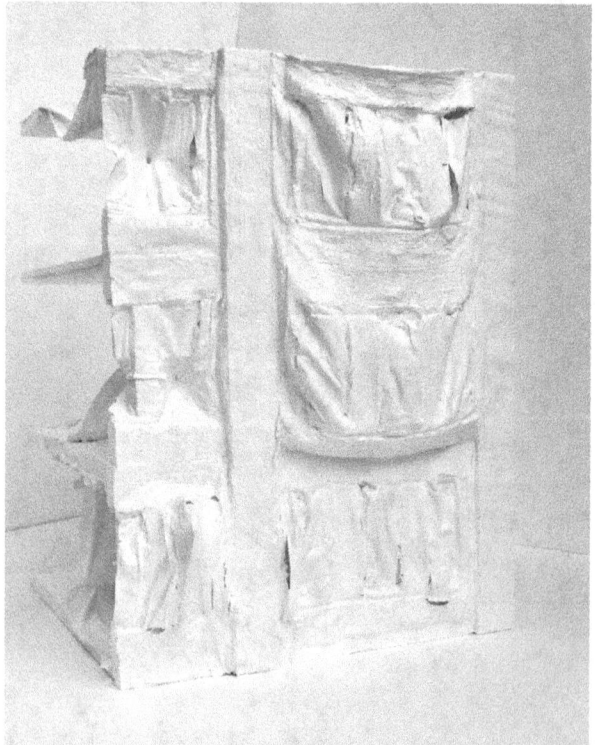

Preservation Detroit Experimental Branch

Geology and Restraint

Jon Piasecki

One of the best things about being a stonemason is that I get to visit stone quarries. Each quarry is the site of a specific geological autopsy where an interested individual gets to travel back in time, below the current surface of the earth. All around are puzzlements. One finds: fossils, intrusions of quartz, evidence of faulting, sinuous signs of metamorphic pressure, shafts of uplift and fans of erosion. All of this is laid bare by giant machines. Their massive diesel engines drill, saw and hoist geology into units for sale. Quarries are a kind of library but really more of candy shop for me.

Quarries dwarf me. They provide direct evidence that nature's forces and geologic time operate beyond my scale of understanding. Our huge machines are themselves tiny compared to rock faces they work. My own insignificance inspires my work.

Recently, I built a geology-viewing platform. The view from the individual-sized stone cube to the south over the glacially scoured valley to the schist, quartzite and marble hills in the distance, creates the impression of soaring over a wider world.

The cube is made from Mica Schist. To the extent that geologic time can be understood, I learned that this stone was forged deep beneath an ancient ocean called the Proto-Atlantic. With each stroke of my hammer I released dust lithified almost half a billion years before today and that dust was part of a mountain range deposited nearly a billion years before that. The stuff of my stone traveled from the mountains down to and then under the sea. Then it returned to become a new mountain. It was then hacked from the earth to be laid at the feet of one of my clients. And even this billion and a half year odyssey is still just a flash in geologic time.

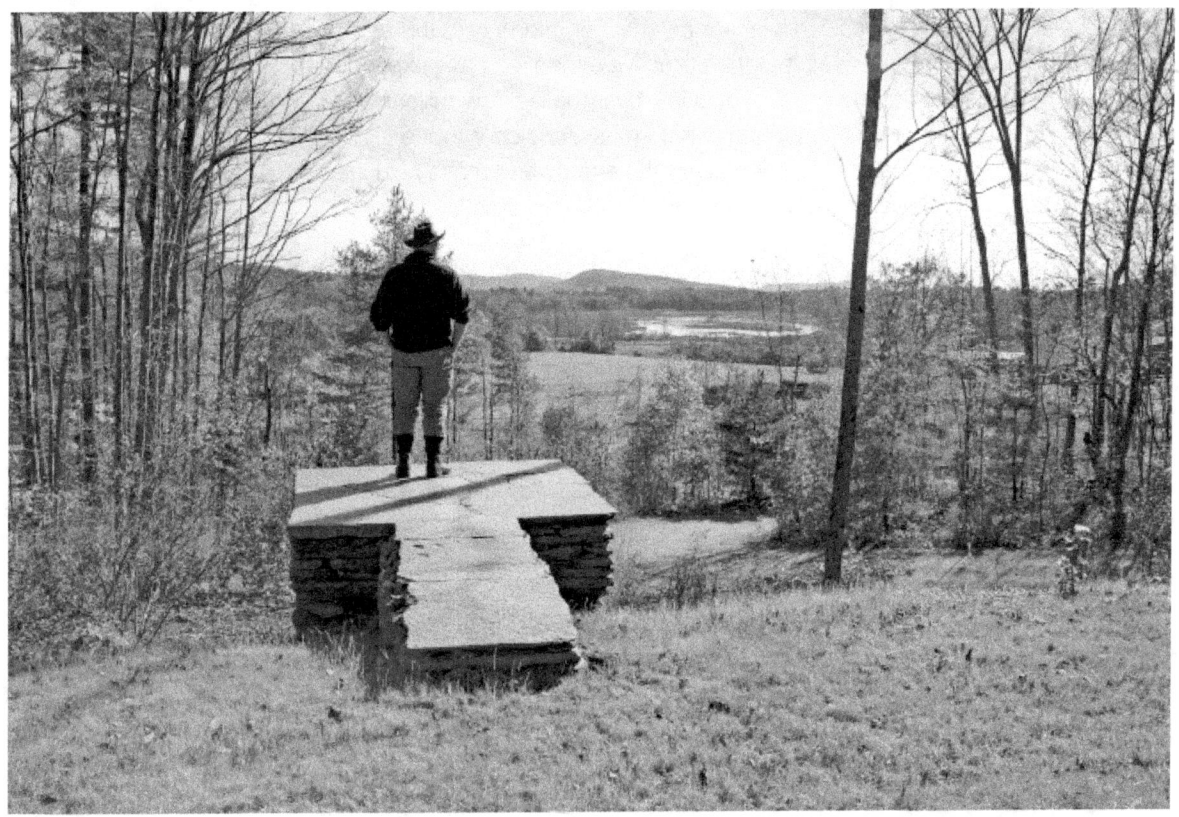

Above: 25 ton Micha Schist Platform.

The viewing platform weighs 25 tons. It is a six-foot dry stacked cube with an elevated approach path. In the last six years I have laid about 900 tons of stone in walls or as paving by myself. That seems like a lot. But it is nothing compared to the supreme masonry and building efforts of our species, like the Great Wall of China, the Pyramids.

These signature accomplishments are themselves tiny compared to the building of an entire modern city. Cities consume mega-tons of material and they are our biggest accomplishment but even these consume a tiny fraction of the energy and mass involved in the migration of the continental plates where thousands of cubic kilometers of stone are routinely thrust skyward or plunged toward the magma. This geology usually happens slowly but can erupt, thrust or sink rather forcefully and quickly.

If there is a lesson in this exposition it is that my meager efforts with this stone cube are orders of magnitude less that the collective efforts we have expended to collectively build cities. But the building of cities, over the last few millennia contain a record of expended energy and utilized mass far closer to the magnitude of my efforts than to the enormity of the energy and mass held in geologic forces at work over the billions of years of geologic time.

To be generous, urbanity, defined as collective settlement in a fixed place yielding architectural remains, has been in existence for perhaps 10000 years. Outside Damascus there is a hill that marks "urban" habitation back to 8300 years ago. In Malta there is a stonewall built around 4500 years ago. At Lascaux, Altimira and the Ardeche there are caves with evidence of our assembly into groups and our artistic predisposition on display. These can date early signs of cultural production to between 40000 and 25000 years before present. The best evidence we have from our own Homo sapiens fossil record date our genetic existence to perhaps 200000 before present.

To distinguish the magnitude of the entirety of geological time from that of the Anthropocene is to compare the volume of an ocean with the volume of a cup. We as a species have taken the first tottering and tentative steps of reason in the last 400 years. We are not quite sure but the earth is 4.5 billion years old and the universe is 10 billion years older.

Three hundred and seventy years ago Rene Descartes' statement "cogito ergo sum" (I think, therefore I am) used cognition to justify the concept of the soul and to privilege human thought as the basis of existence. This soul or "ghost" was deployed to differentiate our species from the myriad other species and inanimate objects in nature. In addition to launching an Age of Reason, Descartes was able to nudge thought a little beyond the confines of the Church while still keeping close enough proximity to the accepted canon of ideas to keep his head on his shoulders. With his mind/body dualism Descartes individualized the nature/culture dualism, in which nature and culture are separate entities and where at its best an enlightened culture uses scientific "stewardship" to bring nature under our dominion to apply our order.

Nature's death, diminishment and subservience are central features to the nature/culture dialog in landscape architecture and the ascendance of culture is a preposition on many of our most lauded modern urban interventions. Culture becomes the privileged entity above nature, as Descartes privileged the mind over the body. Sadly, but predictably, these first steps towards reason have not advanced very far away from the Deist center of the Cartesian grid. Consider the current rage for "landscape urbanism." Through all the verbiage, the overtures

to natural systems and the assertions of site specificity, landscape urbanism is a manufactured ground. In an inversion of Olmsted's desire to uplift culture through exposure to nature, albeit a man made one, landscape urbanism reduces nature to a cultural construct and in its megalomania claims stewardship over a natural system operating beyond the most expansive scope of any of our day's star practitioners and their "curatorial" efforts.

To join the stones of my stone cube I used force to smooth the rough edges between the rocks so that they might fit together. In a homologous manner I would apply the force of a critique launched by Gilbert Ryle on the Cartesian mind/body dualism in philosophy, to the culture/nature dualism that pervades ideas of landscape.

In his book "Concept of Mind", Ryle suggested that the mind/body dualism is categorically mistaken. It compares unrelated elements like comparing apples and oranges. Ryle's critique made room for the mind and the body to begin to unify from their former philosophical schism. Nature would cease to be an object with humanity as the subject. The figure and the ground could become one. Here our compromised environment transforms from an external threat to a direct personal threat. As is clear to any ecologist, our destruction of what we consider to be an externalized nature shows itself for what it is, an exercise in self-mutilation.

Our hubris has and continues to destroy other species and the land itself. Nature will continue to make new species and geology will continue to re-make the land. From a selfish perspective our destructive and exploitive tendencies really put our species at risk through climate chaos for instance. Our fixation on being "made in God's image", having "dominion" over the sea, land, air, and all the plants and creatures there included as well as of being the "chosen people" stifles our creative energies by force-fitting our best thinking into a culturally imposed framework where we are the purpose of creation and so our immediate needs trump all other factors.

As an example one need only consider the tar sands project in Alberta. On a geologic scale this type of carnage this project will cause is the norm. Several cataclysmic events of far greater magnitude have already occurred in geologic time. The most notable is the Permian extinction event. But Nature's extinction events are random, we are designing, engineering and building the Anthropocene extinction event as we collectively spew ever more carbon and methane into the atmosphere. Designers must face the humbling fact that the Howard Roark as triumphant figure is no longer valid, and should adjust their pretensions accordingly.

Our misplaced arrogance as "designers" or "stewards" lets us conceive of "enlightened" projects to improve "inevitable" development. But the blinders we wear as the species at the supposed apex of God's creation obscure the fact that in evolution there is no "apex." Intellectually maintaining our imagined apical position as the reason for all things lets us conceive of building mega-projects but precludes us from considering if we should embark on projects that put our own species survival at risk.

Whether it is the Tar Sands Project, fraking the Marcellus Shale, building the Three Gorges Dam, flood proofing of New York City or creating the Yucca Mountain nuclear waste facility, our creativity is spent establishing that it is theoretically possible to do the project, and to pretend that we can adequately model the vagaries of geologic time. We pretend the project will work and then pretend that environmental concerns will be met. Good jobs, housing and infrastructure for the workers and residents will be provided so that our economy with be driven onwards. We need to take a broader view and imagine what is best for the entire system of which we are a small part and we need to consider how our actions impact our survival in geologic time.

We flirt with our own extinction as we pretend we are at the pinnacle of a creation that never happened, or presume the wisdom to scientifically steward, engineer or design the complex world around us with any degree of certainty about the outcome of our actions. We have abandoned Nature as an inspiration, and reduced it to a resource to be claimed and used in the name of cultural priorities that in the end profit our rulers. Designers, engineers and urbanists become tools to facilitate and aesthetize an agenda of extraction.

The majority of our population is reduced to drones that carry out the utilitarian requirements of an intermediate class lost in a virtual world disconnected from the non-digital and low status physical world and themselves in the service of the few kings, queens, pharos, sheiks, oligarchs and billionaires at the top. Compliance with the institutional reality of our culture reduces our species' resilience. In exchange for mastery in a virtual world we abandon our insignificance with its varied experience, wonder and potency in the natural world made by the process of evolution at work in geologic time.

Geology teaches us that we have a lot to learn. In my opinion we will have an easier time learning if we admit how little we know and if we can conduct ourselves with the humility that our ignorance demands. By looking away from ourselves and toward Nature for inspiration, we can find a way to keep our species above ground and out of the fossil record. Extinction would lock what we have accomplished within the Anthropocene geologic stone layer, replete with bits of plastic and an increased carbon dioxide levels in the included gas bubbles.

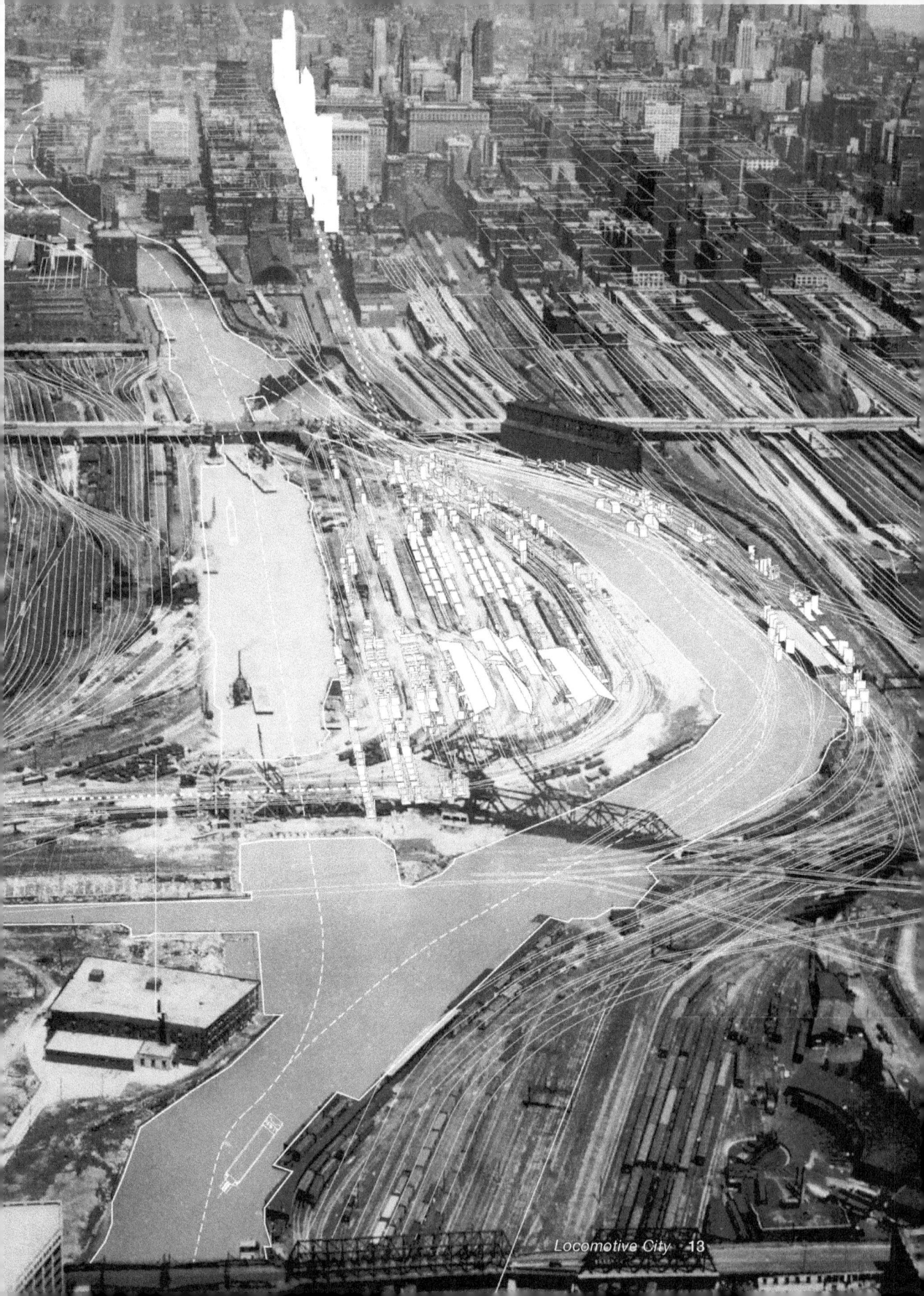

Locomotive City 13

Locomotive City

Justin Hui

At the turn of the century, the American railway not only created new capacities of movement, but the reality of an interconnected world that led to colossal patterns of urbanization and transformation. In the post-war era, much of the railway fell into abandon as industries moved elsewhere, leaving neighborhoods divided by remnants of the industrial past. As American cities become further privatized, can ideas drawn from abandoned rail yards reformulate a city's urban condition and bring greater sense of democracy to cities?

Locomotive City asks how specific features and patterns of the locomotive can inspire a more diverse vision for Chicago. Embedded with specific information accrued from the past industry, mobility, and trade - former rail yards become testbeds for urban re-evaluations that offer alternatives to master plans. Using the locomotive and rail as a carrier of program and landscape, the project re-links and conceptually fuses three diverse neighboring enclaves - Chinatown, Downtown Loop, and Pilsen. Through drawings and analysis, the site re-appropriates an assemblage of distinct urban landscapes, building typologies, and diverse narratives into a new framework modeled on the collage of these three neighborhoods. In this newfound condition, the project purges the contemporary city from its enclaves by means of material, programmatic, and circulatory transfer. It asks how latent memories can reformulate a city's typology and social condition to foster what is arguably at the heart of the city - the persisting congestion of conditions, cultures, and ideas.

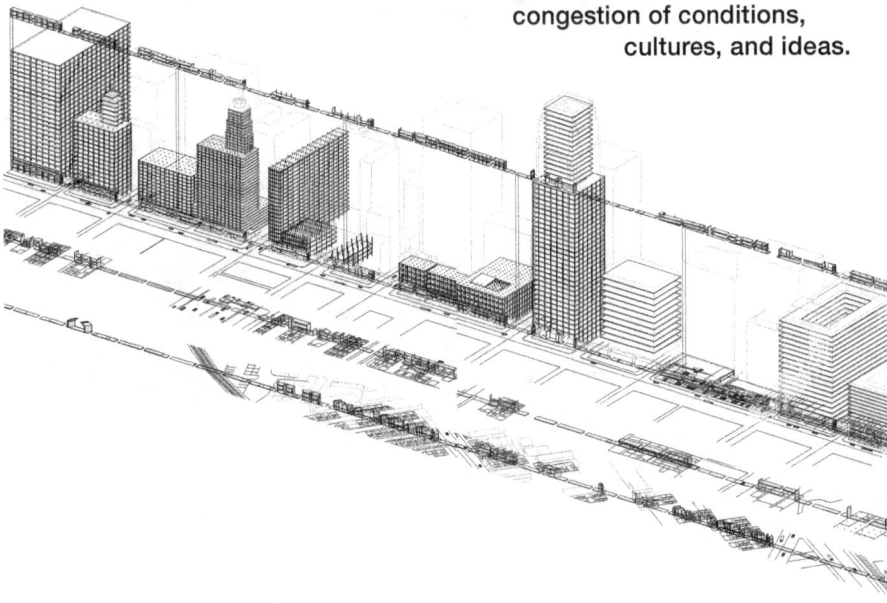

Opposite: Material Transfer. Aerial Photo (l 920) during straightening of Chicago River

Above: Downtown Loop, Chinatown, Pilsen

Right: Conceptual Process of Urban Transfer Urban Extraction by Train Module in Each Neighborhood

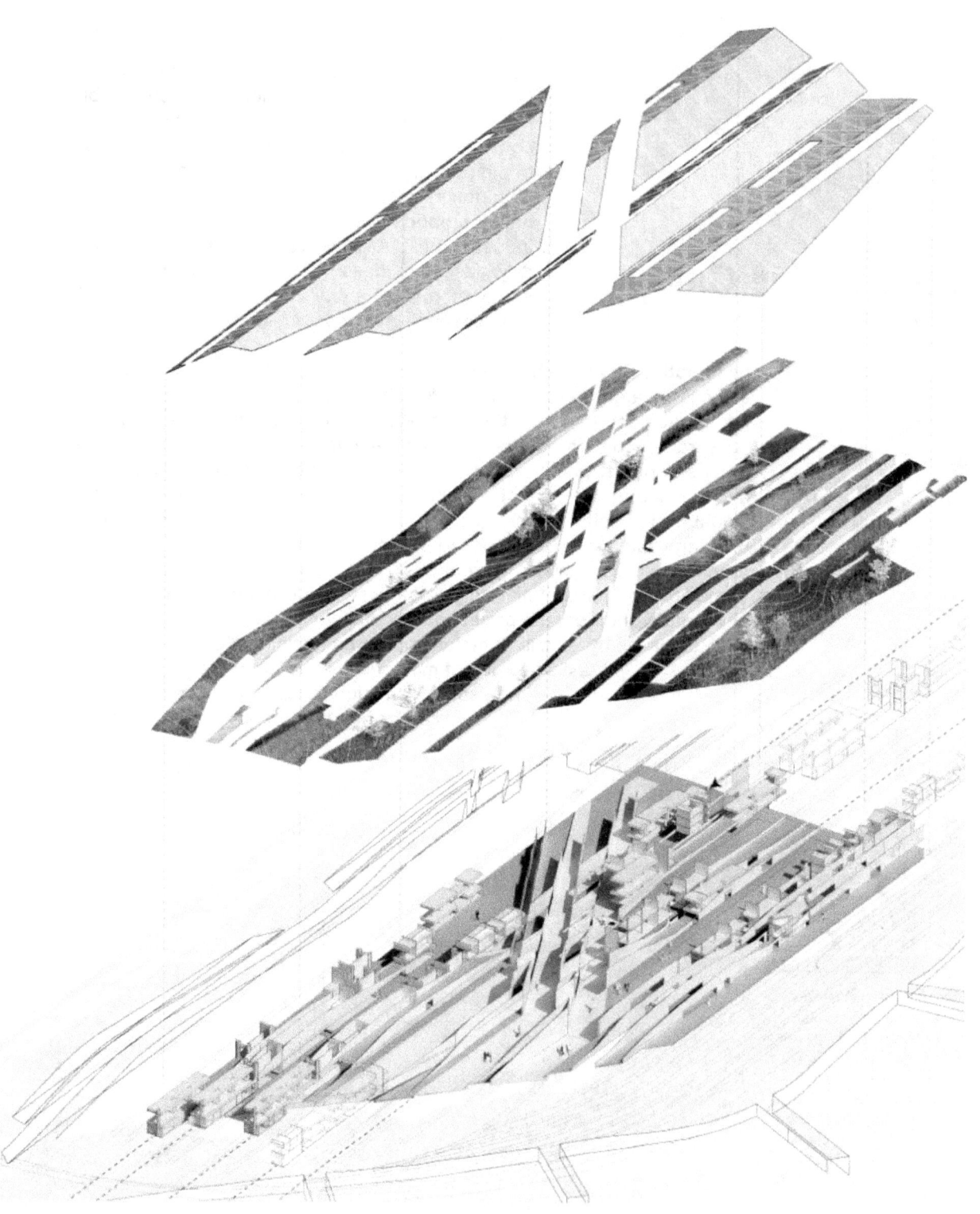

Locomotive City 15

A market hall is placed on site where the tracks converge — a programmatic connection between the three neighborhoods. It is designed like a train station where people and events from all three neighborhoods converge — a micro collage of urban events that enable opportunities for multiple paths, diverse experiences, and discrete forms of transfer. Under one large roof the existing topography negotiates in section with different levels of transferred parts, showing moments of coincidence, autonomy, and contrast between city's contrasting entities.

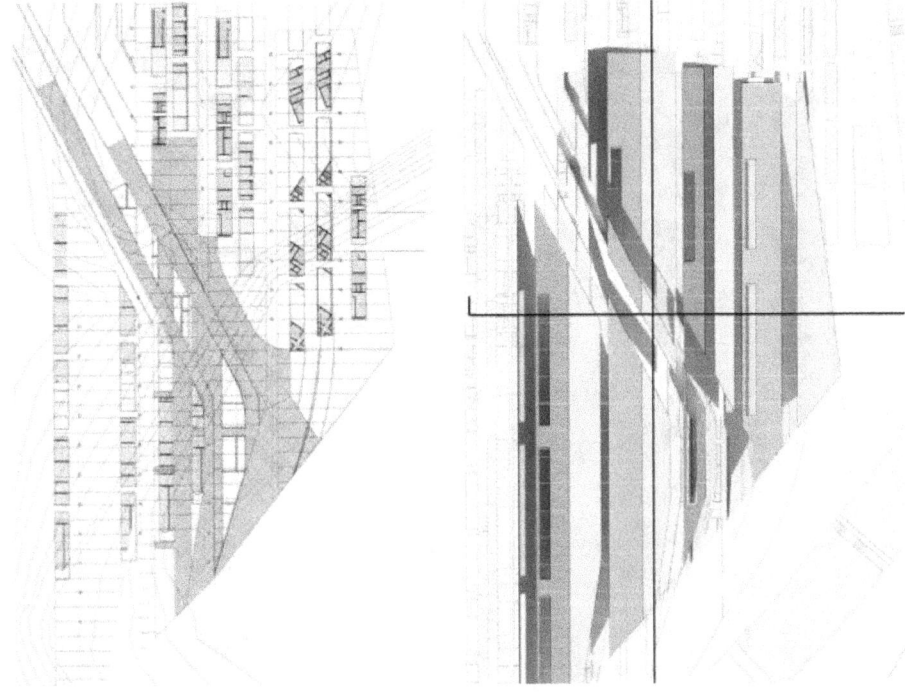

Opposite: Exploded Axon of Market Hall. (from top to bottom) Roof, Condenser of activity, Existing topography, transferred elements

Right: Market Hall pans

Below: Market Hall perspective

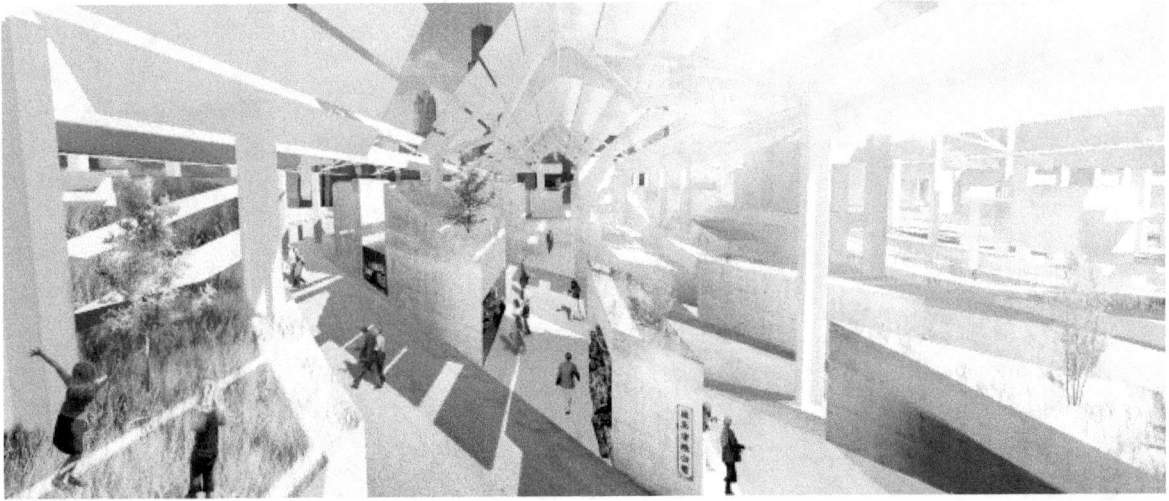

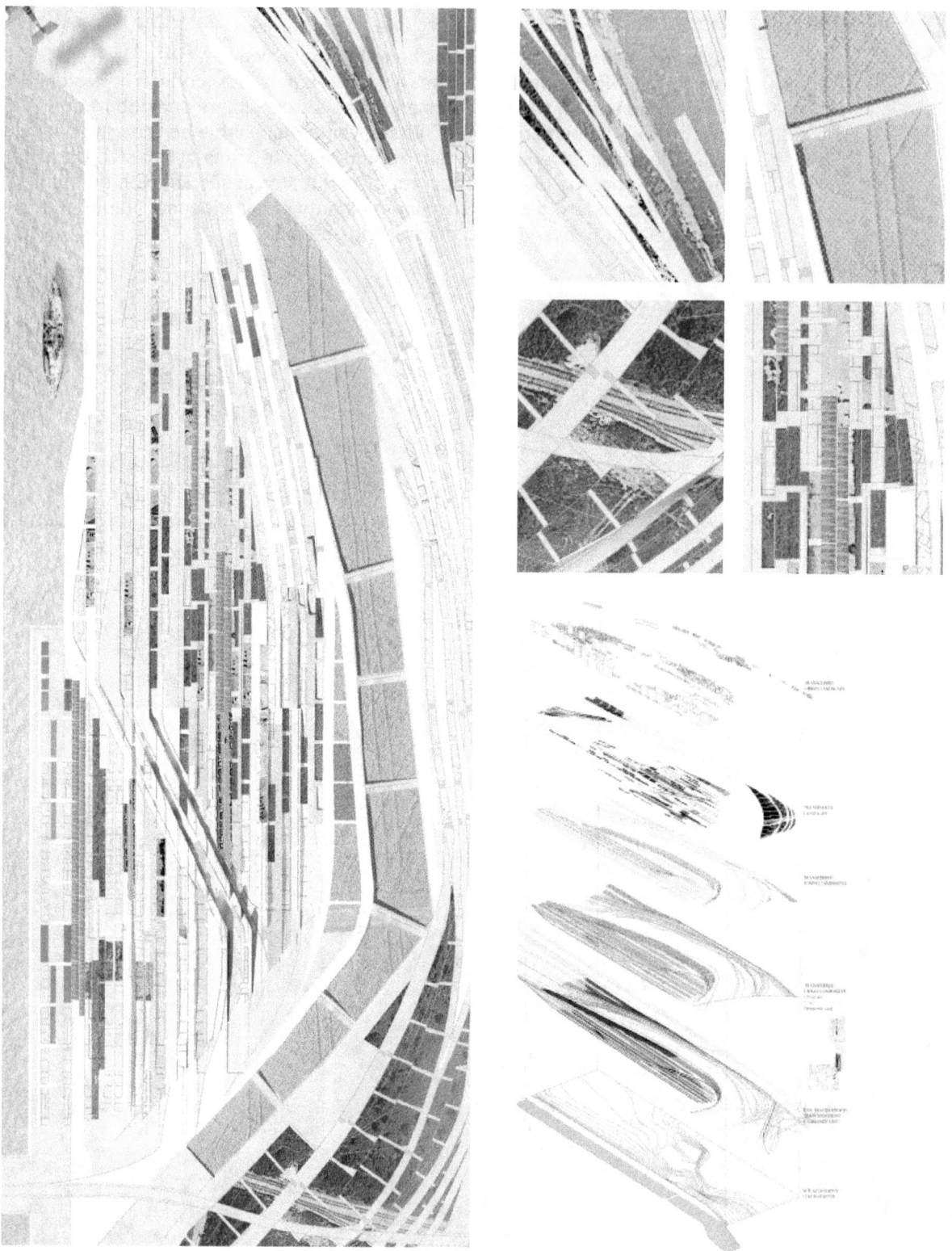

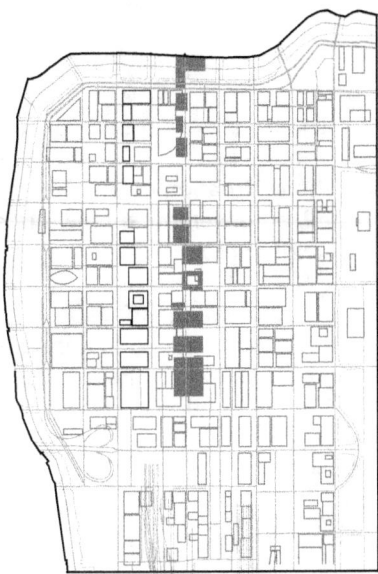

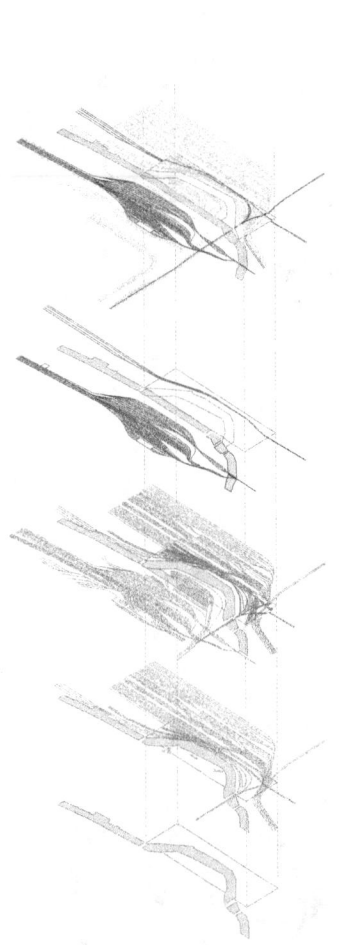

Opposite Left: Market Hall master plan

Opposite Right: Rail Development Diagram

Above: Diesel Locomotive (blue) and Steam Locomotive (red) over time, (from top to bottom) present, 1929, 1928, 1911, 1880

Right: Master plan indicating extraction of urban program and landscape by respective neighborhood (by color)

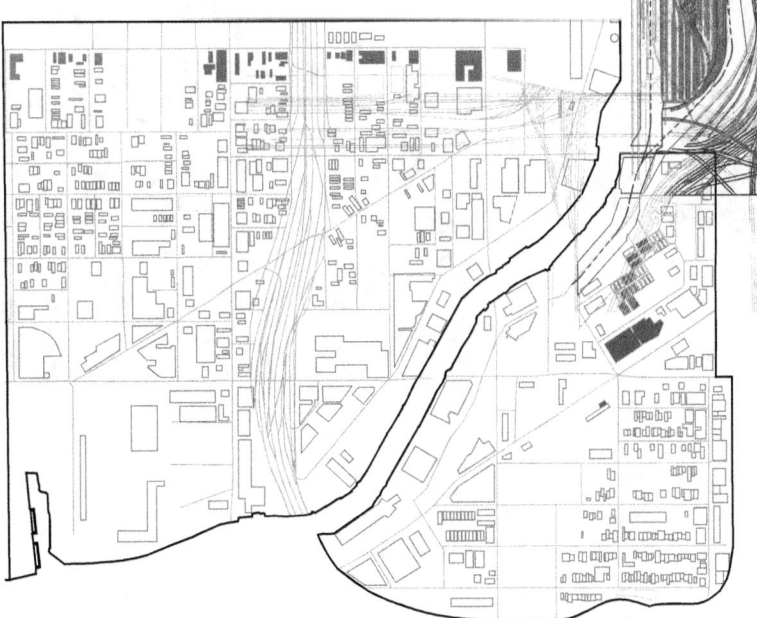

The transfer of green spaces extracted from adjacent neighborhoods and the use of Chicago River as a public waterfront allow for the restoration of the site as a public park with new forms of mixed development, all shared and used by people of all three neighborhoods.

A transferred landscape by the site's rail tracks enables differences of Chicago to play out. Landscape becomes a medium of exchange for people and for different parts of Chicago to be brought together with both disruption and subtlety.

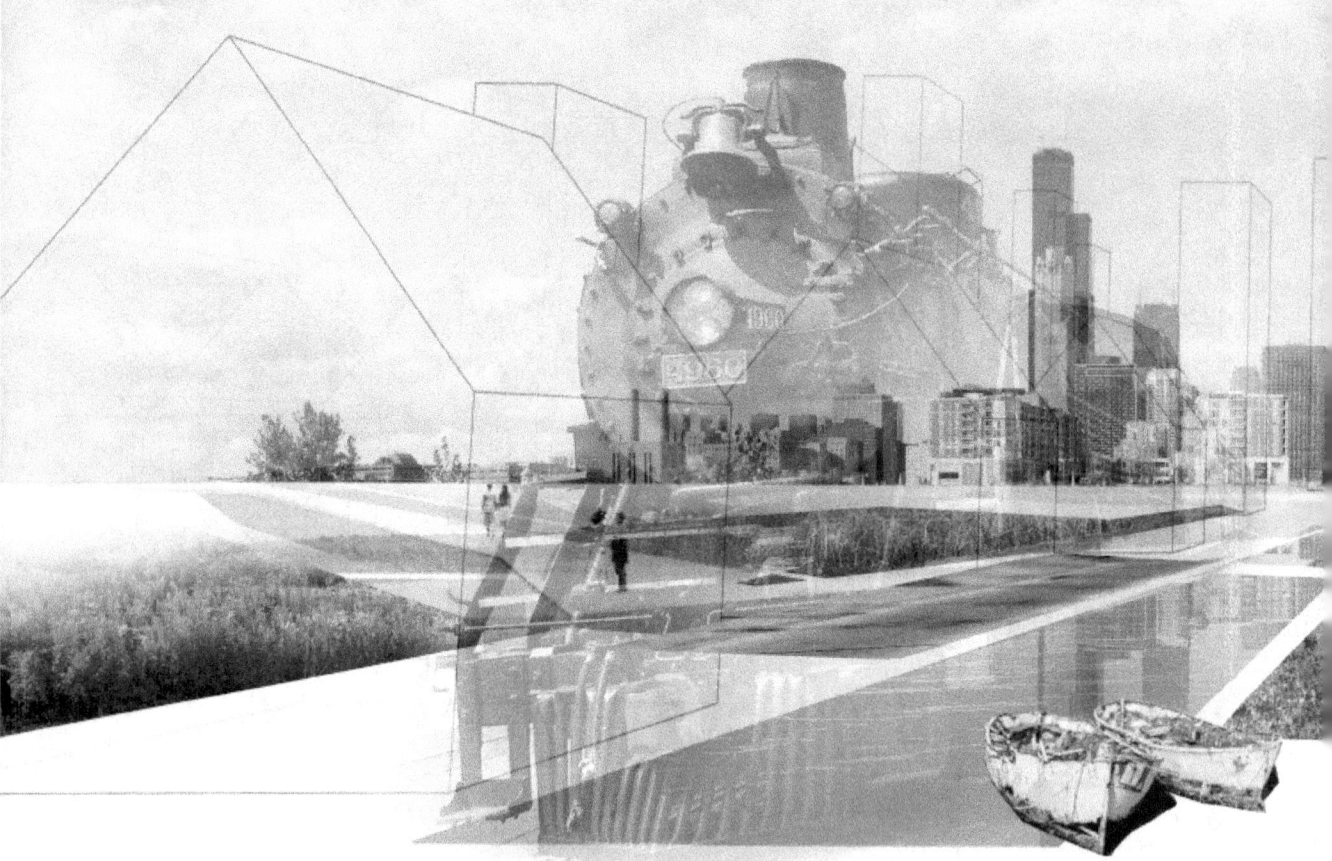

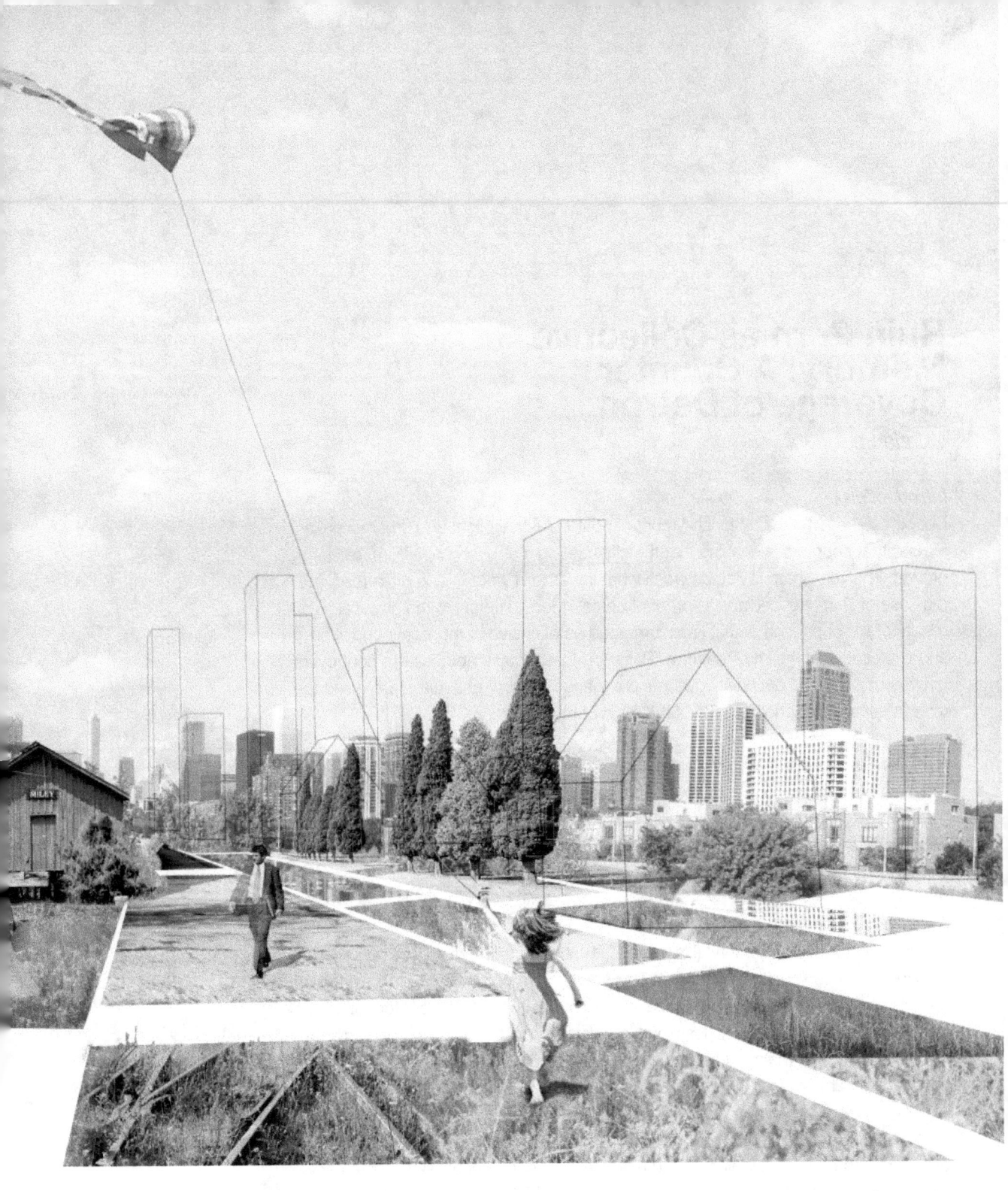

20 *Locomotive City*

Ruin Porn as Collective Memory: A Counter Coverage of Detroit

Valeria Federighi

Introduction
Detroit has become the national symbol of post-industrial blight and urban shrinkage, a trend that counters everything that the city used to stand for: capitalism, efficiency, growth. The very sharp divide between what it was and what it is, is often read, in the case of Detroit especially, as proof of defeat. Media interest in the physical, urban results of the supposed defeat is, in turn, read as offensive to the local population and exploitative of the city. The term "Ruin Porn" perfectly embodies this controversy between insider and outsider, voyeur and engaged person, and it is widely used to refer to sensational photographs of the ruins of the city.

Ruin Porn as Collective Memory analyzes the dynamics that make Ruin Porn the main cover image of the city of Detroit, and how this cover image informs the experience of the city. My claim is that, notwithstanding the controversy that necessarily accompanies the term and the practice of ruin porn, the resulting body of imagery can be read as a sort of 'collective memory' of the city.

Ruin Porn as Collective Memory
The phrase 'collective memory' (Halbwachs, 1950) enters the discipline of architecture in 1964, with Aldo Rossi's The Architecture of the City. For Rossi, urban collective memory resides in monuments, which operate as immanent receptacles of the city's changing dynamics. Rossi puts a definite accent on their morphology: the unchanging form of the monument allows the city to maintain its memory in time, and thus, indisputably, their form is their essence.

In more recent times many theorizations have appeared of collective memory being created on the basis of a shared media experience; Pinchevsky and Tamar, for instance, highlight how the radio coverage of the Eichmann trial was being experienced by the population as a reality, ever existing, running alongside their actual lives, and how "live [radio] transmissions became inseparable from the memory

of the trial itself, [...] presumably related to the dynamics of collective memory, that is, to the way the past is socially constructed in the present."[1]

In the particular case of Detroit, so-called ruin porn as a photographic practice has created a kind of collective memory that is all the more deep-rooted as it is controversial; ruin porn informs both the media perception and spatial experience of the city. As Mark Wigley says about Manhattan,

> *to go to Manhattan is only to go to the hard copy, as it were, of all the images that you know so well, to swim in the source of the flow. And perhaps to discover the paradox that you cannot see Manhattan so well in Manhattan. The famous skyline is only visible from outside the island. In a sense, you have to leave there to be there.*[2]

In the same way, to visit Detroit is merely to look for a confirmation of what we already know. This implies that the actual, material experience is modified strongly by mediatized information, and that our occupation of space in the city is a direct result of that. Detroit ruin tourists have a set of predefined routes that reflect the most widely mediatized icons of the city; they are, of course, the Train Depot, the Packard Plant, Brush Park mansions, and so on. These don't change in time thanks to their photogenic nature, so that the city is allowed to pivot around them; the preferential objects of ruin porn become the polarized forces of physical movement in Detroit, catalysts for un-change. As Rossi's monuments are morphological entities, so are ruin porn objects, as they are stripped of any other significance beyond their decayed form and their attached nostalgic fascination. This is as morphological as it gets.

Ruin Porn is obviously a derogatory term, allegedly introduced by Thomas Morton in 2009:

> *For a while James [Griffoen] was getting four to five calls a week from outside journalists looking for someone to sherpa them to the city's best shitholes, but they've finally begun leaving him alone since he started telling them to fuck off.*
> *"At first, you're really flattered by it, like, 'Whoa, these professional guys are interested in what I have to say and show them.' But you get worn down trying to show them all the different sides of the city, then watching them go back and write the same story as everyone else. The photographers are the worst. Basically, the only thing they're interested in shooting is ruin porn."*[3]

It is a very loosely defined category, but at the same time the sensationalism that is peculiar to both the practice and the term is a definite magnet for attention. Those that attack it often do so in the name of local pride, reacting against misleading

1 Amit Pinchevsky and Tamar Liebes, *Severed Voices: Radio and the mediation of trauma in the Eichmann Trial*, p. 267

2 Mark Wigley, *Resisting the city*, in *Transurbanism*, V2 publications, 2002

3 Thomas Morton, *Something, something, something*, Detroit, Vice magazine, www.vice.com

representations and exploitative voyeurism; those that defend it, on the other hand, call for artistic expression and representational value.

In 1984 Soviet architects Aleksandr Brodsky and Ilya Utkin participated in an international competition with a visionary project called "Columbarium Architecturae." The proposal envisioned an enormous museum structure that would house condemned houses on shelves on the walls. Inhabitants of the city whose house was about to be razed to make way for high-rises could choose to move it into a square niche in the Columbarium and live there with their families. The accompanying narrative reads as follows:

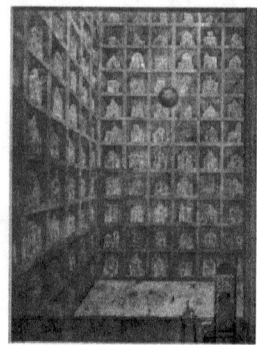

Brodksy and Utkin, Columbarium Habitabile

> *The building we propose for the given plot we have called "the museum of disappearing buildings." It's hard to say how many old buildings, both large and small, beautiful and not beautiful, have disappeared from our city in recent years. [...] Each disappearing building, even the most unprepossesing, is an equal exhibit in the museum. After all, each is suffused with the soul of its architect, builders, inhabitants, and even the passersby who happened to cast an absent-minded glance its way.[4]*

The project is an open denunciation of the destruction of memory carried out in Russia in the name of urban progress; the exhibition space in the Columbarium is intended, then, to act as an absurd, life-size representation of the history of the city.

In Detroit, the razing industry is similarly effective, the only currently lucrative 'building' activity. An average of four buildings –mostly one family houses- are destroyed every day; rarer, but surely more sensational, are the razing of renowned ruins. The Packard Plant, for instance, has been facing $6 million demolition,[5] a cost that the owner hoped to recuperate from scrap iron and steel, although the building has been stripped of most of its resalable materials over the years.

This landscape of forced disappearances allows for the virtual, Ruin Porn landscape to acquire three-dimensionality. The ephemerality of built form makes the immutable photograph all the strongest, and impending destruction calls for dystopian imagery.

The logic of the coverage
Ruin Porn is essentially a media coverage of the city. As implicit in the nature of the coverage, it plays on a structural fragmentation of information and its subsequent assemblage in order to create a new narrative. The origin of the term coverage is strictly technical, as it relates to the size of the image a lens can produce; through transfer of meaning, coverage then goes to indicate the amount of reporting given by media to a specific subject or event.

4 Lois Nesbitt, Brodsky and Utkin, *the complete works*, Princeton Architectural Press, New York, 2003

5 Kate Abbey-Lambertz, *Packard Plant Demolition Plans Set By Purported Owner Dominic Cristini*, in the Huffington Post, 3-2-2012

Ruin Porn as Collective Memory 23

An analysis of coverage as representational process must deal with two issues in particular: what is coverage and why does it rely on implementation? And how does coverage relate to the object it covers? The two questions are actually one, since the very fact that coverage relies on implementation changes radically its relation to the source object and the image it gives of it: it implements it, of course. The reason for that is obviously one of audience, since implementation makes the object more appealing. It has something to do with the "spectacularization" of facts, which, though it is diffusely intended in a negative way, as is the case for expressions such as "infotainment" or even the old "yellow journalism", actually means little else than the adding of images on images.

Jean Baudrillard identifies the unfolding of the image within four phases:

> *It is the reflection of a basic reality*
> *It masks and perverts a basic reality*
> *It masks the absence of a basic reality*
> *It bears no relation to any reality whatever: it is its own pure simulacrum*[6]

To insert coverage in this succession is not possible. But the meaning of the very classification points out to how the image, once produced, is independent of the object that it was produced as a representation of. It is very difficult, I would argue, to think of an image that falls into the first category. We can argue that the intention that produces the image sometimes does, but the image itself immediately slips further. In coverage, this slipping is all the more visible since it is completely intentional and admittedly so. Coverage is, then, a sort of reportage, but with the added value that is embedded in the semantics of the word: it doesn't only "report", it "covers." Herron, for example, very effectively uses it as a metaphor for the different perceptions obtainable by different kinds of city life, those that give the occupant the reassuring impression of being "covered" and those that don't.

As a simple communication tool, though, coverage is still quite ambiguous. The way that it manages to work is twofold, or, better, it is a single way that has two opposite, coexisting consequences: on the one hand, the multiplicity of images that are given through coverage aims at supplying the viewer with a sufficient amount of information, so that the subject is fully "covered" with no need to delve further this aspect borders pedagogy. On the other hand, the amount of information given results in a more active engagement of the recipient of the same, empathizeing with an otherwise distant object, intellectually in reconstructing and analyzing the

[6] Jean Baudrillard, *Simulacra and Simulation*, The University of Michigan Press, Ann Arbor, p. 6

Ruin Porn operates on Detroit with the same duality. Spatial synecdoche highlights few portions of the city and repeats them over and over again, until they become representative, from a collective memory standpoint. Furthermore, ruin porn 'covers':

by the very creation of collective memory, it presences Detroit on a large scale and engages the viewer actively as to its legitimacy.

Steven Johnson defines this trend of fragmentation as "Sleeper Curve"[7]: a tribute to W. Allen's movie The Sleeper, in which scientists of the future discover that junk food is, really, healthy, the expression is used to argue against contemporary perception of the deteriorating standards of pop culture. According to the author, contemporary media's multithreaded narratives help us develop quickness and agility in understanding.

Example of Cropping, Cooper School, Andrew Moore

As all coverage structures and, interestingly, ruins, Ruin Porn works through asyndeton and synecdoche: Michel De Certau's spatial interpretation of the two rhetorical figures is well known.

> *Synecdoche expands a spatial element in order to make it play the role of a "more" (a totality) and take its place. [...] Asyndeton, by elision, creates a "less", opens gaps in the spatial continuum, and retains only selected parts of it that amount almost to relics. Synecdoche replaces totalities by fragments (a less in the place of a more); asyndeton disconnects them by eliminating the conjunctive or the consecutive (nothing in place of something). Synecdoche makes more dense: it amplifies the detail and miniaturizes the whole. Asyndeton cuts out: it undoes continuity and undercuts its plausibility. A space treated in this way and shaped by practices is transformed into enlarged singularities and separate islands.*[8]

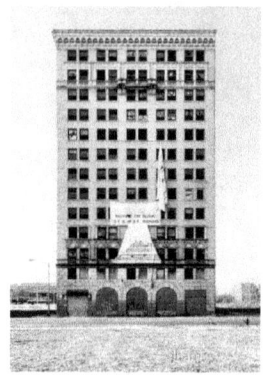

Example of Frontality

Although De Certau's interest lies more in lively sidewalks than in ruinous landscapes, his reading of spatial structures is actually useful in trying to understand how Ruin Porn relates to the city. Both figures, I would argue, are in place: Ruin Porn as primary coverage of the city and, as a result, as its collective memory, both makes 'more dense' and 'undoes continuity'; both 'amplifies the detail' and 'cuts out'. If Ruin Porn can be read as the Collective Memory of the city, then it can be allowed to rearrange the topography of the city according to its logic. In this way, we can imagine the plan of Detroit formed by islands of intensity where the most covered ruins lie, the seams of which touch the voids around them and act as osmotic membranes. Instead of Guy Debord's Psychogeography of Paris, in which urban experience shapes the urban form, here it is imagery. The islands form an 'urban archipelago'[9] through which the experience of the city is made.

Ruin Peepshow

Ruin Porn is a very loose category, one that doesn't allow a precise distinction between works that belong to it and those that don't. One of its main characteristics, as I will further explain later, is that it seems to be indissolubly related to the figure of

[7] Steven Johnson, *Everything bad is good for you. How today's popular culture is actually making us smarter*, Penguin Books Ltd., New York, 2006

[8] Michel De Certau, *Practice of everyday life*, University of California Press, Berkeley, 1988, p.101

[9] Pier Vittorio Aureli, *The possibility of an absolute architecture*, MIT Press, 2011

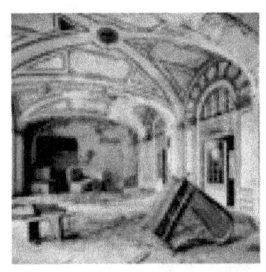

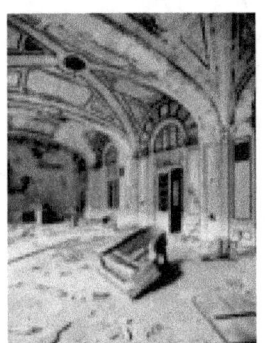

Example of Repetition
Similar Ruin Porn photographs belonging to different publications

the outsider. There are, nonetheless, certain common threads that repeat themselves in photographs that are usually referred to as Ruin Porn. In this paragraph I will attempt to disclose some of them with the aid of the image themselves.

Cropping: Ruin Porn photographers are often accused of manipulating the framing of the image as to carefully exclude from it anything that does not comply with the prevailing aesthetics of ruin and decay. So, for instance, shots of the Train Depot never include the lively BBQ joint across the street on the north side, but they do sometimes include the abandoned hotel on its east side. James Griffoen denounces the same trend in representations of the Cooper School:

> *"If you angle the camera the correct way it looks like you're in the middle of nowhere—but then you turn a little to the right and there's a well-maintained, fully functioning factory, and to the left there's this busy office park. Still, people love to take this shot, crop it so it's just prairie, and be like, 'Look, this is a mile from downtown, it's turned into woods.'"*[10]

Frontality: Ruin Porn photographs tend to depict the object frontally, as if to maximize the divide between the intended orthogonal regularity of the designed building and it current state of decay.

Repetition: as I stated earlier, the city of Detroit has come to be represented, in the Collective Memory, by a handful of known objects that are photographed repeatedly. What is even more interesting, though, is that the very point of view is often faithfully repeated, and the images become almost copies of each other. This has to do, obviously, with the preference for frontal views that I already indicated, but also with the status of icon that the image, rather than the object, has come to acquire. In other words, subsequent photographs don't reproduce the same building, but each other.

Detailing: Ruin Porn photographs employ high-detailed shots in order to two-dimensionally convey the strong materiality of rubble. Techniques like HDR take the definition of detail to the extreme, augmenting contrast and shadows through the superimposition of multiple expositions of the same image.

Commercial appeal: Ruin Porn's economic potential is beginning to be exploited through other means of representation. Here, a Swatch wristwatch that reproduces the famous "melted clock" and artist Mike Doyle's Lego Porn.

Urban impact: The predominant aesthetics of Ruin Porn is affecting the physical conformation of the city. In March 2011, somebody tweeted mayor Bing a suggestion to build a statue of Robocop in Detroit, evidently as a joke. Because the mayor

10 Thomas Morton, *Something, something, something,* Detroit, Vice magazine, www.vice.com

responded, the tweet became viral and a kickstarter project was started to fund the building of the statue. 62 thousand dollars were raised to build the statue.

The Ongoing Moment

The ruin is a sublime landscape, which we can only attempt to record. As Simmel puts it, "the balance between nature and spirit, which the building manifested, shifts in favor of nature. This shift becomes a cosmic tragedy which, so we feel, makes every ruin an object infused with our nostalgia. [...] In these cases, what strikes us is not, to be sure, that human beings destroy the work of man, but that man let it decay." Simmel and Dyer identify the power of the ruin in its shift into another qualitative scale, as if the atmosphere around it changed in density and composition once the building starts its descent into decay. For Dyer it's time, for Simmel it's nature: whatever it is, it is the quality that Ruin Porn strives to capture. Its sensational aspect can even be read as an explicit attempt at outing this inner quality.

Andrew Moore admits his quest for this timeless 'something': "I think there's a long, sort of, artistic tradition of photographing ruins as a way of talking about, you know, man's life, and, and, there's a kind of mortality involved."[11] This explicit search is also what distinguishes the local photographer from the outsider. Frederic Jameson explains the 'ongoing' moment of the shot as the very attempt at taming the sublime:

> *The concrete activity of looking at a landscape, including, no doubt, the disquieting bewilderment with the activity itself, the anxiety that must arise when human beings, confronting the non-human, wonder what they are doing and what the point of such a confrontation might be in the first place – is thus comfortably replaced by the act of taking possession of it and converting it into a form of personal property.*[12]

Jameson obviously intends this personal property as exempt from any artistic intention: his subject of interest is more the contemporary tourist than the professional photographer, but one can't help but want to associate the "disquieting bewilderment" with the activity of looking at ruins. Both Romaine and Meffre's and Andrew Moore's shots of the Train Depot are actually a good example of a perfectly calculated act of 'taking possession' of the 'non-human': by cropping the façade of the building as to exclude its actual contours, they reduce it to a two- dimensional repetitive texture, something that has no scale nor mass. At the same time, the full-bleed frame hints at bigness, untamed size; this ambiguity perfectly distills ruin photography.

The object subsides to the image that succeeds in doing this: Marshall McLuhan tells the popular story of the woman who compliments her friend's daughter; and the mother says "well, that's nothing, you should see her picture."[21]

11 Radio interview by Jennifer Guerra, on Studio 360, *Ruin Porn*, 01-07-2011

12 Frederic Jameson, *Reification and Utopia in Mass Culture*, in *Signatures of the Visible*. New York: Routledge, 1990, p. 11

In Detroit, capturing the ruin over and over again, often from the very same spot in space, which has the advantage of maximizing its iconicity also has the consequence of making buildings the function of images, instead of the other way around. As Ruin Porn becomes the Collective Memory of the city, its materiality is slowly substituted by two-dimensional photographs. Don De Lillo vividly represents this paradox in the novel White Noise, in which the protagonist drives with a friend to see the 'most photographed barn in America', only to find a field filled with photographers, and no barn. The two suddenly realize that:

> "No one sees the barn," he said finally.
> A long silence followed.
> "Once you've seen the signs about the barn, it becomes impossible to see the barn."
> He fell silent once more. People with cameras left the elevated site, replaced by others.
> We're not here to capture an image, we're here to maintain one. Every photograph reinforces the aura. Can you feel it, Jack? An accumulation of nameless energies."
> There was an extended silence. The man in the booth sold postcards and slides.
> "Being here is a kind of spiritual surrender. We see only what the others see. The thousands who were here in the past, those who will come in the future. We've agreed to be part of a collective perception. It literally colors our vision. A religious experience in a way, like all tourism."
> Another silence ensued.
> "They are taking pictures of taking pictures," he said.[13]

Anti-Ruin Porn?

In general, the practice of Ruin Porn counter-rubs everything that Collective Memory seems to presuppose: it is the outsiders' Collective Memory to Detroit. In fact, local attempts at creating an anti-Ruin Porn aesthetics reinforce the powerful image that they oppose. Romain Blanquart and Brian Widdis's photographs only acquire status if confronted against the dominating ruin imagery; in their own words, theirs is an explicit crusade:

In both its affirmative and its dissentient presence, Ruin Porn continues to hold the primacy of Detroit imagery. Ruin porn is Detroit's collective memory.

13 Don De Lillo, *White Noise*, Penguin Books, New York, 1986

Mowing
Pink Pony Express

When the grass is chest high, how are you supposed to feel good? For resident Pam Weinstein, Detroit is the new Wild West. Lack of infrastructure and facilities resulting from economic crisis have left citizens to fend for themselves amidst the chaos. One element they can control is nature. In spring 2010, the city of Detroit began cutting back on cutting grass. The new budget stripped funds allotted to maintain grass fields and empty lots throughout the city. Because of massive shrinkage (population decline), there are many empty lots. A noticeable trend emerged downtown. Residents began landscaping abandoned city property. They mowed their own lawns, and also the lawns attached to abandoned houses nearby.

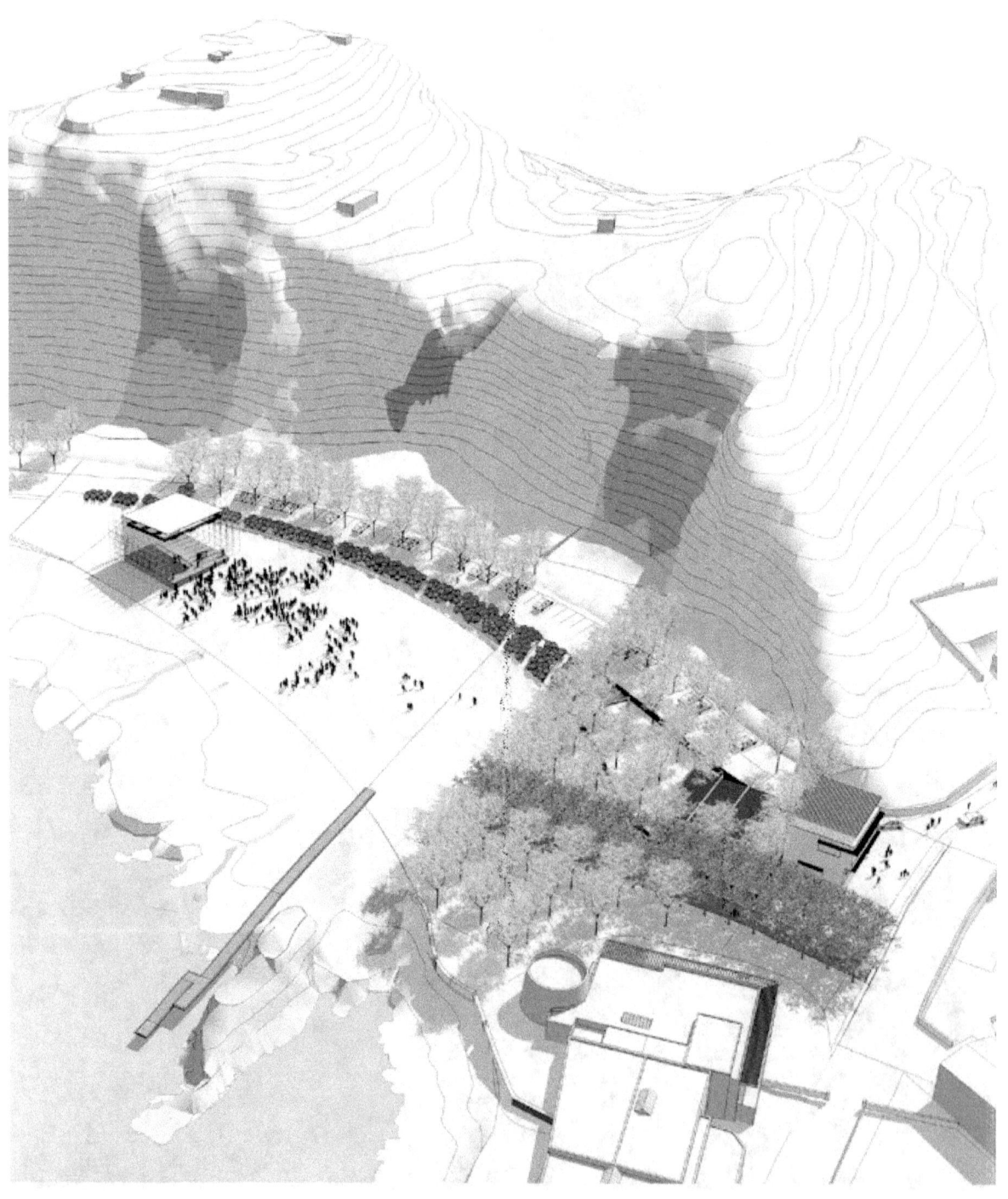

Rocce Rosse

Head Designer: *Luca Peralta, AIA*
Design Team: *Reid Fellenbaum, Scott Goodrich, Christopher Johnson, Franco Niffoi, Giovanni Dessì, Elisa Rainaldi, Gerbino Salvatore, Marina Lattanzio*

A long-abandoned, ancient quarry was the site of a reimagined public space for the commune of Tortoli in Sardinia, Italy. Centuries of excavation have revealed a unique moment in geological formation where several thick striations of rare red porphyry slice through large masses of green and white granite on this coastal site. An abrupt halt to excavation in the mid-twentieth century left two giant porphyry monuments rising from the sea along with a dangerously unstable cliff and a vast sloped, rock shelf vulnerable to storm surges.

In the decades following abandonment, relentless natural processes have all but erased the once visible mining operations of man, leaving behind formations that tourists presume are natural. However, years of intermittent neglect and a growing tourist interest have encouraged an accumulation of disparate site interventions confusing its revealed geology with chain-linked fencing, a barricade of crude retaining walls, a vast plaza of fill used mainly as a parking lot and a ramshackle cluster of varying constructions.

With these invasive interventions in mind, our studio's proposal suggested a careful operation of erasure to remove the post-abandonment interventions while subtly increasing the programmatic function of the site through soft installations of native vegetation, landform and wooden infrastructure. Removal of the retaining walls restores the historic slope and reveals the geological formations of the site. Simple wooden ramps, benches and a bridge increase accessibility to various spaces on the site while their material and construction suggest impermanence. Similarly a temporary stage design and event staging concept was developed to suggest the flexibility of the space. An engineered system of vegetated berms, planted with local flora, replaces the chain-linked fences to protect the site from falling scree and provide a screen for public parking. Entry sequence is staged through a massing of tolerant native quercus ilex, which frames an axial perspective of the central porphyry monument.

Opposite: Site Perspective

Above: (from top to bottom) Contemplative space, Input prospective, Beachfront accessibility

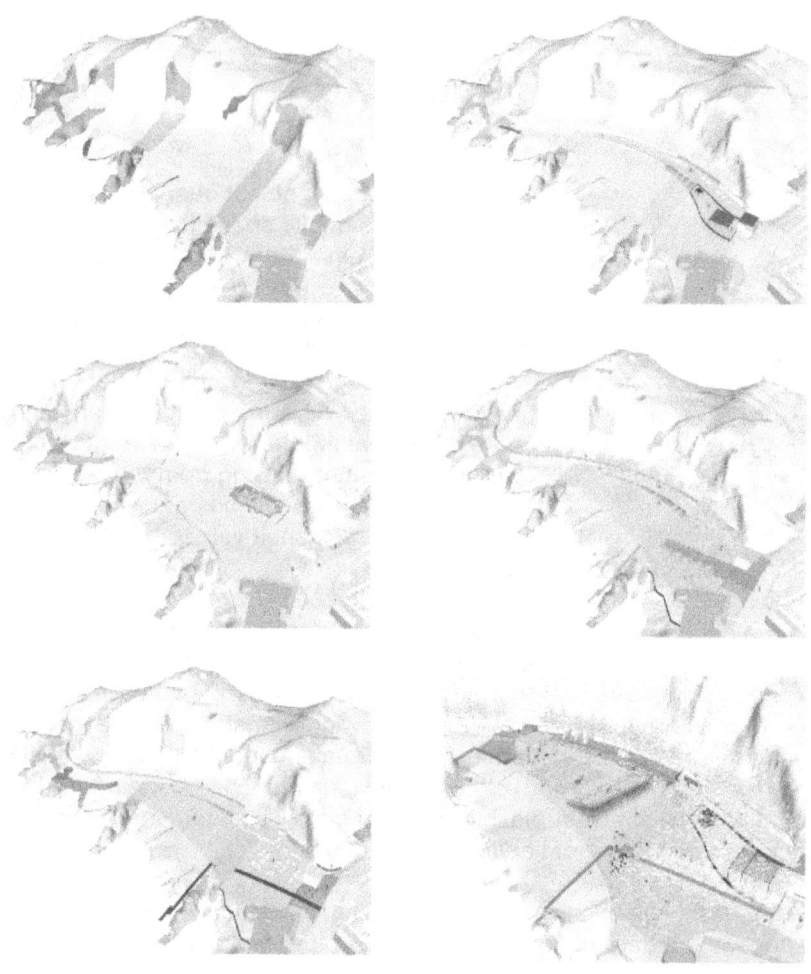

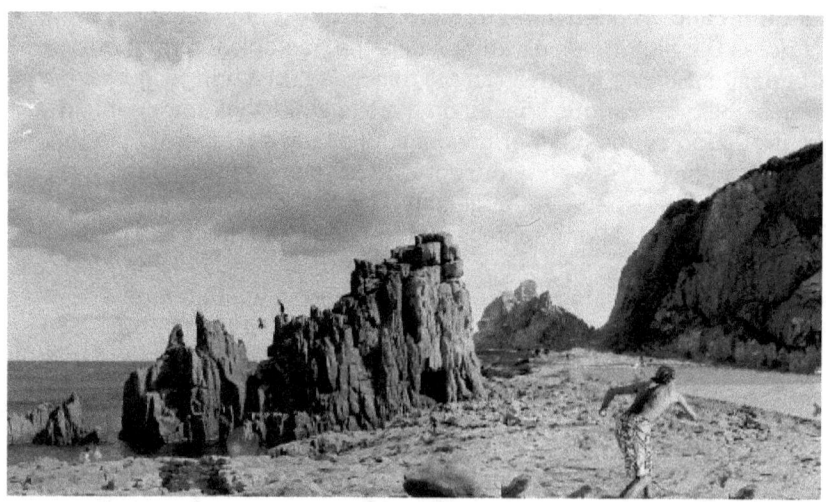

Top Left: (counter-clockwise from upper left) Continuity of the red porphyry rocks, Removal of elements that aren't integrated into the landscape, Interventions project (phase 1), Interventions project (phase 2), Reintroduction, Preparation for concerts / events

Bottom Left: Square red rocks

Rocce Rosse 33

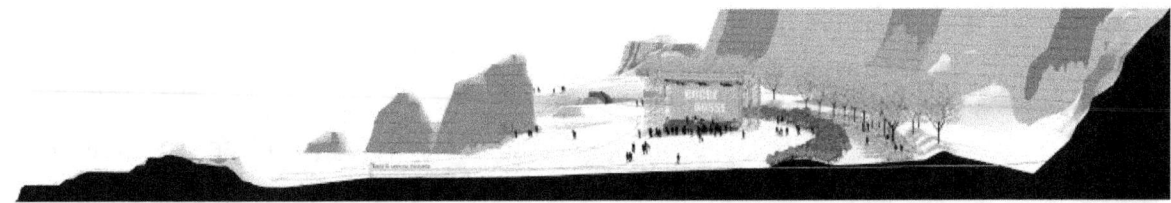

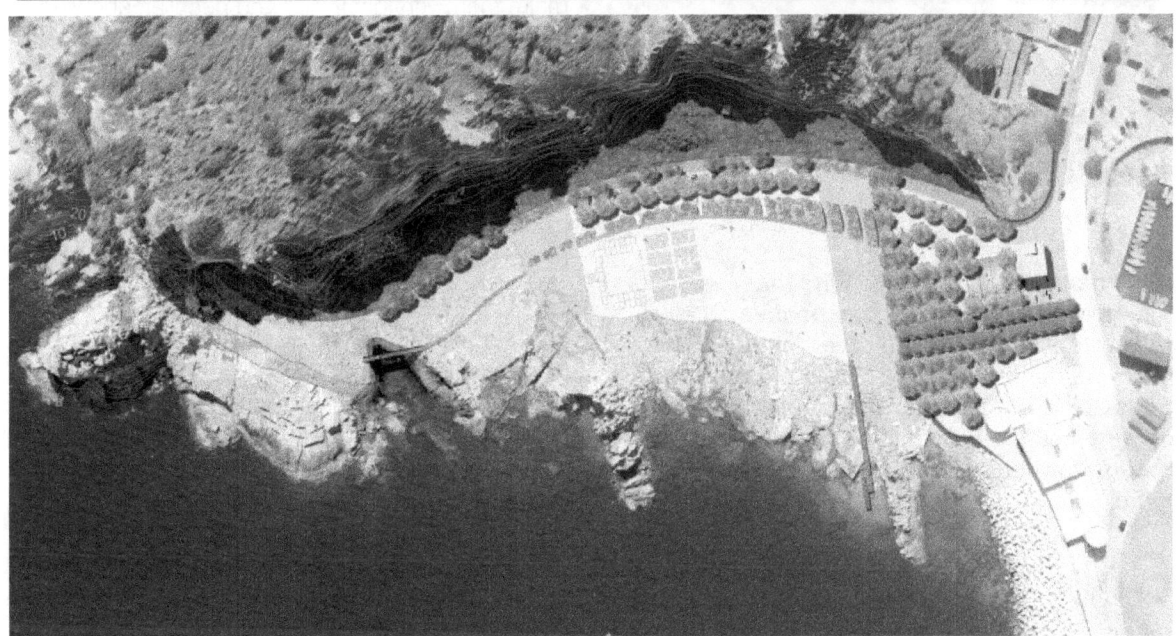

Top: Site section

Above: Aerial perspective

Right: Site plan

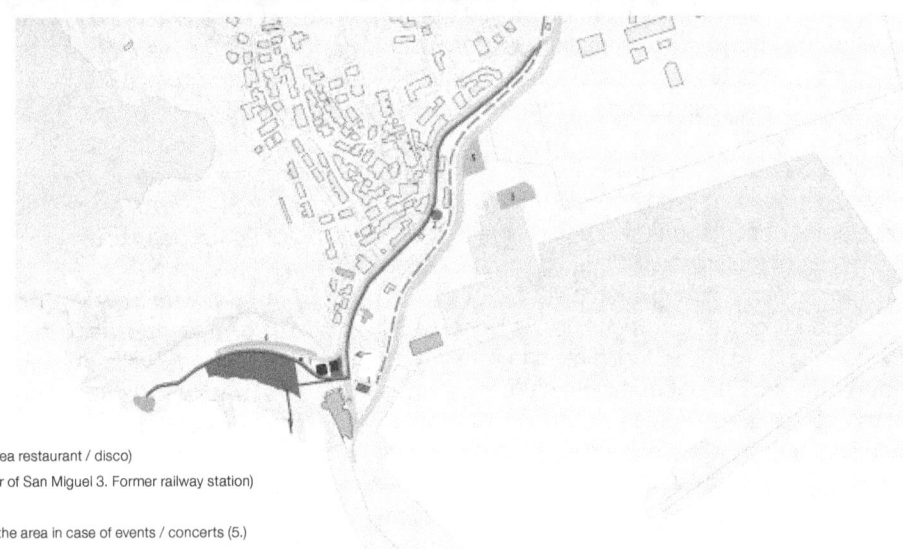

- square red rocks
- new and rehabilitated buildings (1. area restaurant / disco)
- significant historic buildings (2. Tower of San Miguel 3. Former railway station)
- particularly significant buildings
- parking ordinary (4.) And support to the area in case of events / concerts (5.)
- panoramic and significant views
— pedestrian paths
— cycle paths
— roads
-- disused railway line
→ entrance to the square red rocks

An & Interview With Catie Newell

Assistant Professor of Architecture

& *I have just a few questions that I was hoping to hear your perspective on – we talked to a couple of the other faculty that we think have a similar context of operation. So the first question is: how does your work engage decline? It could be any context, though for you Detroit was what we had in mind.*

CN I think for me – and it's something I've developed over the process of my work, and it probably comes through some of the teaching as well –my work is really interested in what the immediate circumstances of the city are. I mean that to say material based, spatially based, and even just cultural contingencies. While Detroit is clearly declining in many different ways, I think it is actually becoming a rich environment that I never look at in any sense of wanting to fix a problem, or bring something back, or rejuvenate it. I'm just not interested in that. In a way Detroit becomes such a strong exemplar of a lot of these conditions that it opens up the opportunity to say, okay, I'm interested in making very new environments, but out of things that people have some sort of conscious awareness to as having been something else before. So I have this whole series of things called "A Once Residence" where I know I'm playing off of the idea that they used to be houses and that people recognize them as houses. So there's just enough recognition of them having been something else before that the new weird environment responds to what used to be there before but also just throws everything off.

So you start questioning what used to be there, what is currently there, and what's sort of new. And for me Detroit has allowed that to happen because it's in decline. So for me it seems really ridiculous to make anything fresh and new there. I'm constantly working with existing spaces, but to make them very unfamiliar and peculiar, knowing that I don't actually need to make a new house that someone can live in – you know, I don't need to renovate it back to something that someone needs. Instead it actually affords the opportunity to test out something a little differently. It's interesting for me, when I was reading your brief that was my first commentary. Their decline is actually the reason that they can go on and be something else, right? They've gotten so bad that they basically have the chance to become something you would never make from the beginning. I don't think any of my work can be made alone or in isolation, but it takes all of these factors to produce the results. So for me, sites of decline end up being the precise site condition that affords any of these things to happen. It could never happen should it not be an existing location. I'm just really interested in what the status of things is and how I can tap into that in the new space – how can I actually amplify that or discuss that. So decline happens to be the one that I'm working on in Detroit, but if there was some other very potent circumstance going on somewhere else maybe that would be where the project would go. So it's almost like Detroit for me is 'as is'; and how is it? It happens to be in decline, and that allows all the other things to happen because there's no red tape and there's no one asking for permits.

I am curious how your other work has come out of this approach to treating it 'as is?' I think you have a distinction among the people that we're talking to as being heavily involved in the process of making.

Right. For sure.

In this case I'm really interested in your projects like Specimen.

Specimen – the last one I did with Wes, yeah.

That one is different because it's not really sited, and it doesn't seem as though it is supposed to be. I actually just saw that one in Grand Rapids and I didn't see the 'as is' relationship. I first saw it on display at the research through making exhibition, but this time it was placed in an abandoned museum. What was the thought there?

I guess probably all of my work needs something beyond itself. It needs this greater context. The context can be the condition of the whole city around it or the existing sense. For Specimen I would argue that we knew we were going into the abandoned public museum, and we knew we were going into the nature's medley room. So it's called Specimen because of course it's surrounded by all those specimens, and something that was really interesting to the project was that our piece became really attuned to the lighting we put above it and also reflected in all the windows of that space. So there were nine of them in the space, which actually became really important for us because with the set-up of the other specimens ours was getting projected into the cases through the glass panes. So there is a little bit of a game there where I think for me the material making is usually taking the materials that are likely to be present in our buildings like glass; this one [Salvaged Landscape] is of course the arsoned wood; the one I did in Venice is also wood because it relates to the boarded up windows. The one I did in Flint has more to do with taking in the volume and moving it, but all of it is taking something that's really familiar otherwise, but ends up being used in a totally new way so it's a little off kilter. Then for ones like Specimen or even the glass cast that I did with Wes, I think those have the aspiration of changing spaces that are familiar to us in a non-familiar way. So maybe that's an easier way to explain a lot of my work. I do actually play off of there being some sort of familiarity to an existing condition even if it's an existing condition that's been lost. Usually that's where I feel like the heaviest weight of my work – heaviest meaning, more of an emotional impact of [where] my work comes from – when it relates to something that feels like it's been lost. This goes back to that "once residence" series, which is all about the loss of a home and recognizing that. Trying to make a new environment that in a way is new and different and jarring, but at the same time I totally know that I'm playing off of somebody being like "wow that used to be a house huh; and now that house isn't there, or that house got burned, or the house got demolished or something."

So even if you're not necessarily defining it that way, you're looking at taking it 'as is'. I'm curious about the common issues that are faced with working in this sort of condition, working in this sort of decline.

Sure. So it might not be fair to say in the sites of decline; that I just simply have it 'as is.' For me I guess the 'as is' means that I approach a site and I look at its realities. I look at it as "wow this has really declined, this is burnt" and also there's "what's the kind of pulse of the neighborhood, what's the economic value of the land?" So for me it's not so much that I take 'as is' is just the way it should be. It's more like I come to a site and it's like "what's the circumstance here?" I think that's what it ends up being. So that's maybe the response to the first part – so what's the other question?

What are the common issues that are faced in this condition; working in the sites decline?

Surprisingly, I see the issues as allowing the chance to make something new and surprising, which I think is how my work is allowed to happen as I like making a new environment, making a new atmosphere. In a way things have become common and there is sort of an emotional loss here. We're not tending this space, so there's that little thought of disappointment or loss, almost a hopelessness, which comes with some of these places. I also think that if they are really in decline, then what I'm saying about hopelessness also goes the other way and can be very hopeful. I don't want to necessarily say that it is about getting away with something, but when something has gone so far into its own decline and you're tending to it, people leave you alone – no one is going to stop you, there's no red tape, there's no necessary impairment. All of a sudden this allows there to be a little bit more room to experiment,

because generally speaking people haven't cared for it in a long enough time that now nobody cares if you're doing anything good or bad to it. Hopefully somebody comes to it and is doing something that is good. So the other thing that happens and I think is a big spark for my work, is that the materials take on characteristics that weren't initially intended – the materials and the spaces. They fall apart; they're sort of aging, there's kind of like something that happened that someone has done – well you guys even mentioned it too, there's violence and neglect and that kind of stuff. Something that's been done to it, more so out of human alteration. So all of a sudden if you were to go through and look at the material attributes, it's not what anyone necessarily intended but that doesn't necessarily mean it's a bad thing, which I guess is the main point of what I'm saying. Things are falling apart, people aren't caring, there's probably no electricity, but all of a sudden that means I've never seen a wall look like that before. And if vegetation takes it over, then all of a sudden there's actually a new definition of what the property line is. I think that can really spur other things. The rules change.

How would you characterize your design methodology in relationship to the state of contemporary architecture on a broader scale of practice, including both your professional and academic work?

I think something of clear importance to my work is that I'm doing it at the scale of the installation and fabrication but I'm doing it in a sense that actually requires me, or allows me to – it's sort of like the design-build but not in a sense that you make it and there's a finished building but rather in the sense that I'm actually creating these very things – and they're very much at home on the site. I guess what I'm actually saying is that I end up being somebody who's designs are very tied to that exact moment in the state of things. That's what I was trying to describe earlier in terms of the circumstances of a city. I become very attuned to thinking that the things I create are a way to expose or amplify or make use of the current realities that exist. So I find the work needs to be very timely, extremely present in it's surroundings and very expansive in what it thinks its context is. But then at the same time, it comes down to the sort of excessive maker detail. I think somebody could very broadly categorize me as somebody who is interested in materials even to the point of atmospherics – especially with teaching Glow Workshop, and that kind of thing. And then, more theoretically somebody would put me into the realm of being somebody who sort of has a lot to do with cultural contingencies more than having a heavy hand in a certain style, or formal, or even just a certain place or issue. It's more so the combination of material with this ambition concerning the current realities that ends up resulting in something. And I know some of the greatest emphasis of my work, both critical and productive, ends up being where I'm not necessarily making something that's operating as a functional building. I'm instead making things that are super speculative and have a lot to do with both the way of us making something and the way of us seeing a city for its condition.

That's a good spot to transition into the next question, which you've already begun to answer a couple times. I think a direct answer would be interesting though. How do you see new work as improving the experimental environment of declining context?

Yeah it's interesting; it's a really fantastic question because it does go back a little bit. I see improving those as a form of practice. To have a form of practice that remains very honed into the conditions at play and asking for something new out of those conditions and not asking for a restart, or a demo, or a giving up. So in a way I see it beneficial to those as a form of practice. As a form of the objects that I actually make, I never think that I'm there to solve a problem. I really feel that my work is inquisitive of what's happening. I'm very hands on. I do very few drawings. I'm all about making it as I go because the story is evolving and material is evolving and all the cultural contingencies with it are evolving and coming into play. In the end I don't actually see it as trying to be productive or fix a problem; instead it ends up being an act of awareness, an act of "this is what I can do so I'm going to do it." It's sort of an act of…

Very Opportunistic.

IIt's very opportunistic and very strategic. And it's not necessarily ever meant to spark something up and running in the sense of what this very site is going to do. It's more making a commentary really, that these things can have another life, and we can do something. It's also a way to say "well I built it this way; maybe this is another way to look at things even if they are being built from new" so maybe that's where it goes back to the form of practice.

So do you think it has more opportunity then working in a context that's not in decline?

Yeah, well I know for sure that my work is more effective because it's in place of decline. I probably have a hard time doing things in spaces that aren't in decline because there is this cultural reference in the commentaries that happen, and I feed off of that to figure out my work. So it needs the state of decline to carry a greater weight, to have a larger discussion with the rest of the field. I need a little bit of an otherwise uncomfortable situation for our discipline to respond and make something.

Do you think the majority of people who work in this context find the same value? I mean, obviously in schools like ours there's a lot of work done in this context; some of it at a similar scale and method to your own and some of it much different.

Right. I guess maybe the one way to answer that question has to do with how states of decline allow there to be a lot of different attitudes grafted onto it. So you can get this sort of apocalyptic version, just make it worse and keep going. You can get this sort of "this is a problem, I'm going to fix it" clean sweep kind of thing. And maybe I kind of fit somewhere else in the middle that's like "look what we got because we messed with it."

I think that's a curious position to be in.

Yeah. And any attitude can take hold of it. So I agree with you, there are so many people doing it in many different ways.

Do you think it's a bad thing for some people to be working in this context; does it trap some into a certain mode of operation? Or is it always this beneficial opportunity?

Interesting. I think it is more of a Litmus test to see how somebody responds. I don't think it's necessarily something that would trap anyone, or I hope it wouldn't trap anyone. Different things are at stake so it makes you take a claim on those. For instance, it has made me think that within the realm – or let's say Detroit specifically – I actually think it's kind of offensive to build anything ground up there right now. So I start taking different claims that I probably wouldn't be so forceful on if I had not experienced this, or somebody's project may make some claim like "I believe it's worth getting rid of all of these things to make this whole new plot of land, and I'm totally fine with wiping out four homes that are somebody else's." All of a sudden it shows you the value system in the decisions. So I don't think it's a trapping thing so much as that you can learn a lot about somebody's opinion of what matters in a decision by putting them in one of these situations.

That's a strange relationship to reality though. I am very curious about the amount of emphasis that has been placed on this space of operation. It actually makes me think of the recent lecture by Albert Pope. I'm just thinking of his criticism of focusing on the 25% instead of the 75% of space. It's totally unrelated to his topic, but I feel like in some senses Detroit is this minority of space, and that in reality there's not nearly as much going on architecturally in this space as there is elsewhere.

It's true.

So in this sort of institution, the amount of emphasis that has been placed on working in Detroit is somewhat unbalanced with reality.

Right.

I think that goes back to the idea of a Litmus test. There's a certain opportunity there.

Yeah. I think there's an opportunity to spark all sorts of conversations. Honestly, Detroit ends up being something that anyone's ideology or point of view or even the way they're working – whether it be through renderings or through physically making or half and half – It can almost carry that opportunity. There are just so many issues that anyone can find a way to talk about it. And then I think there can be other arguments about [making things that are] productive for the city. But as a kind of substrate for discourse it's so potent. There's so much that can be talked about that most research can somehow be applied to it and still end up having an unexpected twist just because it starts responding to things that are really heavy.

Thank you very much. We saw this topic as an opportunity to address something really relevant to the discourse not just in practice but also in the academic world. I think it's something that has a huge span, it's a cultural issue, and with the economy everything is kind of heading toward decline.

Yeah it's a big deal. Everything is declining.

Bio taken from the *University of Michigan: Taubman College of Architecture and Urban Planing website.*

Catie Newell is an Assistant Professor of Architecture at the University of Michigan's Taubman College of Architecture and Urban Planning. Newell joined the faculty in 2009 as the Oberdick Fellow. She received her Masters of Architecture from Rice University and a Bachelor of Science in architecture from Georgia Tech. In 2006 she was awarded the SOM Prize for Architecture, Design and Urban Design with her project proposal entitled Weather Permitting. Prior to joining the University of Michigan as the Oberdick Fellow, Newell worked as a project designer and coordinator at Office dA in Boston leading the design and completion of four awarding winning spaces.

Professor Newell is also a founding principal of Alibi Studio based in Detroit. Her work and research captures spaces and material effects, focusing on the development of new atmospheres through the exploration of textures, volumes, and the effects of light or lack thereof. Newell's creative practice has been widely recognized for exploring design construction and materiality in relationship to the specificity of location and geography and cultural contingencies. Newell won the 2011 Architectural League Prize for Young Architects and Designers.

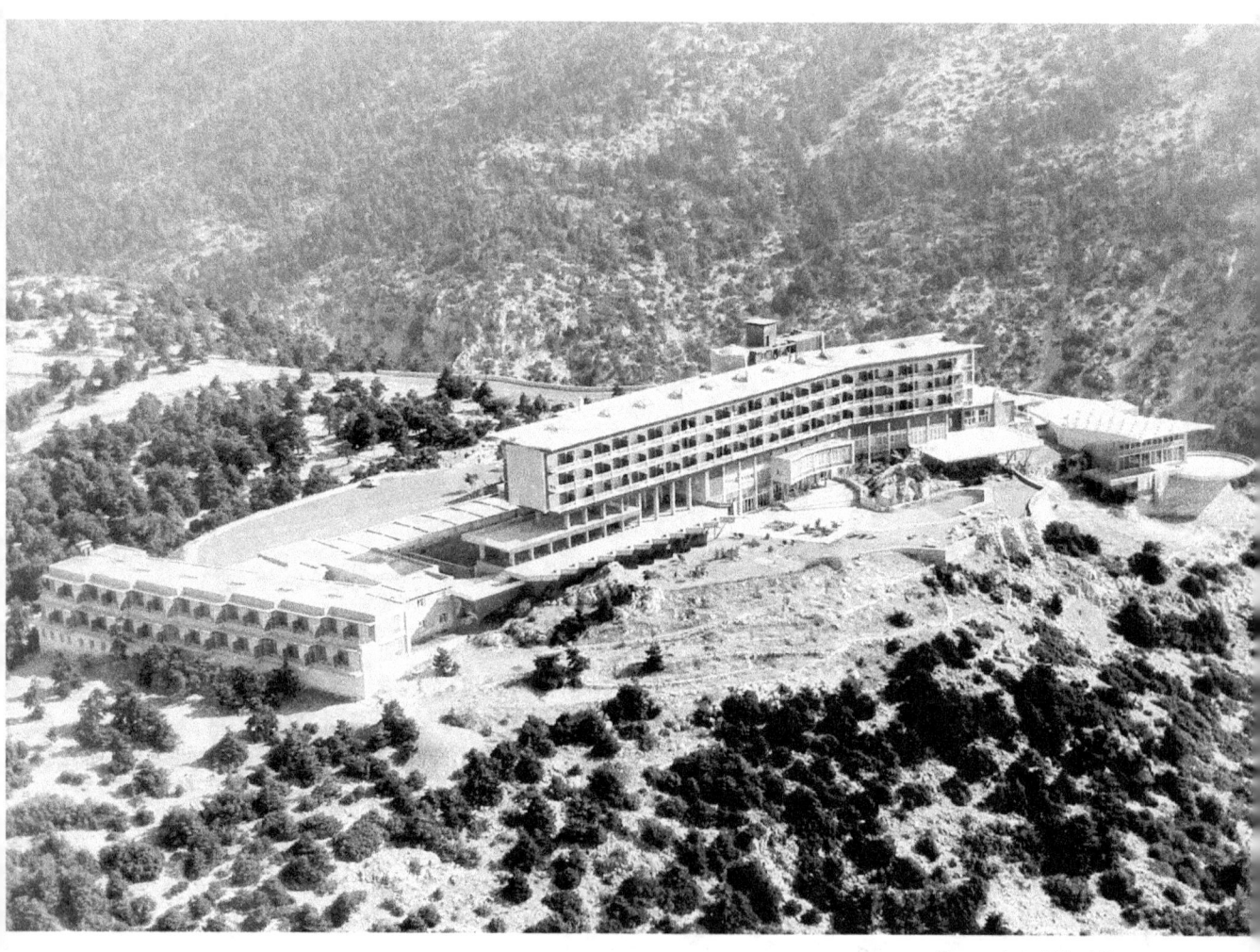

The casino of Mont Parnes in through an aerial photo from mid-1960s. Note the modernistic hotel rooms with the view of the entire surrounding area and the oval-shaped disco-balcony that is currently demolished.

Flat Broke: Productive Destruction for the Mont Parnes Casino, Athens

Adamantios Tegkelidis

While the Greek nation drifts deeper into an unprecedented economic crisis devastating the majority of its population, a simultaneous constructive deterioration is emerging, leading to even wider social decline and building sepsis.

The "Mont Parnes Casino" was designed by P. Mylonas and sits atop Parnitha Hill on the outskirts of Athens. Since its completion in the 1960s, it has remained one of the country's most representative examples of Modernistic architecture.

The current situation of (what is left) of the building, featuring retrofitted mechanical tubes along structural supports visible especially in front of the glazed façade.

Built to promote the power of the Greek economy, the building could be easily translated as a synecdoche of the Parthenon: a temple devoted to money, an undisputed representation of the Greek golden era of the 1950s.

However, the casino was founded on the Marshall Plan and driven by the Cold War politics of that era. Time went by and the nation's wealth dissipated at an increasing rate, until today when 50% of the population lacks basic necessities. At some point, the casino ceased operation, as did the integrated five-star hotel. The death blow came in the form of arson, a fire that consumed most of the surrounding forest and destroyed part of the building. The Mont Parnes Casino officially declared bankruptcy at the same time that the entire nation was facing the same threat. Since then, despite episodic renovations, what is left of the edifice merely stands, waiting for someone to make it livable once again.

A typical interior.

Since both the casino and the Greek economy shared the same fate, we decided to "virtually" demolish it completely, in an attempt to envision and study the results of the alternative topography comes into view. Despite its sarcastic and stylized tone, the project is an attempt to reproduce some generic and fundamental aspects of everyday life through an entirely new paradigm which, in turn, is driven through the "demolition" of a building that used to signify much more than meets the eye.

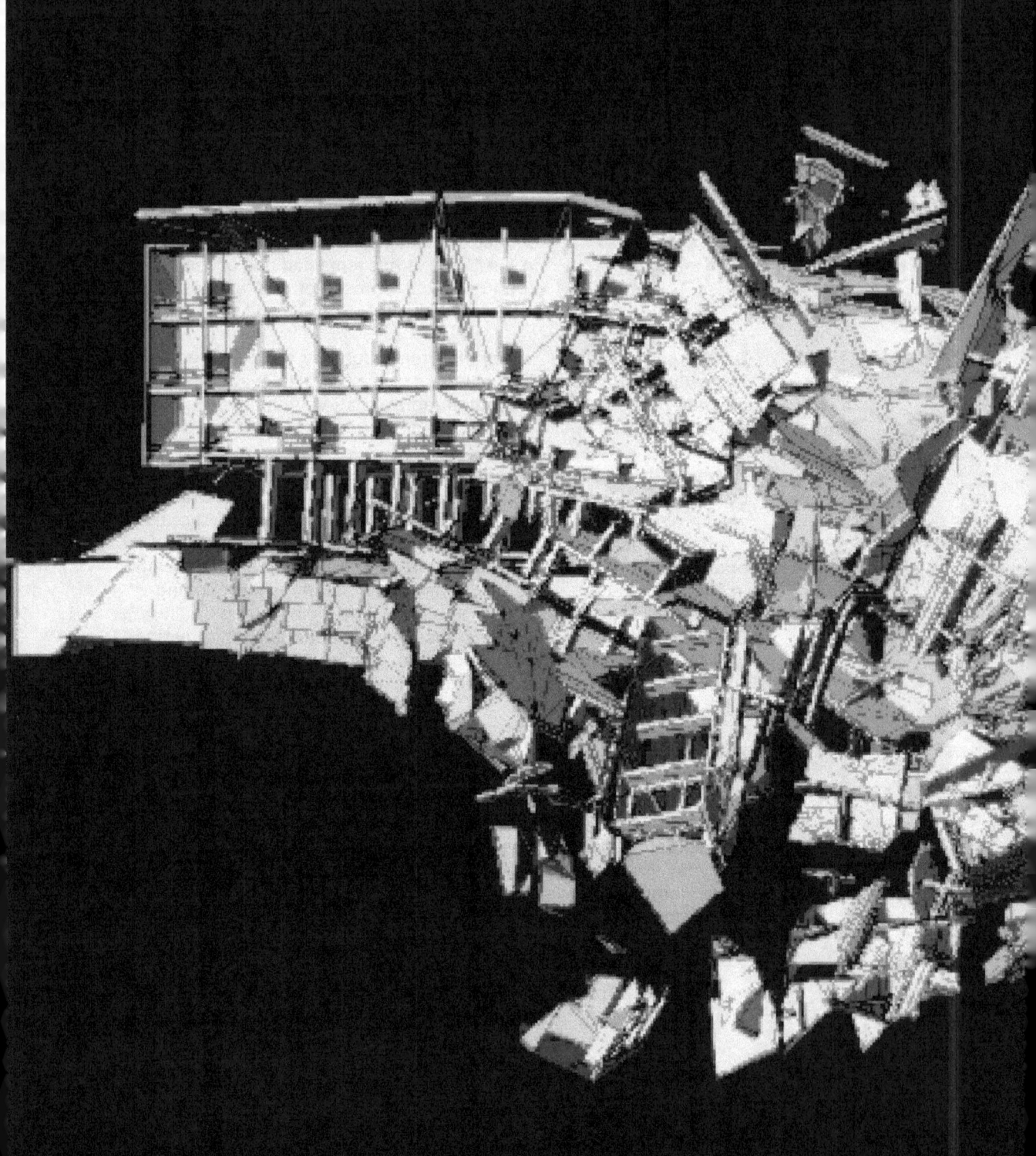

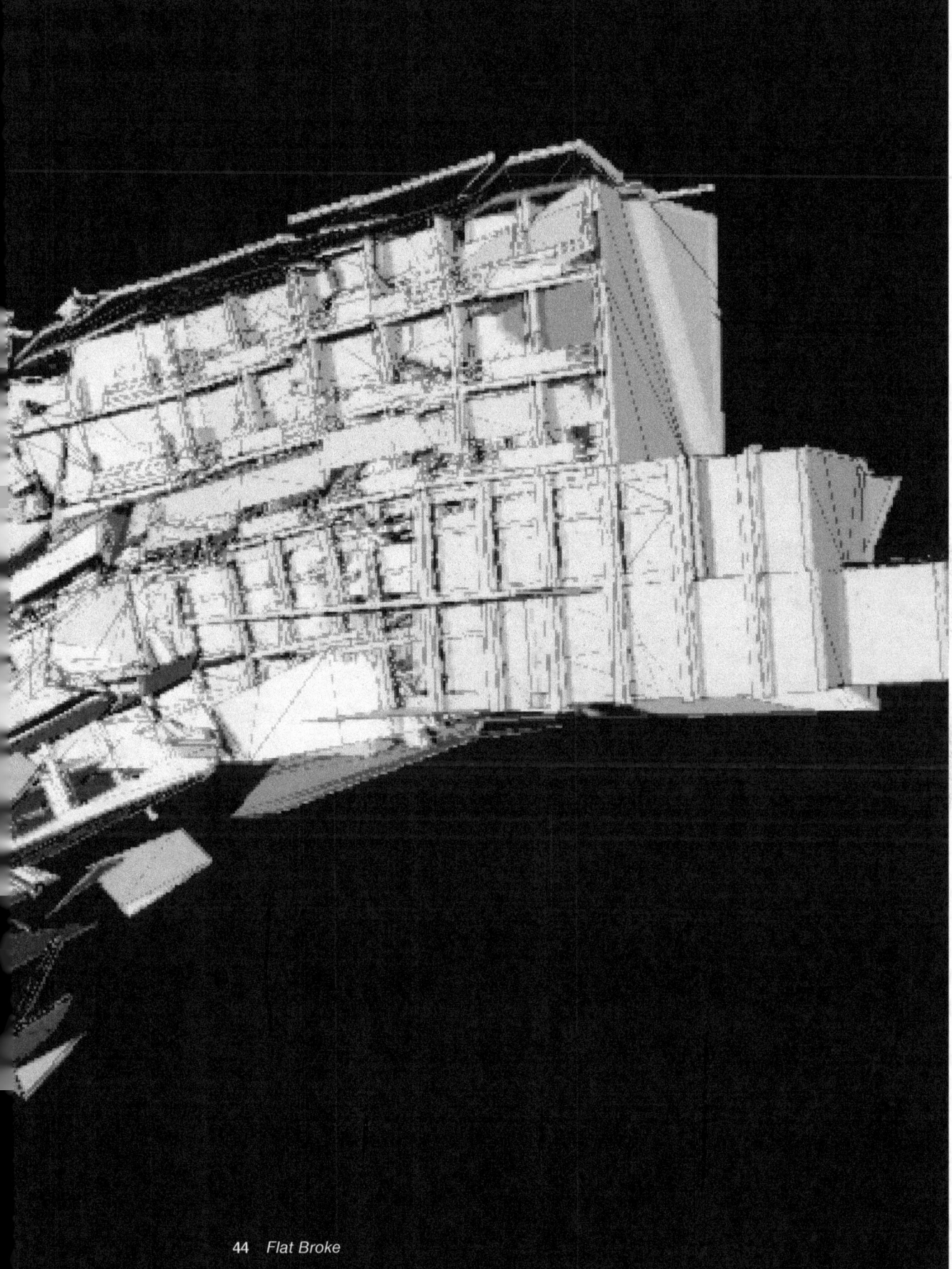

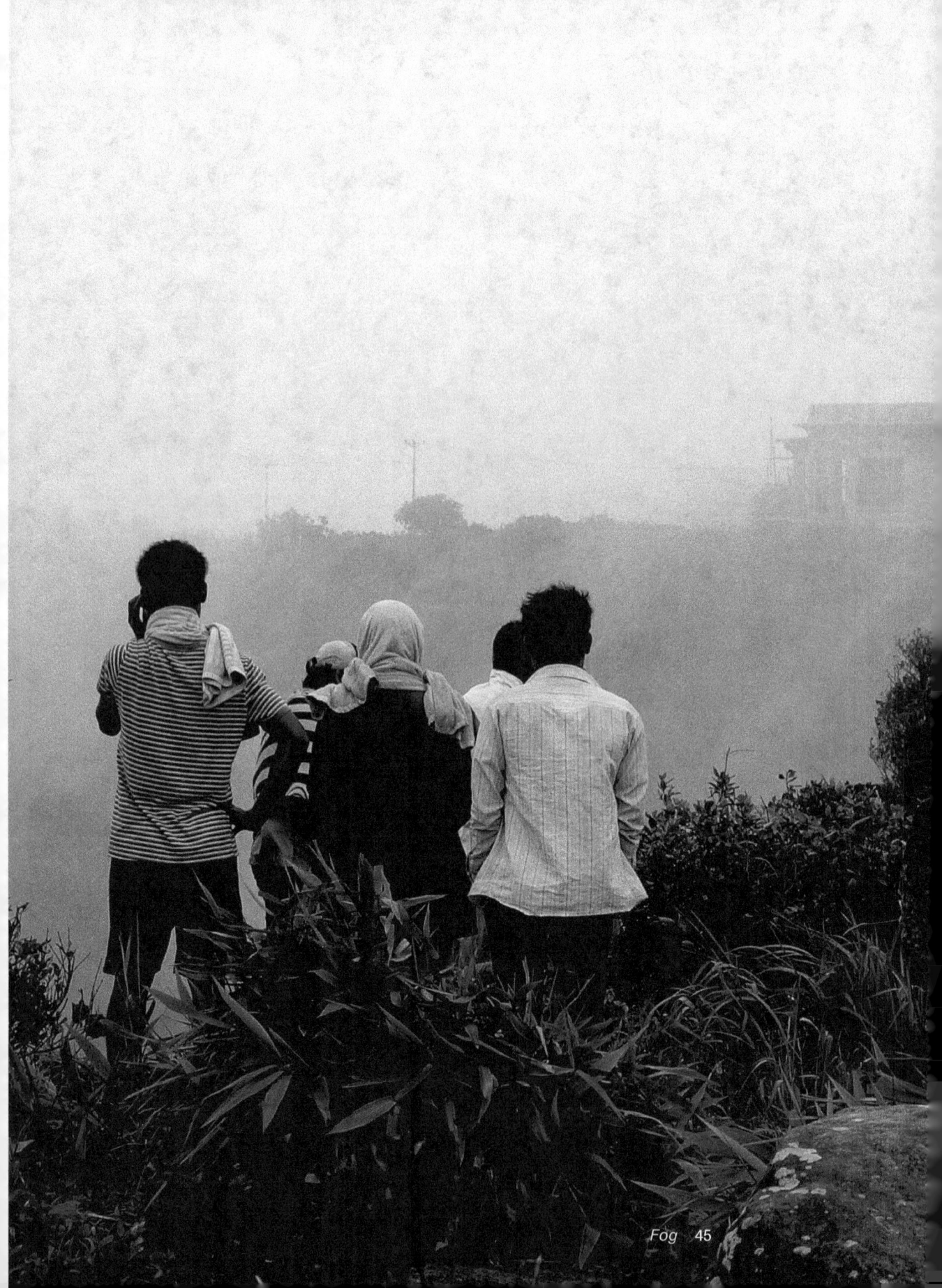

Fog
John Monnat

Copper-colored moss and carved Khmer graffiti drift in and out of view as one wanders through the concrete ghosts of Cambodia's Bokor Hill Station. The old church sits several hundred meters from the remains of a casino, defining the original center of a complex of villas, hotels, guard stations, radio antennas and one UFO-shaped water tower. Riddled with bullet holes, the casino and church were the scene of a month-long shootout in 1979 between Khmer and Vietnamese forces, a duel of ideologies in a landscape of French colonial buildings. Now, if one squints towards the casino, dozens of young, flip-flop wearing workers emerge atop the concrete mass, a cliff's edge anthill of renewal.

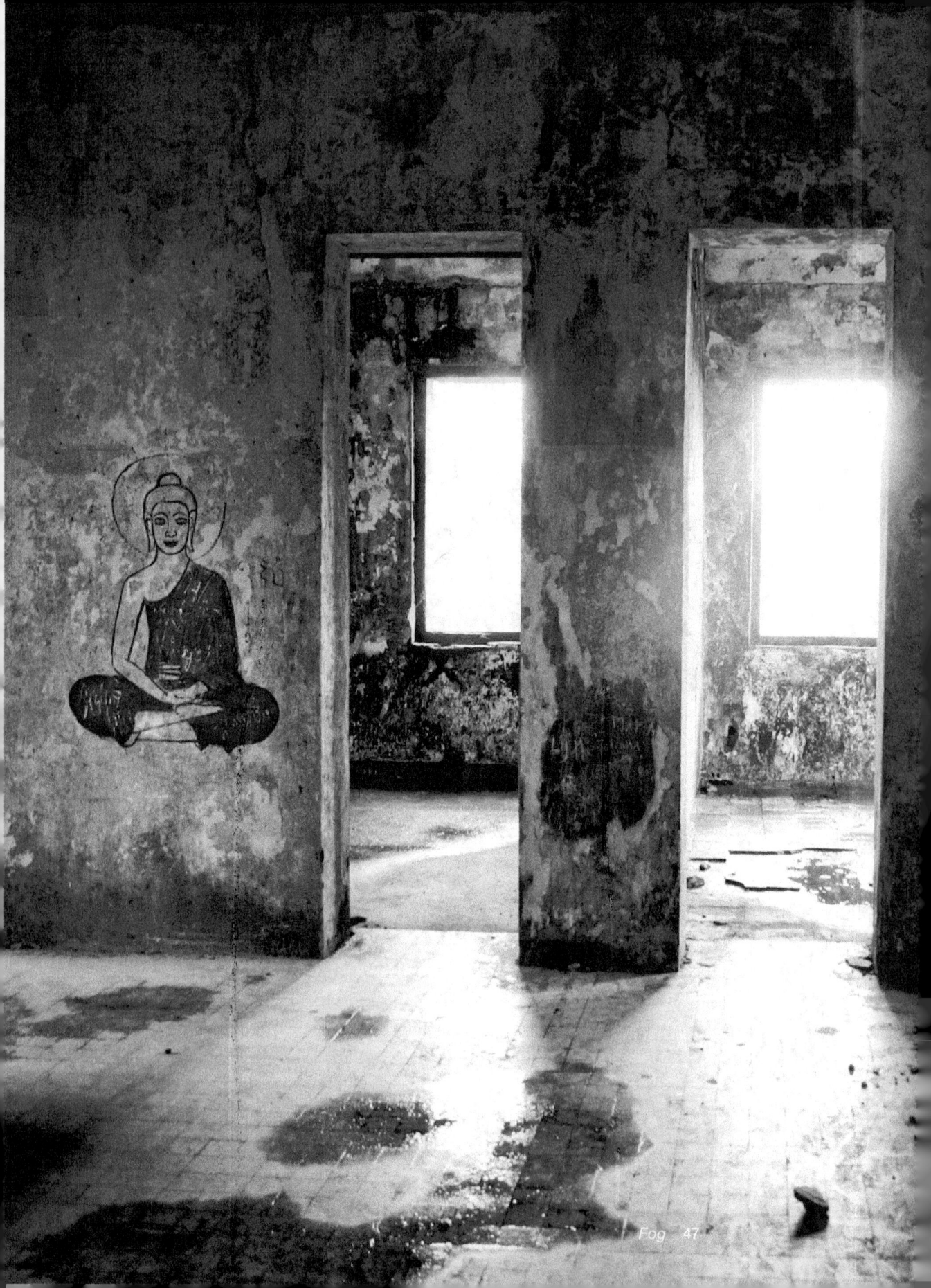

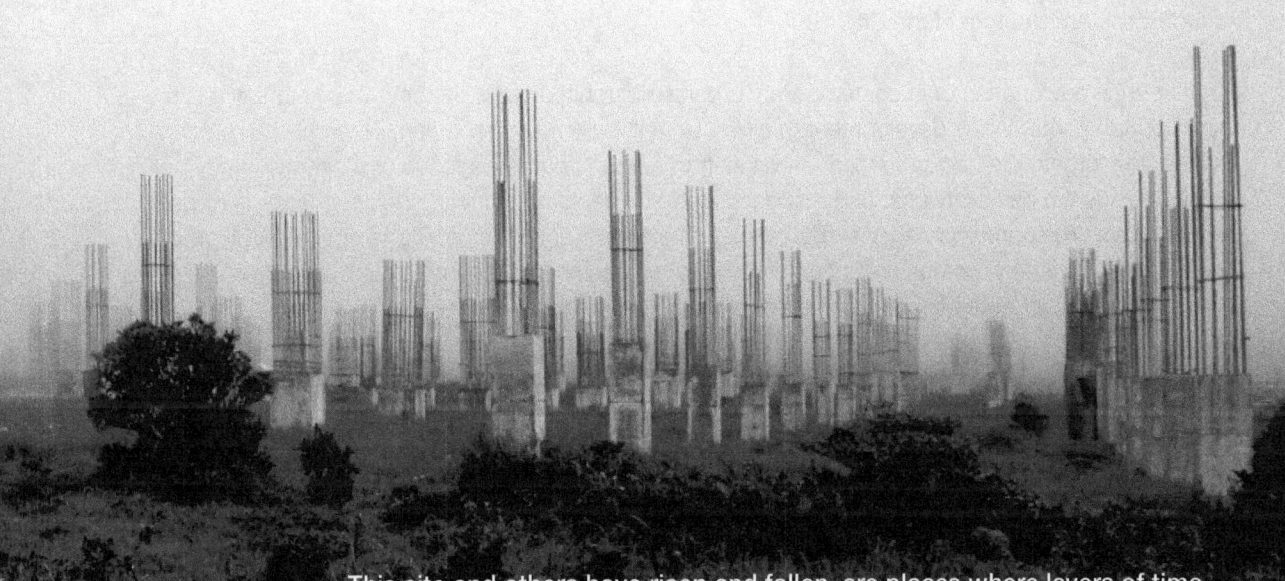

This site and others have risen and fallen, are places where layers of time and memory loop back on themselves. I watch a monk on his cell phone become enveloped in the mist rising from the ocean. He is at once next to me and then gone through the fog, only to reappear again further down the hill. The concept of annica, or impermanence, is strong here. This place has seen raw nature, development, conflict, abandonment, and redevelopment. No state seems to outweigh another in terms of importance; no person wants to dwell on the past, however recent.

The surrounding jungle is being cleared for a huge development of suburbs, casinos, and shopping malls. Workers and tourists congregate early at the old Buddhist temple as a loudspeaker blares monks chants off the plateaus edge. Family's stream in and out of a gaping hole in the side of the temple wall, a temporary entrance for its expansionary trajectory.

Everybody Loves Action Figures

Andrew Santa Lucia

Action Figures

And always we could see...our childhood, strangely aged, present in the flux of the city.
- Aldo Rossi, Architecture of the City, 1966

More so than any one factor in contemporary urbanism, architecture is the city. That is to say it is the first important factor in the development of cities, both literally and phenomenally. Architecture can act as icon and forgettable background in a swift shift of a tourist camera's focus or a change in city policy. Architecture is the basic city unit, unlike suggestions of it being networks or blocks or streets or parks or infrastructure. The contemporary city has numerous stresses acting upon it, attempting to mitigate any one social/political/environmental impact with different systems implemented, such as transportation or synthetic nature, yet architecture is constant; without it there are no cities.

There exists in the discipline and profession of architecture a want to become vocal urban agents again. While some focus on developers and the market, others insert themselves into urban policy and local government. Ultimately, architects have always had the most amount of control in the city with their buildings. It is these same buildings that have become part of urban lore and public memory. It is no surprise that some architects still push for either critical distance, a situational partnership or a better relationship with markets, when discussing moving forward alongside new models of city making.[1] But the one area where architects have always had control is in the design and implementation of the discursive elements that are built-in to architecture.

1 Both autonomy and complete openness have been argued to be ways to preserve both the discipline and the profession of architecture. While the autonomy argued by the critical school in the 1980s and 1990s created an alienated architectural process & product in terms of people and inhabitation, the belief that disciplines should be separate pushed architecture in directions that has done more to disrupt its position in the process of cities, than push it as a meaningful and public act. The trend to look at the market relationships that exist with developer and architect has pushed forward much more pragmatic associations in work, than disciplined practices. I use both definitions to locate two poles that architects have historically oscillated on that have had wide range affects in our place in contemporary urbanism and policy.

Architects should reanimate the urban environment through a keen understanding of not only what buildings do, but also what they can become. Images of public memory and the physical movement engendered by city buildings are an instance of architecture as the city. This reality could be a jump-off point where architects assert control over the urban environment, but a nuanced instance of it at a more human scale. People never experience the city on the level of satellite photographs, site plans or urban sections, only through personalized images and moments. These individual tidbits of urban identity, or personal architectural narratives, are enabled with our interaction in the city, not unlike the way children engage their action figures.

Everyone loved their toys growing up, be it Barbie, GI Joe, Ninja Turtles, Ghostbusters or Power Rangers – human, animal, specter…every color under the sun. There was something for all of us out there because action figures were fun and easy, not complicated and intellectual. Action figures were part low-res virtual simulations, part high-participation mode of engagement with variant lifestyles, before digital versions encompassed our attention span. Architecture acts in a similar way and the city is a collection of these figures.

The combination of physical context, restrictions and social history constitute a type of package or packaging for architecture. These packages make up scenes or consumable images of cities, such as historic avenues, infrastructures or city blocks that include specific buildings. These bundles do not define the singularity of architecture as the city, but make up a social contract with citizens to either accept this as a total package or a reality independent of the buildings within them. The buildings themselves act as the *élan vital* of cities because of their ability to be *figures* or icons. Architecture receives this distinction because it can be independent from context and easily identifiable as such. Finally, the simple fact of movement and memory – in a word, *action* – make up the malleable joints of the figure's limbs, so to speak. Buildings can be moved through, as well as remembered and idolized. Circulation constantly changes and adapts to specific interactions, while memory is flexible in its ability to shift shape in time versus space.[2] The action figure becomes the sum of architecture's ability to go home with us and be reassembled into new memories or forgotten ones or incorrect ones, yet still singular and ours. Finally, a varied and vast collection of these personal Images (packaged-action-figures) constitutes nuanced narratives that define a city.

Packaging
The packaging of the city is fairly non-negotiable, hence a preoccupation by the discipline and profession with the current network and infrastructural fetishes that supposedly hold architecture in place, yet ultimately obfuscate its affective power. The contemporary city is more method of safe display than variant characters in stories within a volume. These packages are cumbersome in certain regards because they limit how and when you interact with the city, but give users and architects more the reason to tear them apart and interact with what's inside (or outside, actually) – architecture.

2 While discussing the inherent landscapes of the Futurist universe, Sanford Kwinter states "the movement it was obsessed by were those that carved shapes in time, not space." Memory is a shape and it can shape action – think all the people who try and hold up the leaning tower of Pisa or the same banal photograph of overjoyed faces staring at their reflection on the Bean in Millennium park. The shapes our memories take are precisely influenced by our collected experience through time. See Sanford Kwinter, "Landscapes of Change: *Boccioni's Stati d'animo* as a General Theory of Models," *Assemblage* 19 (Dec., 1992), pp. 50-65.

The experience of the city is of architecture in an urban situation, between buildings and streets, along causeways next to parks, bus stops and trains; one that inextricably includes the person in its image.[3] It's an a *priori* context giving its user history and a shape of things to come, but affords a possible simulation space in the current moment. The packaging is rigid in its response to economic realities and iconoclastic conversations, unlike the figure inside which is moveable and adaptable to our own wishes.

City packaging is the basis of local and regional debate – blocks of buildings take on personas prior, during and after development that different constituencies use, either for or against certain agendas. They are negotiated pieces of the urban puzzle that don't always fit and are seldom smooth from inception to creation. These pregnancy/childhood periods for architecture are one of the realities of the profession, as well as the beginning of their place within urban narrative.

The ubiquitous term 'context' is used in contemporary urbanism to mean several aspects of the city folded into it. In this case, context describes one part of packaging – the scene. The scene is important because it is the initial part of any narrative. Scenes dictate sometimes vital and sometimes irrelevant information to a story, where the interest in creating a space or vehicle for narrative becomes a dominant practice. A building's physical context amongst other buildings, around different infrastructures, within different regions, inside of variant neighborhoods, near parks or the water, constitutes elements of urban composition but not foreground.[4] As background, context/packaging restricts and does not enable architecture aside from a back-story. A preoccupation with context could spell a disassociation with architecture. In this way, context is not a suitable word to describe architectural realities because of position as descriptive typology or background.

Figure
Packaged narrative affects the figures that architecture makes. A building's body can be responsive to history, culture, as well as propositional in terms of alienated, complicit or projective futures. The body of a building is discursive in its totality. In this way, architecture becomes a figure – the associative linkage between history and place, as well as recognition and memory.

3 Michael Fried in his 1960s essay on minimalist art entitled *"Art and Objecthood"* states that *"...the experience of literalist art is of an object in a situation one that virtually by definition includes, the beholder."* This subject/object dichotomy and erasure of traditional boundaries found in the then current model of art consumption gave a clear picture into where architecture stood (and currently where it stands in the city), in terms of engagement with the users that inhabit it and the systems that enable movement through it. In this case, architecture was always considered to be the other side that art got to when things like sculpture became too big, such as Smithson's Earthworks and Serra's sculptures. See Michael Fried, "Art and Objecthood" Art Forum 5 (1967): 12-23.

4 In Robert Venturi's MFA thesis, he introduces the term context in reference to Gestalt Psychology's Figure/Ground theory. The figure/ground relation attempts to break down the elements or parts in a scene. Venturi's use of the term context is closer to the idea of composition, which I feel is a more productive discussion in terms of urban narrative construction and action figures in cities, than context. See Robert Venturi, "Context in Architectural Composition" (MFA Thesis, Princeton University, 1950).

Cities are easily repackaged as different things all the time. Figural language has been used in architecture to discuss positive/negative relationships in plan/section/elevation compositions, as well as users in space, to name a few, but its most productive use can be as the historical visual bridge between people and form.[5] The reciprocity between user and building here suggests that figures are more fluid than their histories in that they can be reconstituted *ad infintum* to resemble something else. Looking at figures within urban narratives holds that malleability is central to architecture's position as the city *vis-à-vis* citizens and their interactions with it. It's an essentially easy task to allow architectural figures to be dominated by a packaged image of the city. The latent possibility for figures to emerge as the main city unit is in their ability to be negotiated into and out of those histories. In a way, they hold all the proverbial chips in the no-limit poker game happening on the level of urban planning and policy. Aside from building types, building-looks are the first and last part of the urban narrative – they eventually convey what to love or hate, as well as what's memorable or forgettable. Figures are the only urban players left capable of making an offer to the city. Architectural figures are the city because they become the icons or forgettable backgrounds associated with a collection of buildings. As icon, architecture has an image to uphold and continue to proliferate, where as a heel or antagonist, architecture can either continue to be forgotten or disliked. Yet each is integral in urban narrative. These characters that architecture plays throughout time ultimately become the most pronounced elements in city making because of their immediacy in people's lives.

Action

The actions that figures perform and enable are most notably a function of movement and memory. While both aforementioned concepts are hardly new, their pertinence in the real place our synthetic figures take, are central. Movement presupposes that action is a physical occurrence engendered by urban figures. While action activates, it does not become entirely definitive of what is architecture *a la* Tschumi's events.[6] Memory works in a different way. While also engendered by urban figures, memory is much more nuanced and malleable considering its general relativity. Action figures are personalized versions of the city that citizens can identify with.

In urban design, the issue of circulation is an important reality, but an unproductive euphemism – there is no surgery being done and no arteries to deal with. Movement in, on and around urban figures is relegated to quantitative variables dictating limits of construction and not necessarily terms of engagement for a qualified experience. Of course, things like scale, property lines, setbacks, pop-outs and pretty much any affective device propagated by architecture's place in legal reality and design propositions, change the way people not only perceive but move within cities.

5 Alan Colqunoun writes that, "The figural cliché is the reverse side of the same coin that contains the notion of form and represents the "instinctual" side of the same historical phenomenon – an instinct, which is naturally exploited by the system of production." This folding of user experience and physical form in the term figure is one way to discuss the phenomenon of city and memory. See Alan Colqunoun, "Form and Figure" *Oppositions* (Spring:1978): pp. 28-37.

6 Bernard Tschumi stated that, *"Architecture ceases to be a backdrop for actions becoming the action itself."* While this was critical turning point in removing traditional dichotomies between form/function and shifting them to events/spaces, it does not necessarily define architecture more directly than form or figure or style. It did, however, free a territory for the discussion of architecture's soft and hard relationships with users and the events that were partly controlled by architects. See Bernard Tschumi, "Events and Spaces" in *Questions of space: lectures on architecture.* (London: Architectural Association, 1990), 87-95.

The iconicity of movement can be a palpable element in an urban narrative. Procession is a key player in the ability for action figures to perform. John Hejduk, for example, used literal mythologies to characterize his architectures for the people who would move through them. Movement and action can be ways to interject architectural control over some of the most recognizable elements in cities. From the linearity of the Forbidden City to the meandering down the Spanish steps, from the urban-massing-meets-planned-nature of Michigan Ave. to the immersive rhythm and lull of Times Square, urban movement is part of collective urban memory.

Memory is a plastic area of an architectural figure's mere existence. It's a sticky residue that happens when users interact with action figures (and sometimes by way of virtual introductions through images e.g think the "Flickr-ization" of collective memory enabling personal relationships with things and places one has never actually experienced). Rossi's introductory quote here speaks to the development of our personal modes of engagements with the city, from our earliest memories to our most recent get-togethers. The city (or lack of city) has been with us since we can remember; action figures are what we used to put in our pocket and play with, grew up and changed our view of them, maybe being a bit too childish, but nevertheless being simulation for other areas of our own lives. Architecture is fluid and malleable in this way too, shifting importance in some area of a person's life to become a distant memory, aggregating to inform a more complete stance on our interaction with the urban environment – the sine qua non of our urban identity.

All Out Play All the Time
Action figures do not need to be alienated from personal scale due to their sheer size. Size is only one aspect of scale, in terms of individual interaction. Subjectivity, after all, is constructed in multiples and in terms of the city, multiple architectural scales.[7] While action figures work at a real and dematerialized level of engagement, they are also conditional and variant. Architecture is sometimes fat or thin; fast or slow; dark or bright; open or closed; broad or narrow; private or public.

Action figures are the city in their identities – part recognition on a collective scale, part reconstructed narrative on the personal. For example, the Sears Tower is as much Chicago as the L, Wrigley Field, the gridiron, the Flatiron, the Emerald necklace and Marina City. While legality calls it the Willis tower and private ownership dictates the name change, citizen's daily interactions and memories enabled by it as an action figure provide the possibility of personal authorship. That is to say citizen authorship can

7 In "The Unconstructed Subject of the Contemporary City", Albert Pope critiques anthromorphism as an alternative to blunt modernism, in terms of engaging cities. I use Pope here loosely to discuss the possibility of both repetitive and singular action figures throughout cities as integral. Most importantly, his assumption that blunt modernism's dematerializing force, in terms of materiality and composition, can be a freeing agent in the urban environment due to its ability to be read in a number of ways, as well as be a vehicle that can perform as several things. See Albert Pope, "The Unconstructed Subject of the Contemporary City," in *Slow Space*. (Monacelli Press, 1998), 160-178.

create personalized narratives apart from the accepted ones, at times even more popular. They can also affect existing ones or add to them as well. With the shift in communication speeds, these authored narratives pop up more and more; creating fragmented and splintered virtual projections of cities for mass consumption.

Architecture is the city because it can talk and create urban situations, without the need to be read historically or be in a network or define itself through infrastructure. Talking is situational while reading is absolute. The potential for architecture to be engaged in the discussions of its citizens is precisely why action figures bridge the phenomenal gap between urban form and user experience – it becomes an extension of a populace. Action figures are not new, but they do provide a great amount of freedom to engage with in our contemporary cities, a freedom once enjoyed as children that might be more productive for our day-to-day lives now than once thought.

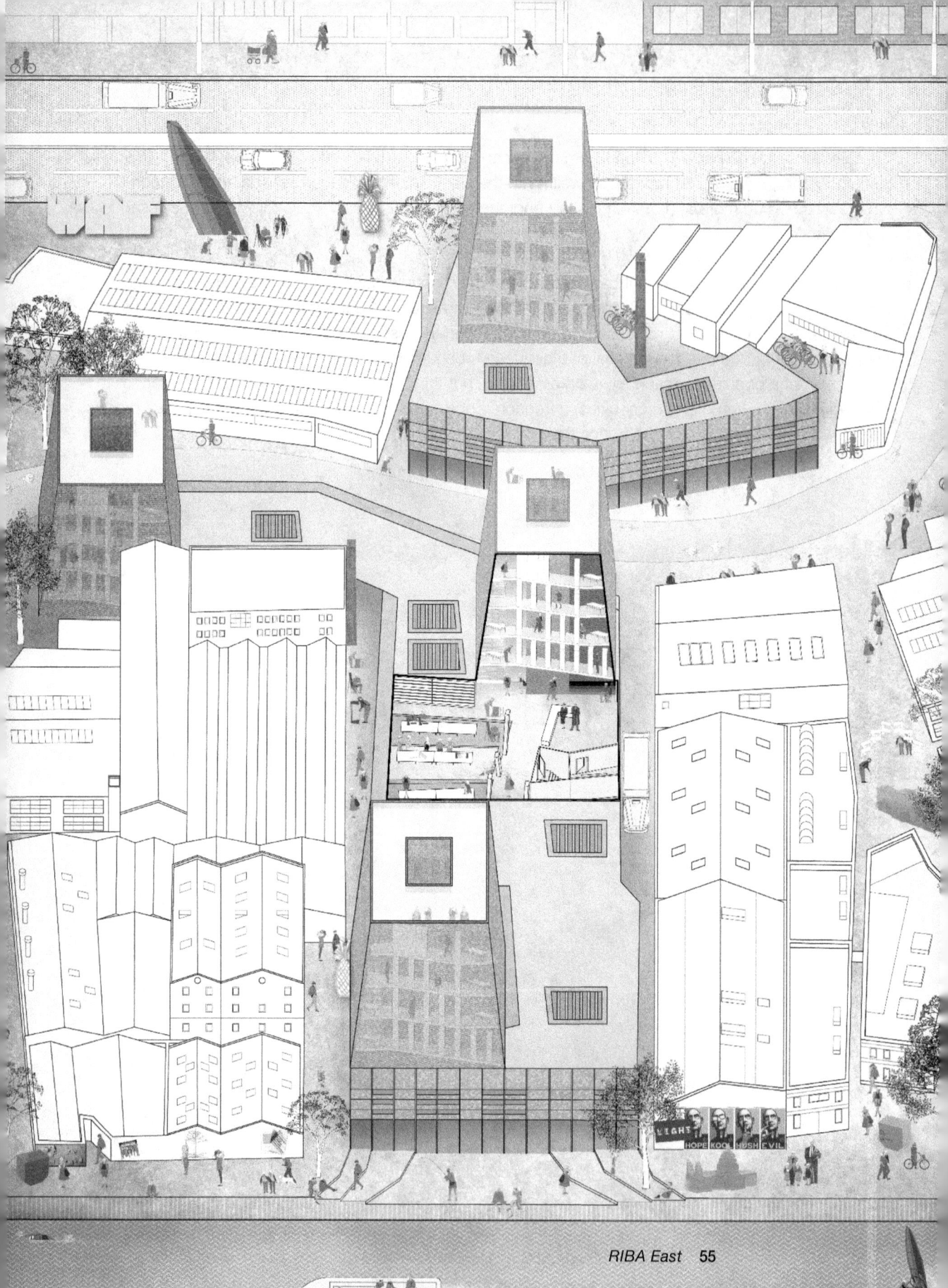

RIBA East: Regeneration Through Catalytic Insertion

Sam Rose

A Post-Industrial area of East London earmarked for creative industries, Sugar House Lane is to be demolished to accommodate a new perimeter of mixed-use development by Newham Council. The paradox is that this rich context of robust, north-lit factories is ideal for creatives and should instead be renovated to preserve their spatial qualities and embodied energy.

The proposal uses an outdated creative institution, the RIBA (Royal Institute of British Architects), to charge the voids with new potentials by investing some of its intellectual assets into the disused industrial yards. The current RIBA HQ was described by the current president as a "glorified events venue" no longer a forum for the increasingly introverted architectural community. Therefore, RIBA East's catalytic archives are linked together by 'events' such as studios, exhibitions, and auditoria that reinvigorate the institution as well as the inactive street fronts, typical of Post-Industrial grain. RIBA East provides the platform for promoting new ideas and the forum for their critique. In these conditions, the architectural community can flourish with the RIBA at its core.

The intellectual investment stimulates a fresh, unsentimental perspective on a context that becomes a blank canvas of potential relationships and creative activities. Creative institutions, with their wealth of intellectual assets and reputation, can be used as tools for the regeneration of areas ideal for creative industries. With the council's strict framework policies, creative institutions increasingly expanding, and post-industrial areas lying dormant, it is a potential solution that is beneficial to all parties.

Shifting Properties:
New Directions for Spatial Development in Resource-Dependent Regions

Lauren Abrahams

For upwards of 300,000 people the landscape of Nova Scotia represents both a source of livelihood and a way of life. For centuries, hundreds of small communities dispersed along the coast have remained economically dependent on natural resource harvesting and processing. This scattered ring of development, bounded by expansive bodies of water and bounding expansive forested hinterlands, occupies the interface between two primary industries, fisheries and forestry. In the last two decades, an emphasis on globalized production has reshaped the natural resource economy, leading to enormous uncertainty surrounding the viability of these industries. Consequently there is enormous uncertainty surrounding the future of rural communities dependent on these industries.

Compared to the unmistakable physical decay that defines hollowed-out manufacturing towns, in diffusely settled resource-dependent regions the signs of decline are less visible. Marked by waves of hardship and prosperity, rural Nova Scotia has always appeared variegated and worn. Weathered wharves and collapsed sheds characterize the salty vernacular, existing alongside modest homes and vacation properties. Obscured by the dense forest cover, abandoned mills are fixtures in the harsh, worked landscape. As industries atrophy and populations decline, the lack of structural evidence is deceiving. Within this climate of rapid economic and social erosion, existing systems of property relations are being put under pressure, 'opening up access to other actors and encouraging new laws that govern natural resource use.'[1] The result is a drastically transforming institutional landscape of ownership and rights to land and natural resources. Despite an enduring commitment to traditional resource-based activities, these cadastral reconfigurations are poised to significantly transform the rural environment. This research aims to situate the dynamic processes underway. How are these shifting property rights impacting communities in decline? Can the evolving territorial footprint of landscape access and resource use generate new directions for spatial design in shrinking, resource-dependent regions?

[1] Wiber, M., Pinkerton, E. and Parlee, C. (2011) Stinting the Intertidal Zone: the many dimensions of privatizing a commons, Conference of the International Association for Study of the Commons (IASC) in Hyderabad, India, January 11-14, 2011.

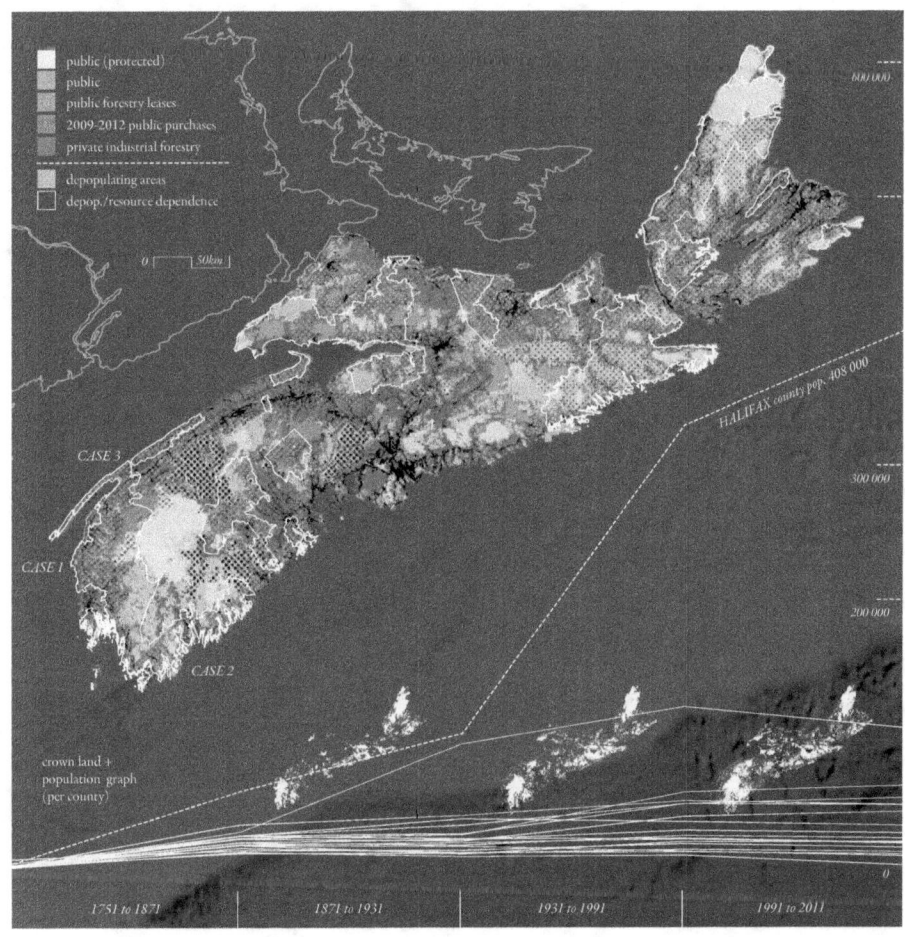

The Landscape Of Rights
Reconciling traditional resource values with emerging landscape interests is leading to an increasingly dynamic institutional environment in Nova Scotia: With major competition from rising production regions, forestry is folding; large tracts of land held by a handful of private industrial forestry companies are being put on the market. In an unprecedented effort to increase the public or 'crown' lands base, the province has bought back over 800 000 acres of forests since 2009. Still in recovery from the collapse of the ground-fisheries in the mid 1990s, aquaculture is being promoted as a new coastal economy. Facilitated by a recent jurisdictional change, public intertidal beaches once considered open-to-all are now being enclosed through industrial leases. After centuries of ecologically destructive resource development, biodiversity protection is gaining ground. Human activities across previously productive areas are being limited towards reaching the policy goal to protect 12% of the provincial landmass.

 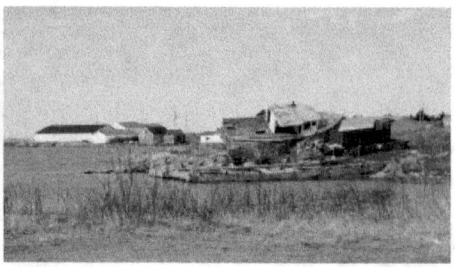

Both triggered by and triggering economic and demographic decline, the role of resources and the people benefiting from their use is rapidly diversifying. With the spatial outcomes yet to be grounded, these changes are inciting controversy in declining resource-dependent regions. As previous land uses are shut down the evolving territorial footprint of resource use, both at the community level and the provincial scale, offers a critical opportunity for design consideration. As a starting point, three communities are taken as case study areas, all exhibiting high levels of depopulation and resource-dependence.[2] Against this common base, each case interrogates a different property shift, situating it within the specific landscape and cultural conditions.

Case 1: Buying Back The Forests

With the closure of the Weymouth saw mill in 2006, the JD Irving Company's monopoly on forestry in the region lost its footing. As the mill owner and one of the largest landholders in the province, the company was forced to shut down its operations. Consequently, a significant amount of its land holdings were put on the market. As an important centre in the nineteenth century ship building boom, the forests in western Nova Scotia have been cut for centuries, leaving behind a modified landscape with compromised ecological integrity. Until recently, forestry had provided a stable livelihood for hundreds of small woodlot owners and mill workers alike. Within this climate of decline, JD Irving's announcement to sell their land was met with much unrest. Many feared that these lands would be brokered to foreign residential developers interested in the seasonal property market. Such changes to the landscape composition do not create jobs and would reduce informal access rights to woods and rivers for recreational purposes. To address these concerns, the 'Buy Back Nova Scotia' coalition formed. While JD Irving did sell a small piece of land to Vladi, who advertise pristine private islands for sale internationally, the coalition ultimately succeeded in convincing the provincial government to purchase over 65 000 acres, much of which is slated for ecological protection. This unprecedented provincial commitment to biodiversity is considered by many to be a great achievement. However, for local woodlot owners struggling to eke out a living in the shadow of a rotting industry, wildlife habitat is hardly a priority worth $40 million.

2 The case study areas were chosen according to the following measures: (a) depopulation between -5% to -15% of the total population in the period 1991-2011 (b) resource dependence >20% in 2006. Resource dependence can be measured in a number of ways. For the purposes of this research, it is measured along percentage of population employed in resource industries. This includes fisheries, forestry, farming, and hunting. See: http://www.gov.ns.ca/finance/communitycounts/

After years of catering to the forestry companies, these transfers represent a paradigm shift for public ownership and management of lands. Record crown land acquisition continues, most recently 550 000 acres were acquired from Bowater in December 2012 after the closure of its mill earlier in the year. Concurrently, the two largest industrial forestry leases that gave control of enormous amounts of crown land in northeastern Nova Scotia to single companies over half a century ago are now coming to term. So in Weymouth as in many communities across the province, a web of processes is underway. Public lands are being purchased and considered for a range of future uses— protection, sustainable forestry, renewable energy production— while private lands are being developed for leisure and tourism or cut earlier and younger as livelihoods are made increasingly difficult.

Case 2: Ceding The Seas

In December 2012, the provincial government granted two industrial salmon aquaculture leases to Cooke Aquaculture, one of the largest fish farming companies in the maritime provinces. The rigorous 26 month long approval process incited major controversy in the coastal region of Shelburne, the final decision being met with a mix of optimism and regret. Southwestern Nova Scotia is a lobster stronghold. Unlike the ground fisheries managed through a quota system that defines the quantity of the catch per individual, the lobster fishery still operates with area licenses. Accordant with zones and seasons, lobster fisherman are free to catch as much as they want. This way of fishing promotes an embedded tradition of informal cooperative management within communities to protect and steward the source of their livelihoods. Cordoning off areas of the coast with net pens and processing facilities in support of aquaculture development is considered by many lobster fishermen to be a major threat to their way of life. Others in the community see aquaculture as a long awaited opportunity to grow and diversify their local economy without compromising the entrenched connection with the sea.

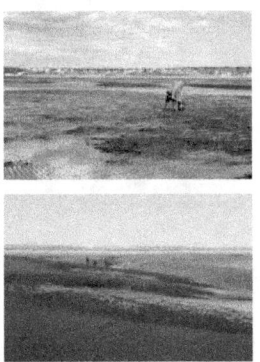

'The Aquaculture Controversy' is playing out all along coast of Nova Scotia. A recent book with the same title unpacks this phenomenon attributing the friction to the fact that aquaculture is the first 'new' resource industry to emerge since globalizing processes have taken hold. Without precedents, the ecological and social impacts on shrinking regions are unknown; it is often difficult to discern science from speculation.[3] So while the province is reconsidering mono-functional forestry development on crown lands in favor of more diversified landscape use, the two century old practice of corporate monopoly through industrial leases is just now in its infancy with regards to aquaculture development.

3 Young, N. and Matthews, R. (2010) The Aquaculture Controversy in Canada: Activism, Policy, and Contested Science. Vancouver: UBC Press.

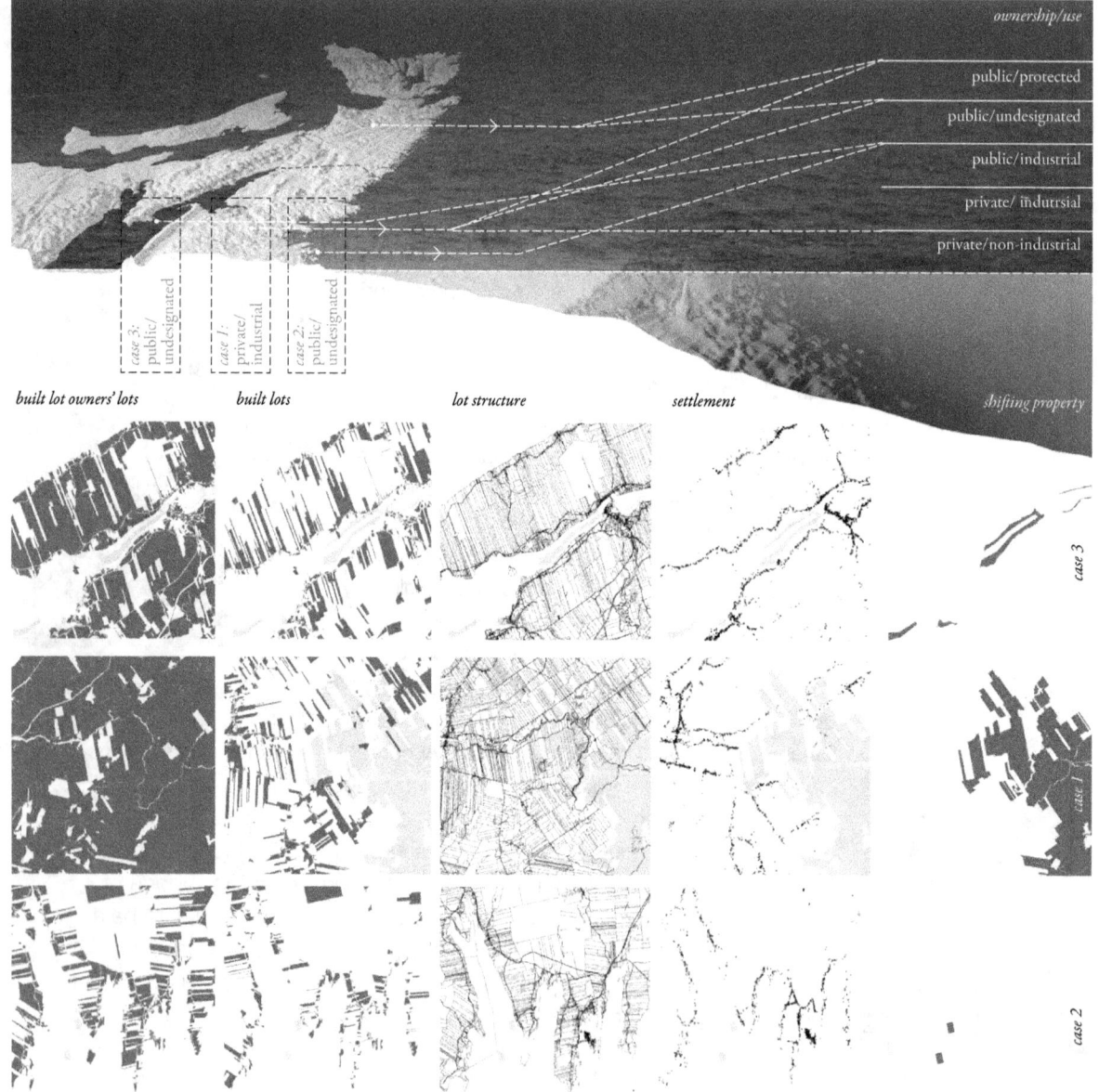

Shifting Properties

Case 3: Enclosing The Beaches

Another kind of aquaculture controversy is taking place along the muddy shores of the Annapolis river valley. Industrial shellfish aquaculture leases are altering the traditional relationship between independent clammers and the once open beaches they harvest. For centuries, clammers have freely harvested in this area, selling their digs to local processing plants. In the 1970s, concern was mounting over pollution and contamination of the clams that were being harvested locally. Depuration plants were built, legislating that clams harvested from zoned beaches would require filtration through these plants before they could be legally processed. In the late 1990s, Innovative Fisheries Inc. (IFP) became the sole depurator in the region. This monopoly remains today, and has greatly changed the landscape of rights across the beaches. Subsequently, IFP has become one of the major provincial players in the shellfish industry, holding some of the largest exclusive leases to bays and intertidal beaches. The depuration monopoly has wider reaching implications for intertidal zones across the province and has been coined the 'stealth privatization' of a fishery. This characterization is in part a response to the underhanded system in which clams dug on 'open' beaches still require depuration, indebting independent fisherman to IFP.[4]

Contestation of the banks of the Annapolis River is as much about livelihood as it is about way of life, and reflects a larger issue across the province that cuts through forestry and fishery practices. Economic and demographic shrinking only describes one dimension of decline in resource-dependent regions. The changing landscape of resource rights is confronting well established patterns of community access and use, threatening the loss of embedded cultural practices. Attempts to reconcile private development and informal arrangements have led to a range of recently introduced provincial mechanism, such as 'community land trust's and 'community forests.' A community-based resource management plan is currently being developed to address clamming along the Annapolis River, bringing together levels of government, industry, NGOs and independent harvesters. Yet to be implemented, these first efforts to institutionalize community rights are a further example of the expanding field.

4 Wiber, M., Rudd, M., Pinkerton, E., Charles, A. and Bull, A. (2010) Coastal management challenges from a community perspective: The problem of 'stealth privatization' in a Canadian fishery, Marine Policy. 34: 598–605. For more information see: http://www.coastalcura.ca/.

Territories Of Design

Reflecting back at the provincial scale, the aggregation of local shifts describes a region in transition. On the one hand, the sum of all these property transfers can be understood as a variegated landscape marked by internal contradiction. On the other hand, these sites of controversy offer possibilities to envision spatial interventions that integrate traditional and emerging resource interests. As the case study areas demonstrate, a meaningful discussion around regional decline must move beyond the usual dichotomies—shrink or grow, public or private, profit or protection— towards envisioning future possibilities grounded in space.

At the intersection of woods and waters, the diffuse settlement pattern and topographically responsive lot composition could provide an interesting, inherited structure against which to explore new integrative models of occupation, production and recreation. For many in Nova Scotia an enduring rural ethos remains resistant to change. But with a renewed institutional scaffold already taking shape, spatial transformation is inevitable. Reframing these shifting properties as territories of design can bridge the operational gap between the institutional and lived landscape by exploring new ways of relating to resources and new spaces to support them.

03 This work proposes the creation of a wetland covering the Gulch in its entirety. The wetland's main purpose is to rethink the use and management of one of Atlanta's most scarce resources: water. Far from being simply a new landscape, the wetland is intended to become an urban "water facility", where plants, birds, fish, and humans will learn to cohabitate. At a primary level, the new facility consists of a series of parasitic constructions aimed at collecting waste and runoff water and purifying it through processes naturally occurring in any wetland. Given their efficiency in providing clean water, these new constructions become sought-after shelters and will offer multiple nesting opportunities. The filtered water is either used for irrigation purposes in the areas adjacent to the Gulch or returns to the "nests" via processing spaces built in the heart of the marsh. The mountain-like constructions will support recycling related activities and as the population soars will provide opportunities for fostering socially active spaces. The size of the Gulch wetland can provide clean recycled water to a population of 12,000.

04 The construction of the wetland is as important as its function. Here, new ways of building become linked to novel social practices and a redefinition of the relationship between humans and environment. The "isolation" of the wetland in the heart of the city encourages the formation of new communities as alternate societies capable of addressing environmental issues. More than anything else, the artificial wetland is conceived as a laboratory aimed at becoming an off-grid, self-sustaining unit. In this process of appropriation and negotiation of newly acquired boundaries, a new urban vernacular, based on addition and subtraction and integration of new technology, may arise. The ultimate goal is to use this "facility" to grow architecture.

05 View from the CNN parking deck. The wetland becomes where plants, birds, fish, and humans cohabitate.

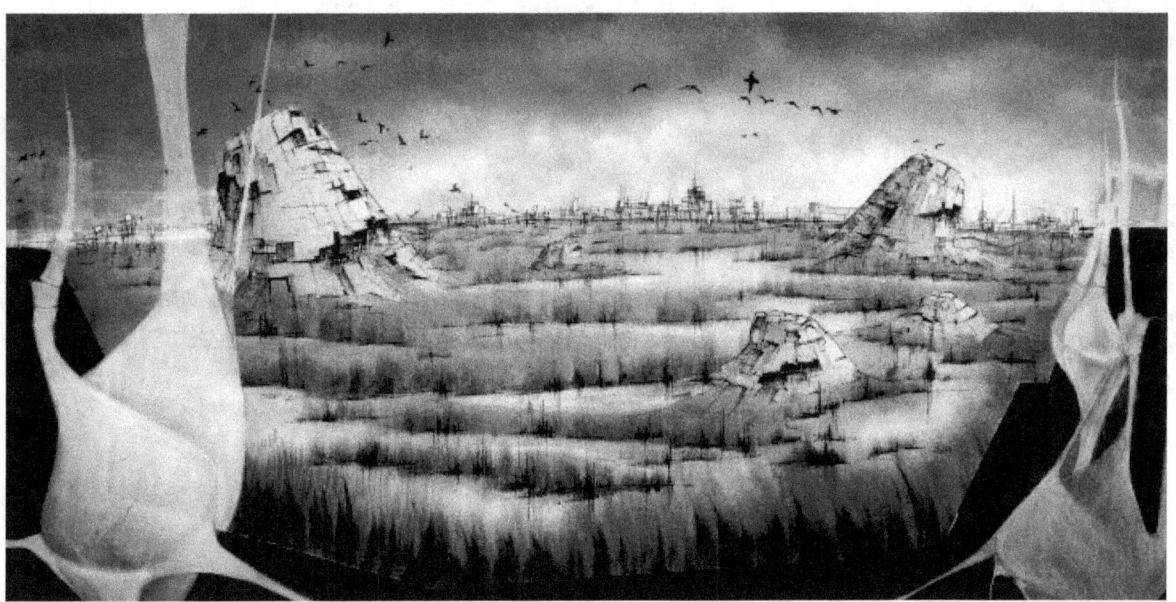

06

Section through wetlands. The new landscape is conceived as a laboratory aimed at becoming a self-sustaining unit.

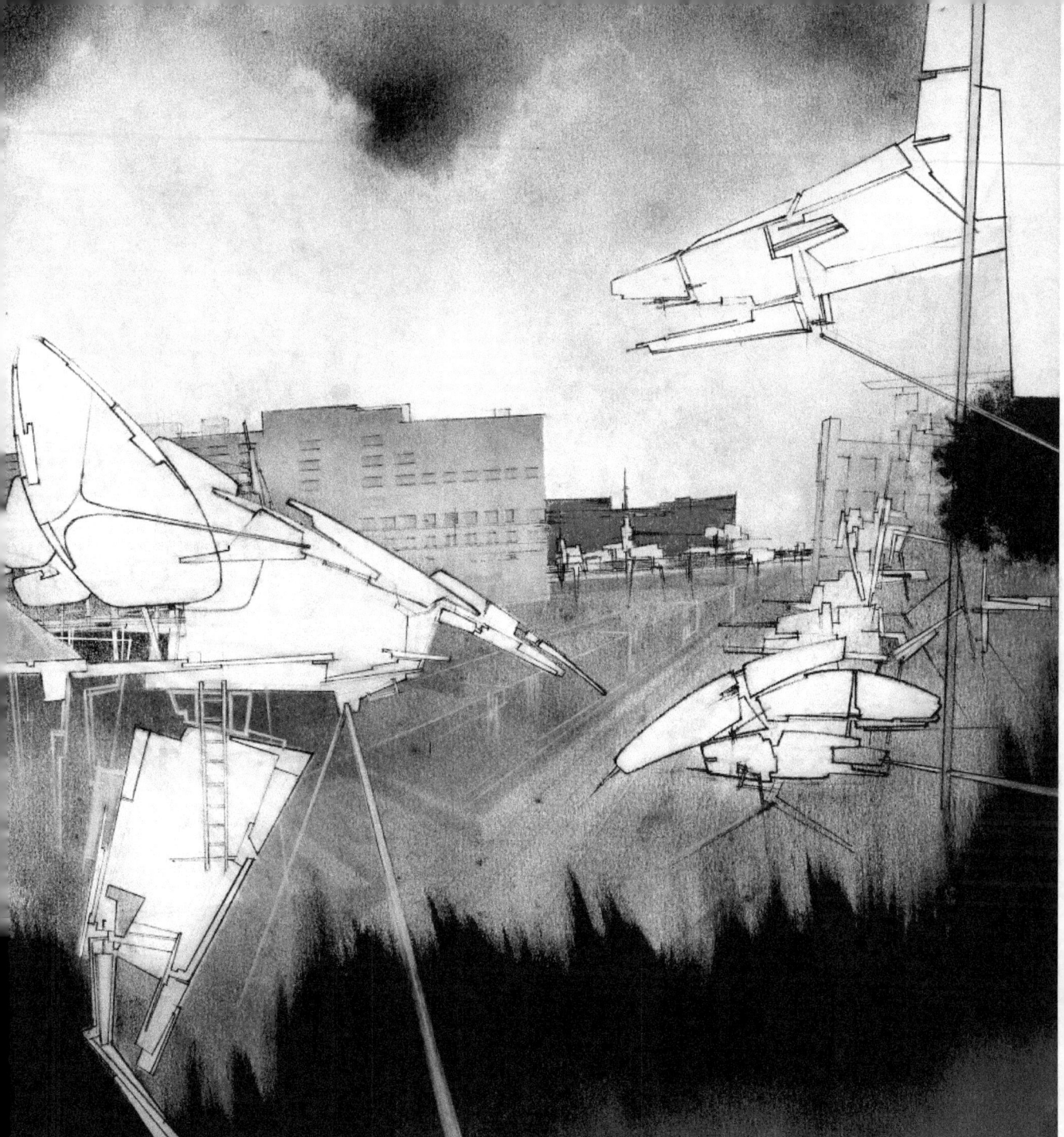

07

The nests play a key role in the wetland, and their access to clean water turns them into coveted shelters.

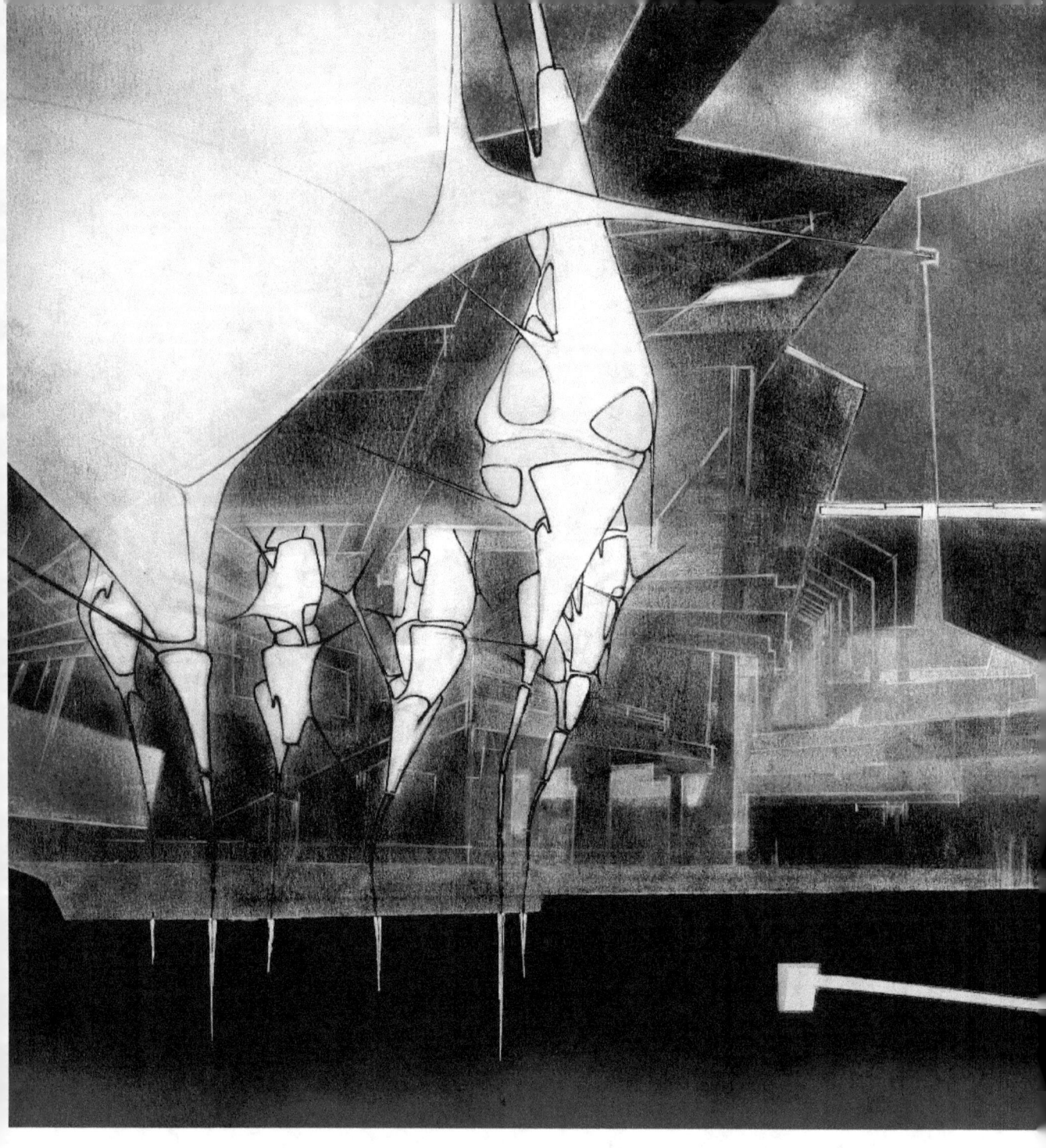

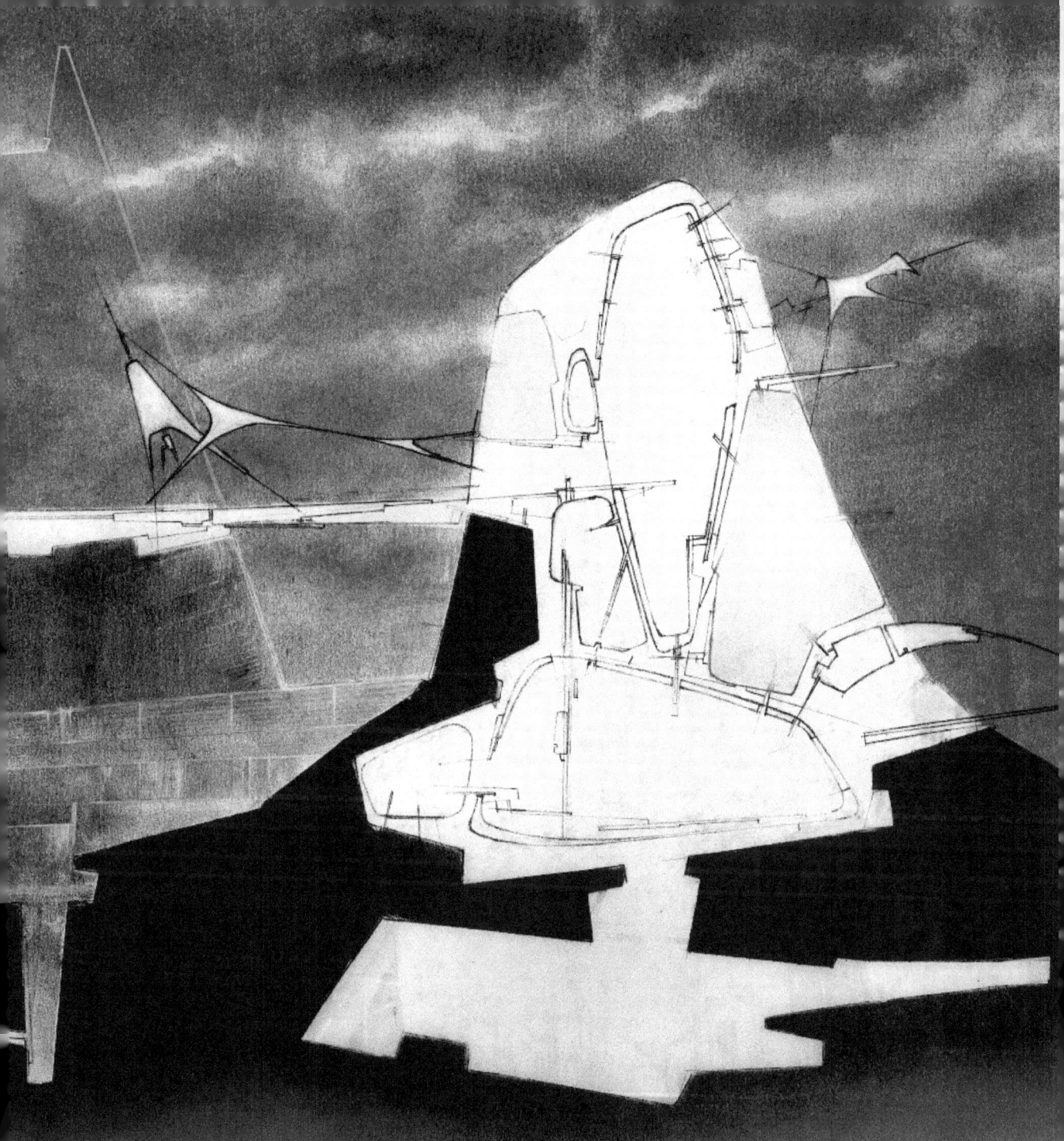

08

Section through an artificial mountain hosting recycling-related activities. Domestic nests are grown in an abandoned parking garage.

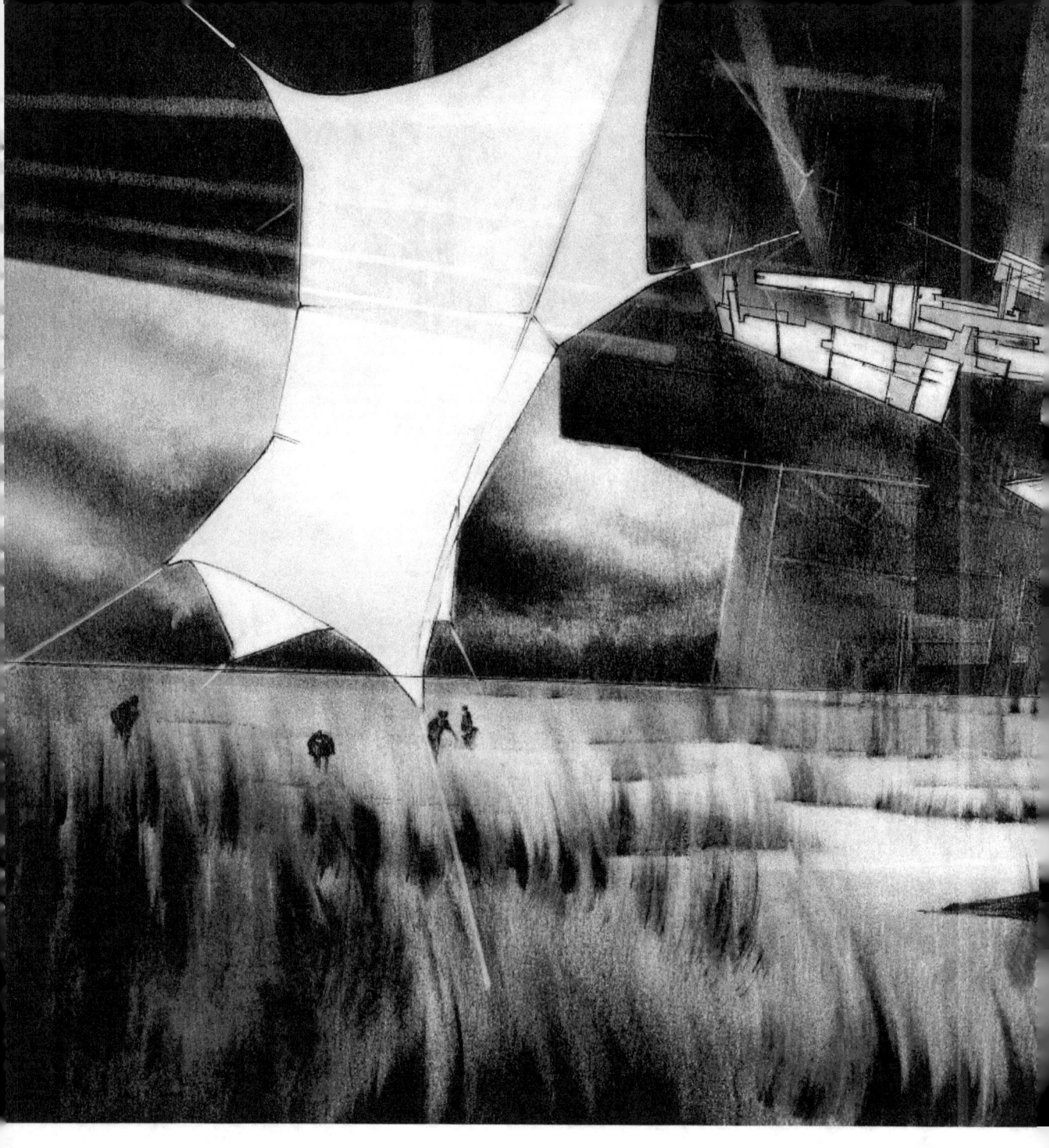

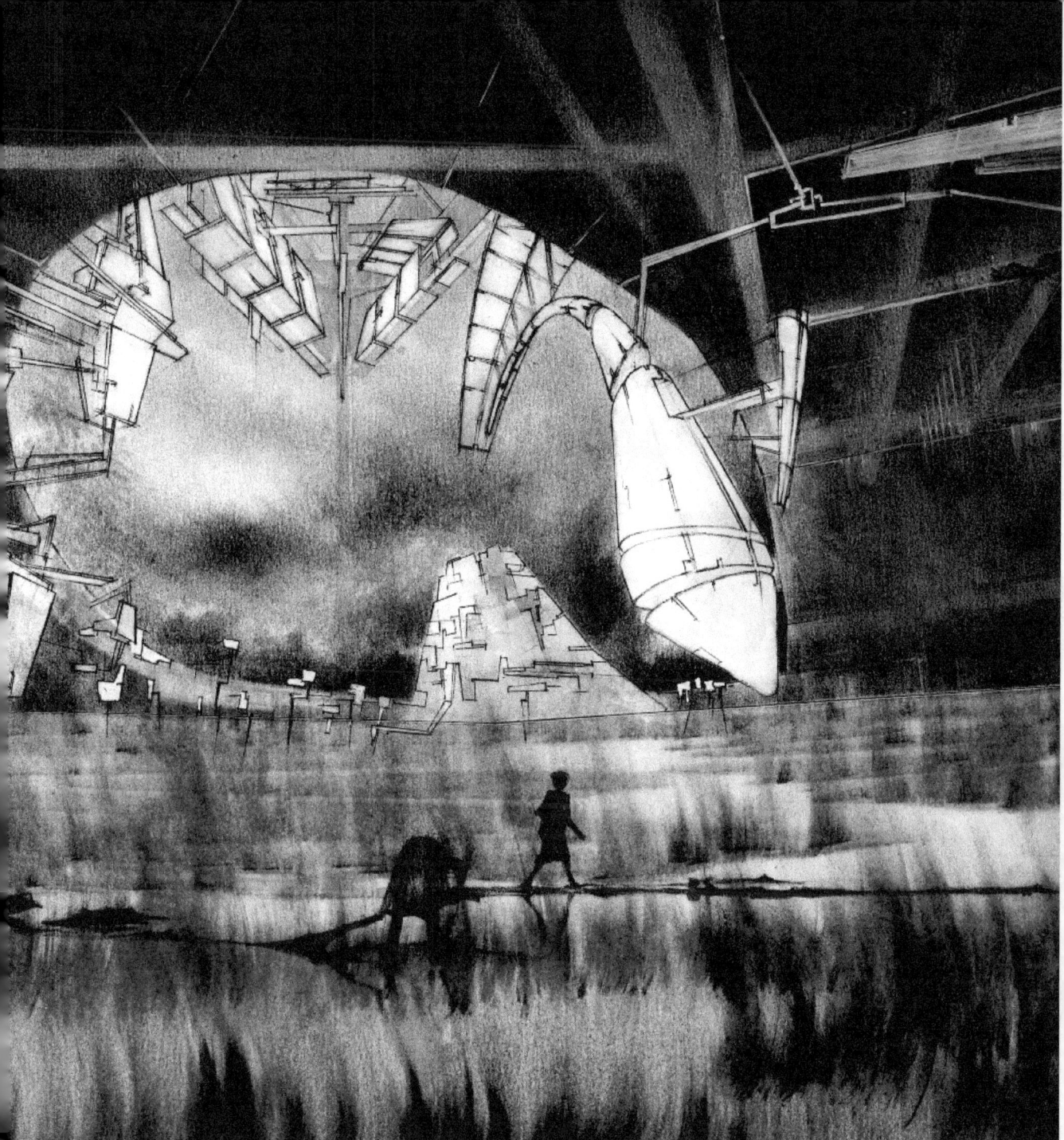

09

Farming under viaducts: the parasitic nests provide filtered water for irrigation purposes.

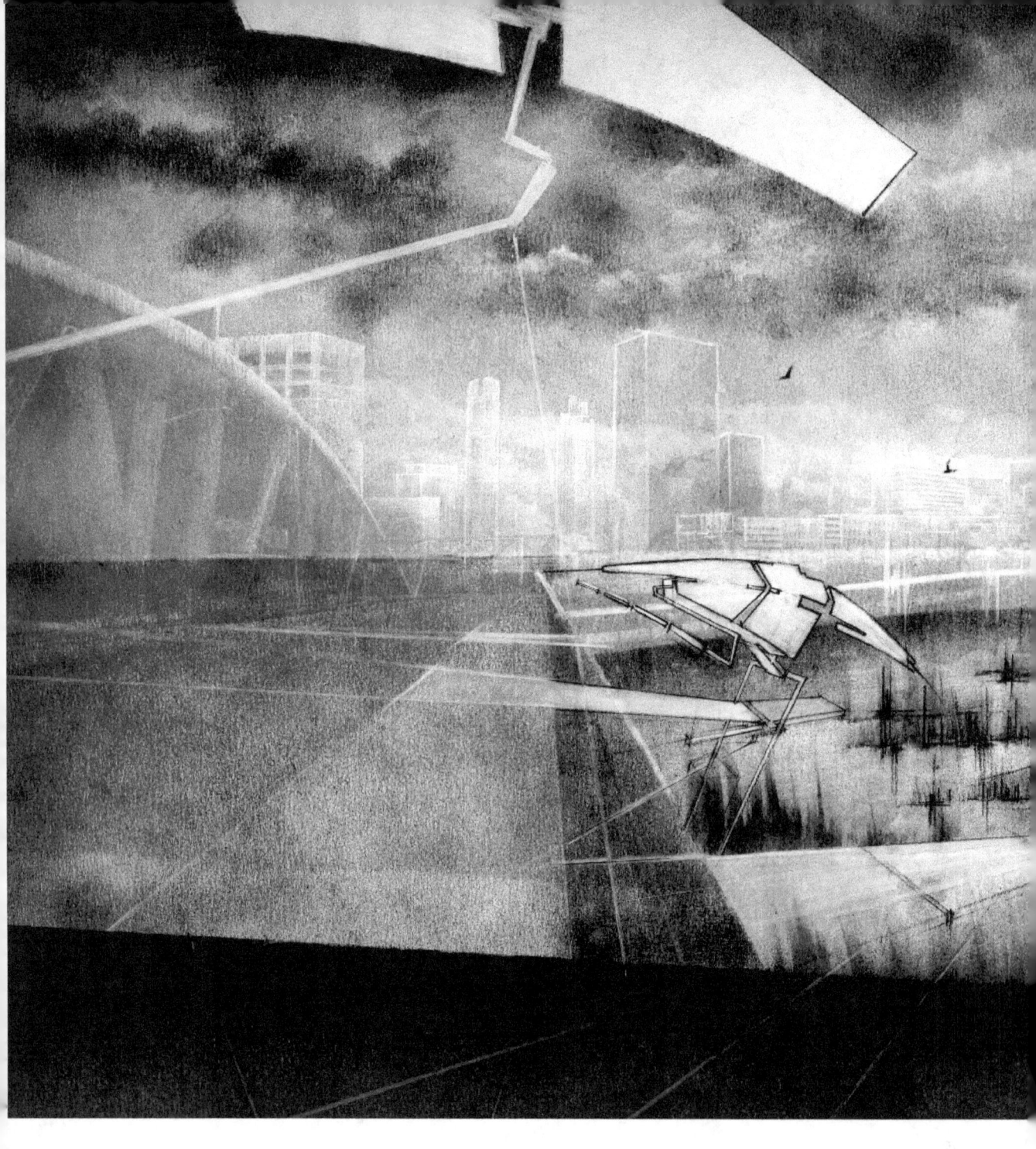

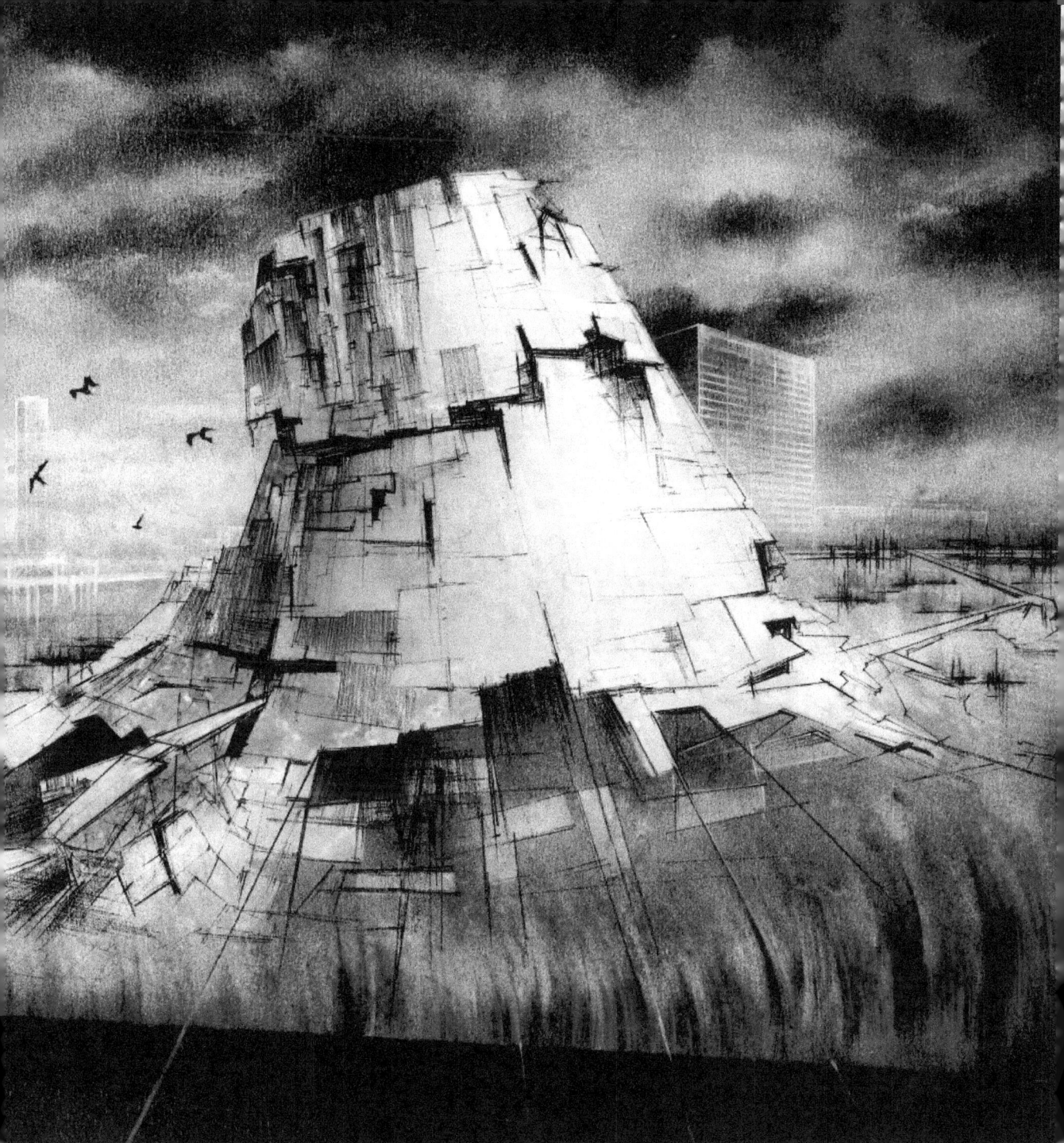

10

Artificial mountains represent a crucial ecological feature of the new landscape. Inside, these constructions host production and social spaces.

Degradation Is...

Degradation Is...
Konstantinos Maroulas

Degradation is an intrinsic characteristic of human life over which we have little control: we live in order to cover our needs, material and mental.

The recent crisis in Greece (as elsewhere) makes clear that current needs cannot be covered with current means.

Living as a social act can no longer be viewed the same way or carry the same meaning: realizing the individual in this present leads to comprehending the collective.

In this present, the message is given by the viewed: memories of vigor and relics of greed. Billboards are now our watchtowers.

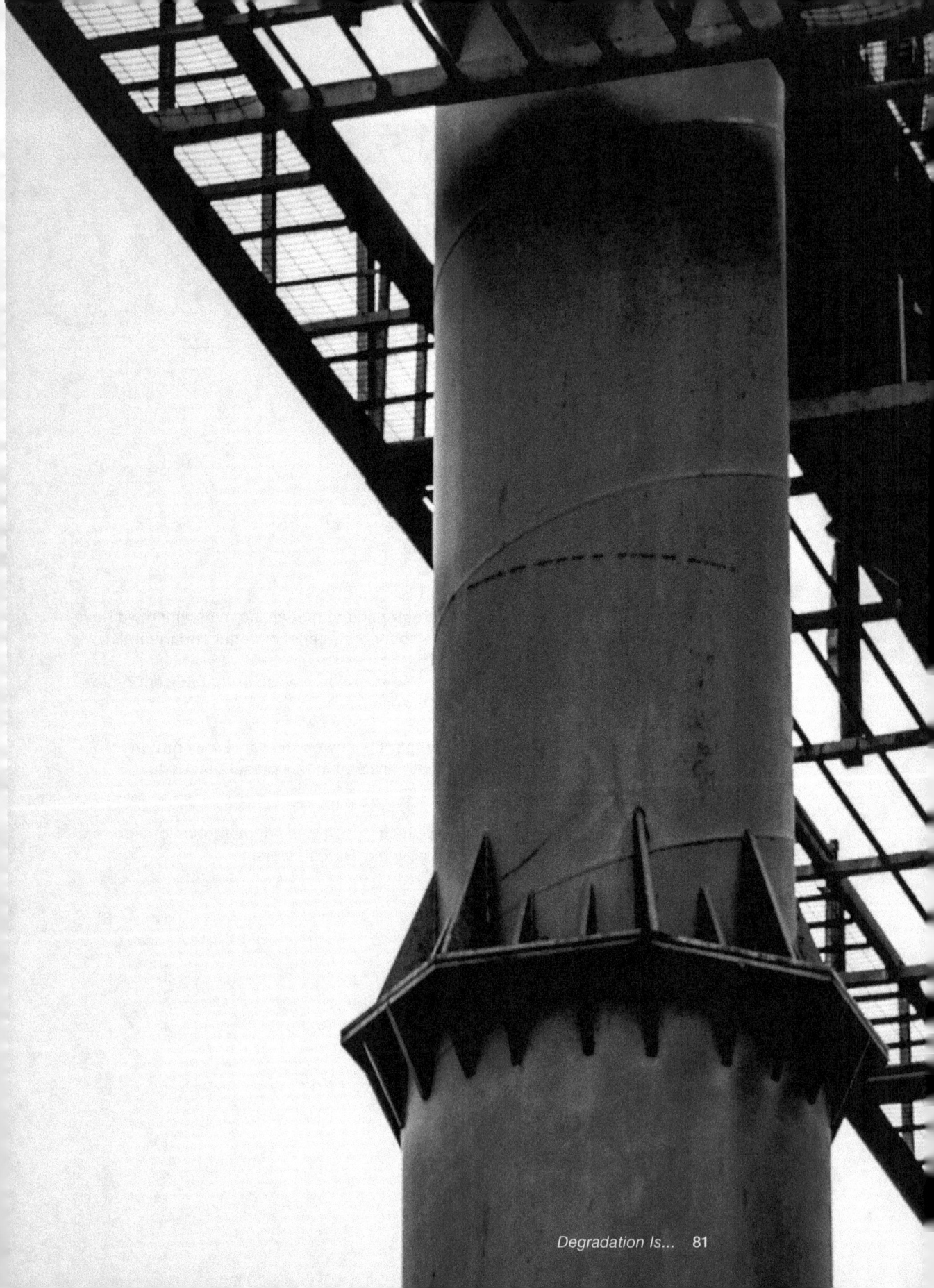

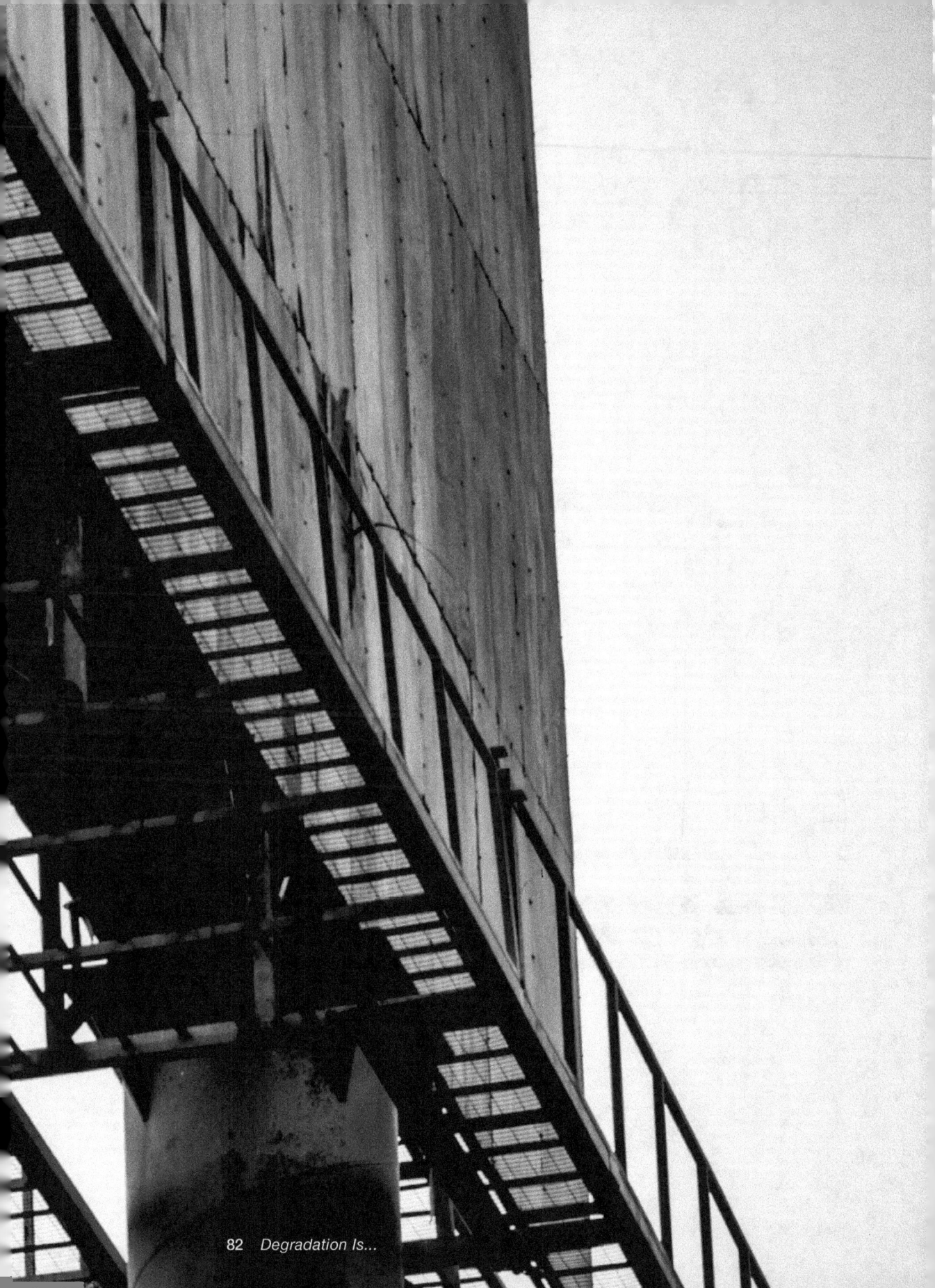

Sign City 83

Sign City
Ashley A. Reed

Detroit, the motor city, is in a state of decay, which has incited a number of revitalization proposals. Yet, none of these proposals have been successfully implemented. Might a proposal "mashup" be more successful? What form would this new city take?

Eight distinct proposal types were identified from the array of revitalization approaches. The *'Museum of Ruins'* proposal advocates the preservation of Detroit in its current state to memorialize the post-industrial city. The *'Return to Nature'* proposal recommends the demolition of Detroit and its eventual development back to its original natural state. The *'Landscape Urbanism'* proposal promotes the establishment of a natural fabric to reconnect the remaining city. The *'Urban Agriculture'* proposal suggests the replacement of industrial wasteland with farmland to jump start Detroit's economy. The *'Riverfront Development'* proposal advocates the establishment of a commercial and community center along the Detroit River. The *'Creek Daylighting'* proposal recommends the uncovering of past waterways and development along their banks to create prosperous threads across the city. The *'New Suburbia'* proposal promotes the enabling of Detroit residents to individually reclaim abandoned properties, prompting an expanded form of urban dwelling. The 'Mass Transit' proposal suggests the linking of inner city regions and stretches out to the surrounding suburbs through multiple modes of transportation.

If all of these individual proposals are valid revitalization options, why is 29% of Detroit still vacant?

Detroit is still decaying because vacancy is dispersed across 360 square km. To put this scale into perspective, the land area of Detroit is equal to 4.6 Manhattans. Furthermore, the population of Detroit is dispersed less densely than comparable cities. As a consequence of this scale, revitalization is extremely costly, and there is a disconnect between planners and Detroit residents.

These conclusions suggest a master plan scale adjustment. What if proposals were implemented at the scale of the sign? Rather than implementing a proposal, a proposal sign is implemented as an instigator for development. What are the potential urban scenarios of a revitalized Detroit, the sign city? How would these signs be implemented? Who would view these signs? How would these signs interact?

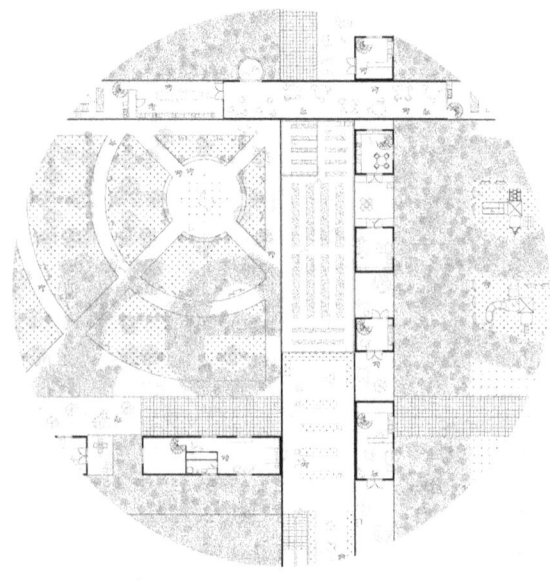

Sign City

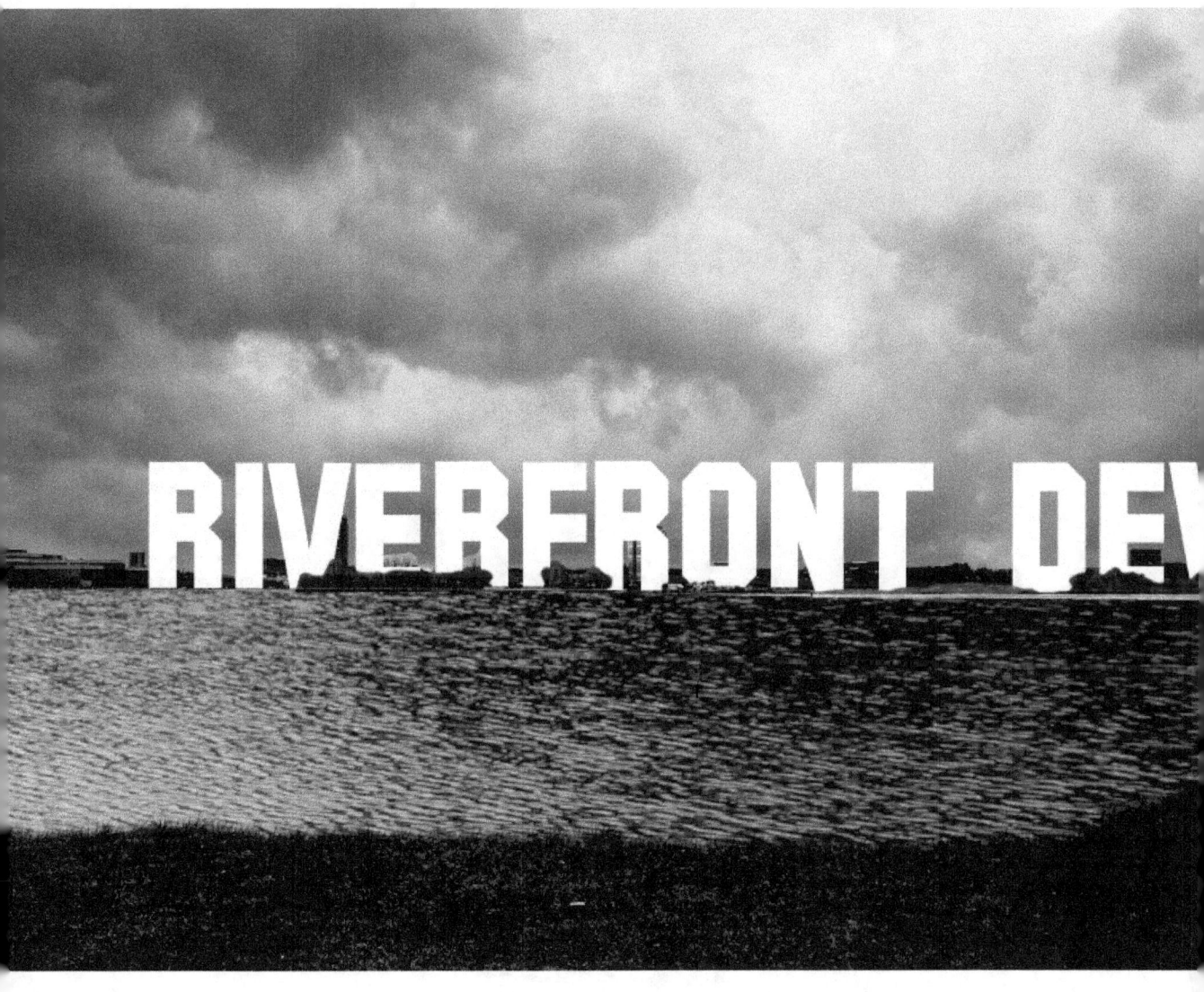

Decline is an "in-between" condition; a state of transition from that which we know to what we do not know.

Design allows us to perceive decline with an optimism motivated by a desire for change.

Between Great and Lake: Design for Great-er Lakes Sub-Culture

Elizabeth George & Julia Sedlock

The water level in the Great Lakes is dropping. Some may say that the lakes are "greatest" when they are at their fullest, and are therefore headed towards a sub-Great condition, a site of decline. Yet, by offsetting the existing shoreline to project a future decrease in water level, we translate "decline" into opportunity for cultural investigation.

Territory
Great Lakes Shoreline,
10,900 linear miles X 200 ft

Translatable Scale
National and Global

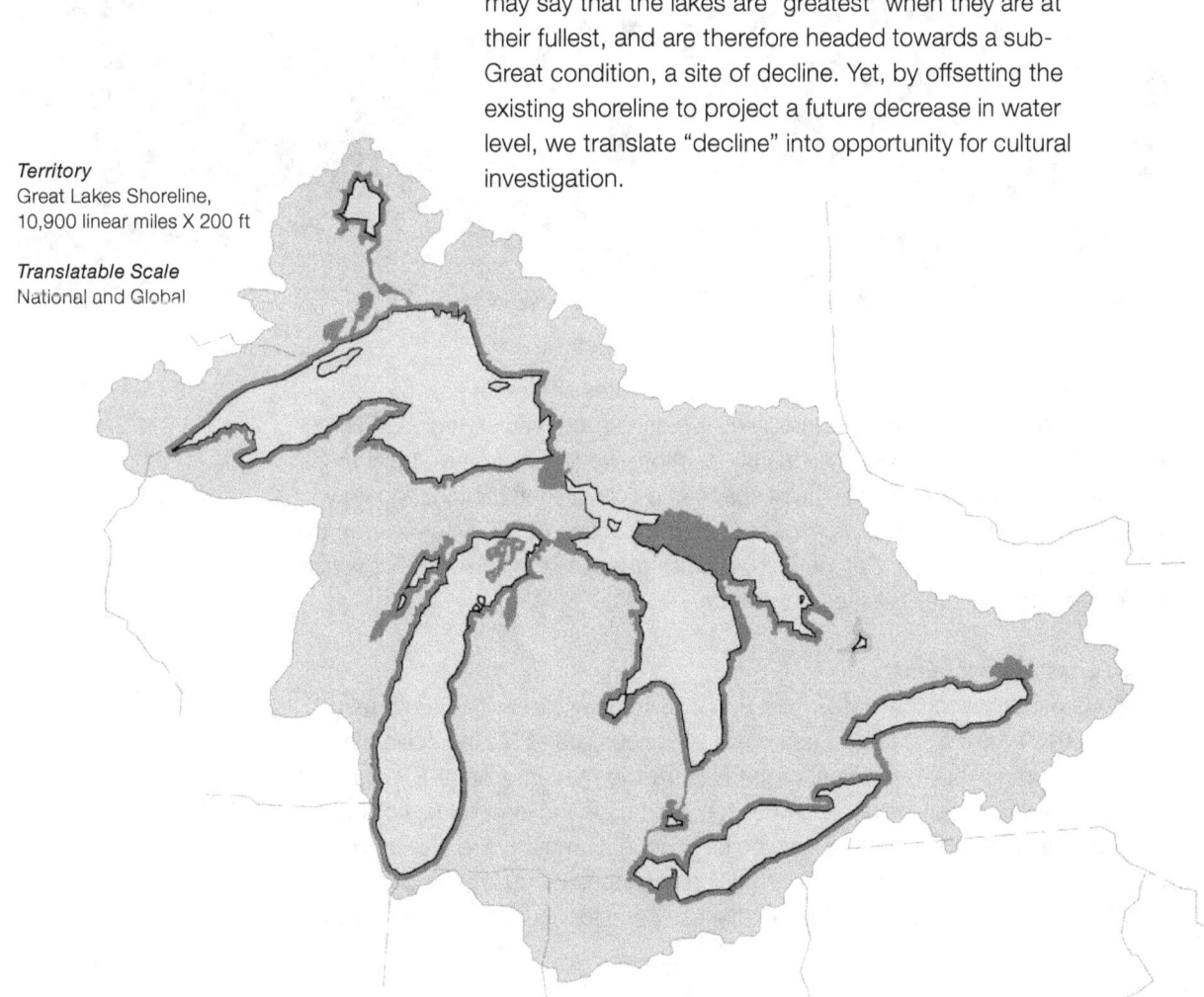

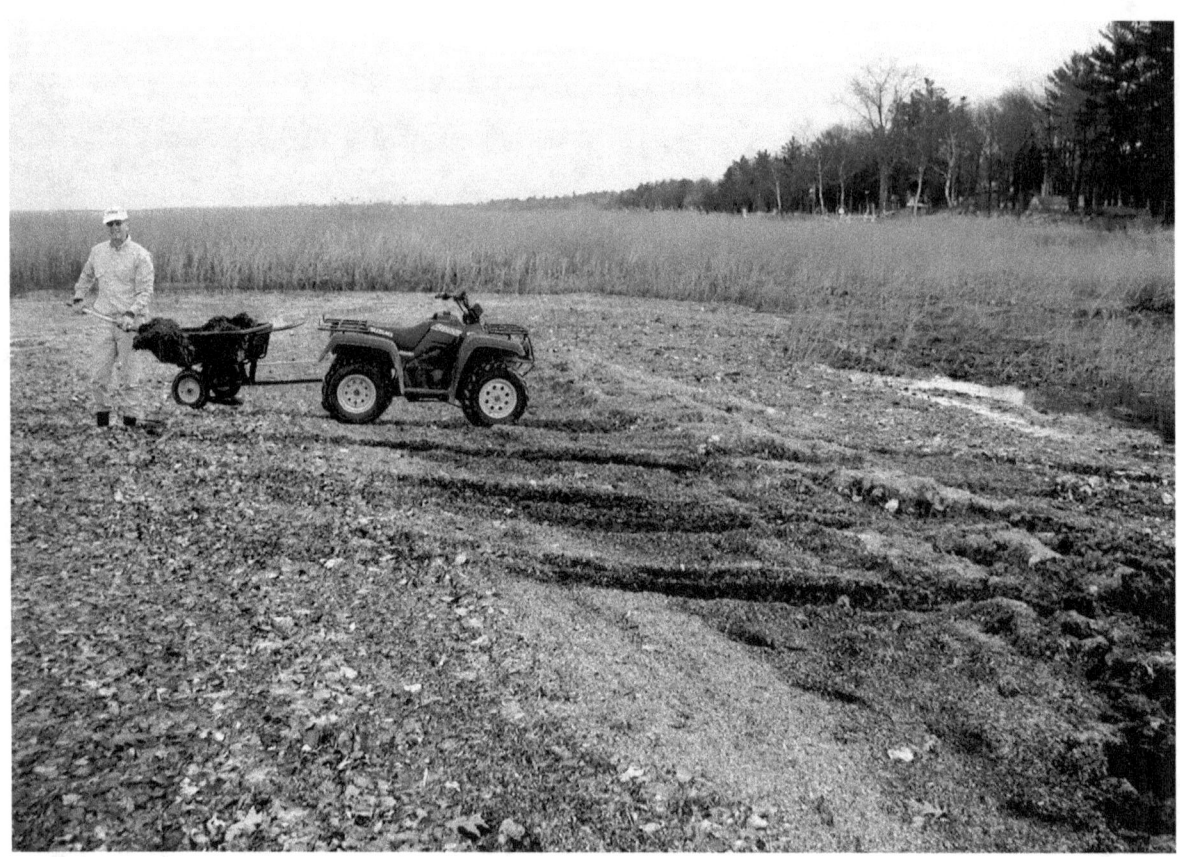

The offset above reveals that between the Great Lakes shoreline, as we know it, and the projected outline of future lakes lies an Extraterrestrial Region (E.R.). With this discovery of previously unknown territory, we find alternative trajectories for development, new ways to inhabit space and cultivate interaction, and new ways to live. In other words, we engender the production of subcultures. With this political and social potential of the E.R., we may translate the sub-Great condition of decline into a Great-ER Lakes Subculture.

From Loss to Leverage
As the Great Lakes region loses water, it stands to gain land in its Extraterrestrial Region. This transition will make an impact at various scales. At the scale of the individual homeowner, beachfront property is transformed into Great-ER lakefront property, raising questions about ownership, land use, and land value, not to mention sentimental value. Families who have spent summers and weekends at the lake are frustrated to see their traditions change, yet frustration gives way to new experiences when change makes space for new practices and new relationships.

At a larger scale, the Lakes also define boundaries between cities, states, and countries. If these bodies of water reduce in size or change shape, these boundaries may be reconfigured to produce subsequent changes in regional connectivity, politics, economics, and culture. While a typical response to environmental decline is a solution or method to save the resource, this proposal responds to the idea that this change may be beyond repair. Rather than dwell on the loss of a natural resource or its resulting real estate dilemmas and shipping disasters, we acknowledge that the possibility that the new condition produced by these changes will exist as fertile ground for future intervention.

Decline is an "in-between" condition; a state of transition from that which we know to that which we do not know. Design allows us to perceive decline with an optimism motivated by a desire for change. Standard references define decline as a negative condition because it describes loss, or moving from a high point along a downward slope. Such loss is typically associated with grief. The Kubler-Ross model for grief (from the 1969 book On Death and Dying) includes five stages, ending with acceptance. By concluding with acceptance, this model fails to leverage the transformative potential that is embedded with any experience of loss. In the case of the Great Lakes, it is the design community's responsibility to circumvent the passive posture of acceptance through the willful act of projection in order to translate the perception of loss into an opportunity for growth.

Lessons in Leverage

Perceptions of loss may be leveraged in design as nostalgia (a longing for a previous condition) or as opportunity to move forward. New Urbanism is an example of the former. To counter negative perceptions of urban sprawl, the New Urbanist charter adopts 18th and 19th century models of urban planning and architectural style. This position assumes that the only way to improve this condition is by reverting to a historic ideal of small town life. The movement has been prolific in its transformation of the suburban American landscape, feeding on the public's nostalgia by propagating obsolete models of urban design that have little relevance to twenty-first century culture and lifestyles. Nevertheless, we might observe the success of their leveraging tactics, if not for the results they yield, then for the popularity they garner. New Urbanism presents a legible image of lifestyle and culture for its audience to consume, countering the frightening unknowns of decline with the known image of a life that once was.

However, this is a nostalgic form of time travel that attempts to bring the past back to life in the present. Instead, architecture and design may provide a key to unlocking a way forward into the future through projections that reconfigure the material of the present to create new and potentially better conditions. Rather than re-present a known condition, it is the discipline's responsibility to construct an image of what that unknown future might look like. For example, UrbanLab's Free Water District reconfigures the region's assets (fresh water) and liabilities (population decline and manufacturing job losses) into components of a new urban condition along the lakefront. The proposal layers new industry with ecological infrastructure, public space and the urban program of a research university. Water intensive industries are granted free access to the lake's water resources and in exchange recycle wastewater through a series of constructed wetlands. The layering of landscape, building, open space and infrastructure produces a thickened condition at the lakeshore that mediates between lake and city in a healthy and productive way, while generating new urban forms and densities. Although the proposal does not explicitly inhabit the Extraterrestrial Region that might result from future Great Lakes water loss, it does conjure images of new ways that lake and land might knit together at this new, extended boundary condition through combinations of programming, ecologies and architectural form.

New Urbanism

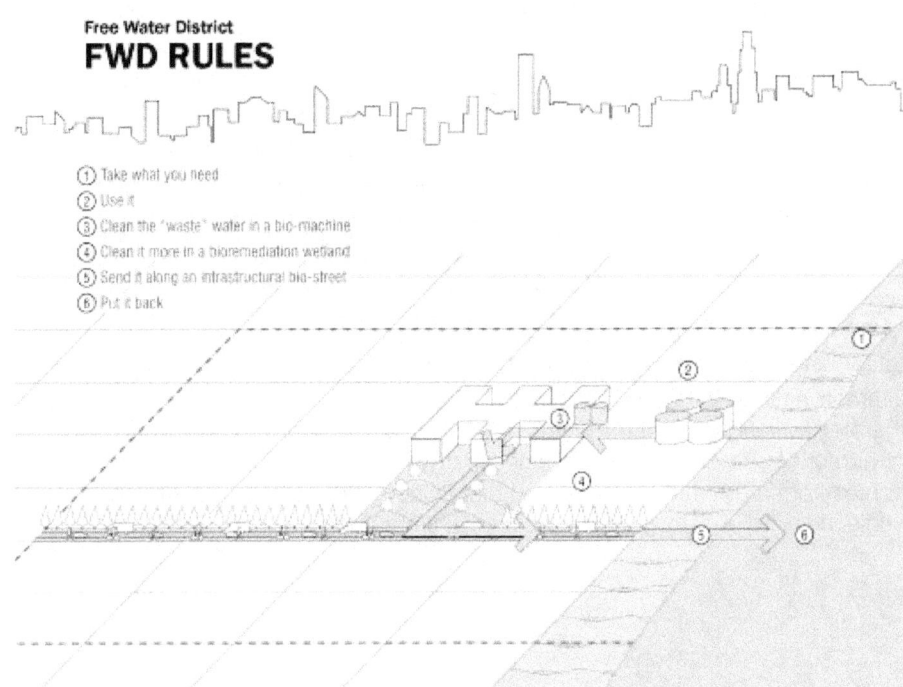

Free Water District "rules"

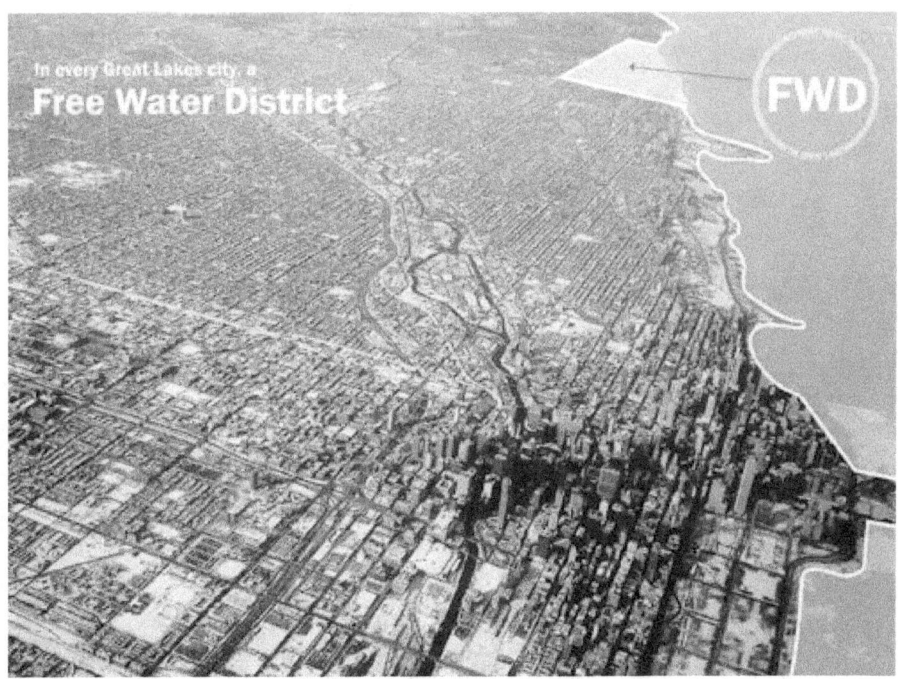

Free Water District
(designed by UrbanLab)

Extraterrestrial Sub-cultures

If UrbanLab's proposal is motivated by the injection of outside influences (in the form of industry or a research university) to stimulate it's petri-dish of urban culture, then this provocation for the Design of Great-ER Lakes Subculture is more interested in the hybridization of local specimens to insert into its new territories. The Third-coast boasts its own idiosyncratic brand of social and cultural spectacle – seasonal festivals and events that celebrate everything from beer, cheeseburgers and Jimmy Buffet to kites, porches and tall ships. During these happenings, town populations swell to ten-fold their typical size, temporary tent-cities are erected, and costumes become the sartorial norm. The Design for the Great-ER Lakes does not attempt to replicate these expressions of vernacular culture (that would constitute a New Urbanism-style misstep) but rather uses these instances as evidence and material for the cultivation of new, alternative Great-ER Lakes sensibilities. The optimistic development of the Great Extraterrestrial Region of the Lakes may in fact address environmental issues, or attract new institutions or industries that will produce jobs, but the motivation comes from a different intention, one that celebrates, seduces and charms new audiences into understanding the potential embedded between Great and Lake.

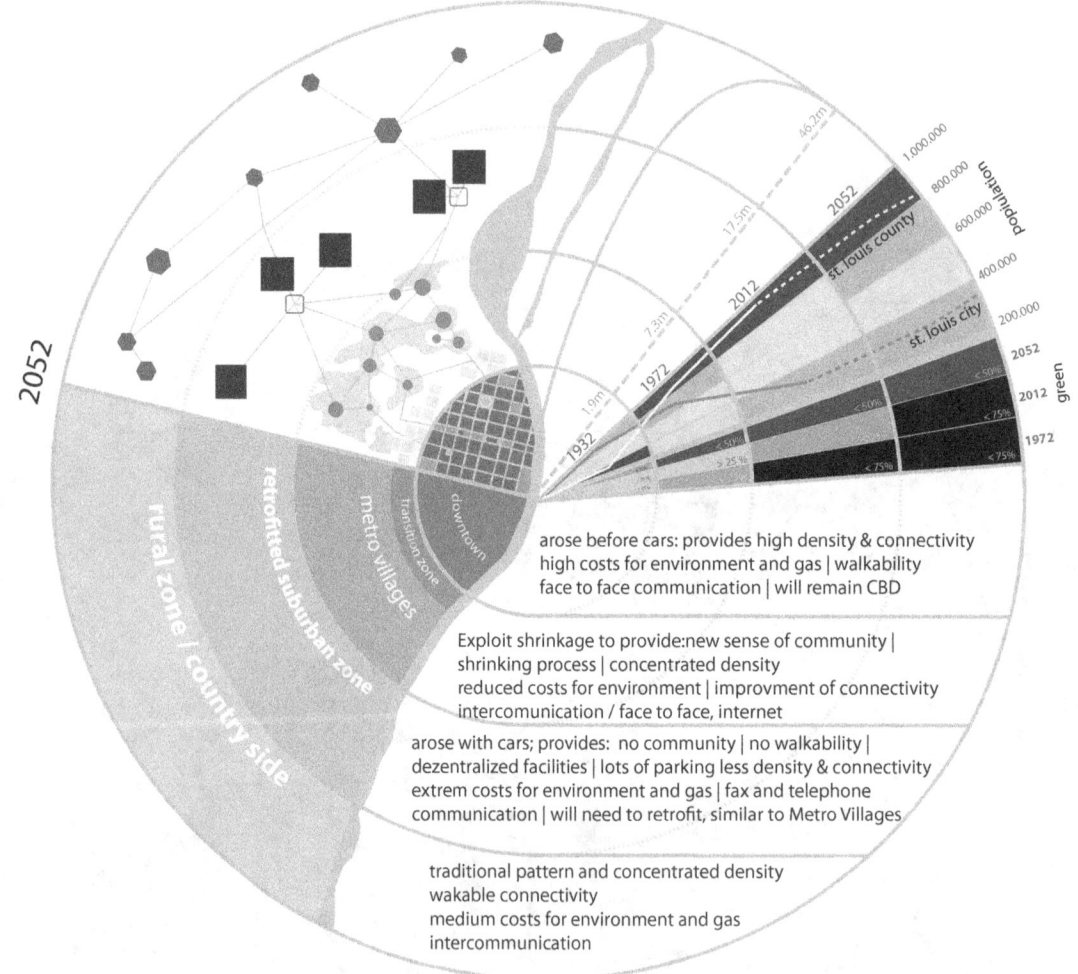

St. Louis Metro Villages

St. Louis Metro Villages: Re-Greening & Concentrating the Shrinking City

Marius Mueller

Pruitt-Igoe had grand ambitions to provide housing and modern amenities at a large scale for those in need – but it opened just as St. Louis' population was starting to shrink. Not only was this a significant factor in the ultimate demolition of Pruitt-Igoe, the shrinkage accelerated – and not only in St. Louis.

The regreening of the Pruitt-Igoe site can now serve as a catalyst for a new, healthy model of living in the shrinking city: the metro village. By concentrating growth around existing community anchors and neighborhoods, while regreening vacant and underused land for gardens and forests, a series of metro villages can offer residents a modern version of the American Dream: the city out one's front door and the countryside at the back door.

The next forty years of development in St. Louis can exploit shrinkage to prepare residents with more resilience in the fall of rising costs of energy, food + temperatures – while improving the quality of life and ecological function. Rigorous mappings of existing conditions determine the boundaries of the areas to be infilled and those to be regreened. The villages offer a range of densities, diverse uses and public activities, as shown in the detail plans above of Carr Park Village. The infill is sensitive, mixing old and new with high aesthetic quality. Urban streetscapes contrast with and connect to rural landscapes and forests will be as important as the villages in providing identity to the place and will serve as connective tissue between the villages.

The oldest growth forest and most prominent green space of all occurs at the Pruitt-Igoe Memorial Park. The existing trees in the former buildings footprints are maintained. The rest of the site is cleared and replanted as a memorial orchard. The annual harvest brings community members back to the site annually to share in stories of the past + hopes for the future.

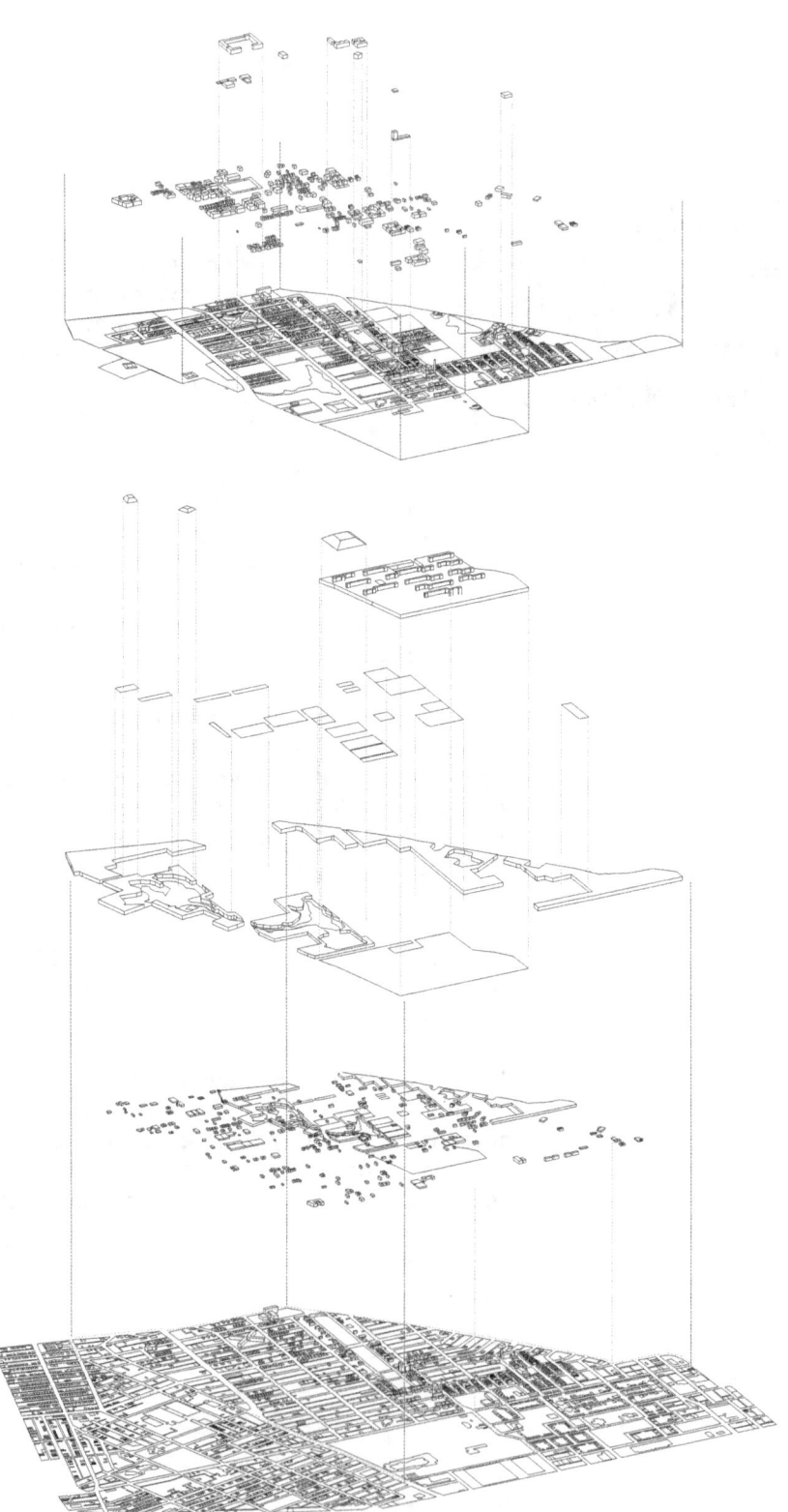

St. Louis Metro Villages 97

New Community Anchors 2052
health center, townhall, library, senior-
citizens home, civil service, daycare, school,
PI pavilion

New Infill
residential, mixed use

Detail Plan of Carr Park
with the Pruit Igoe Memorial Park

Pruit Igoe Memorial Park 2032
mounds

Agriculture
community gardens, personal gardens

Revitalization 2012
infill the voids, urban forest, recreation
corridors, green belt connection

Out Takes
unused and ramschackeled restructuring
of the grid

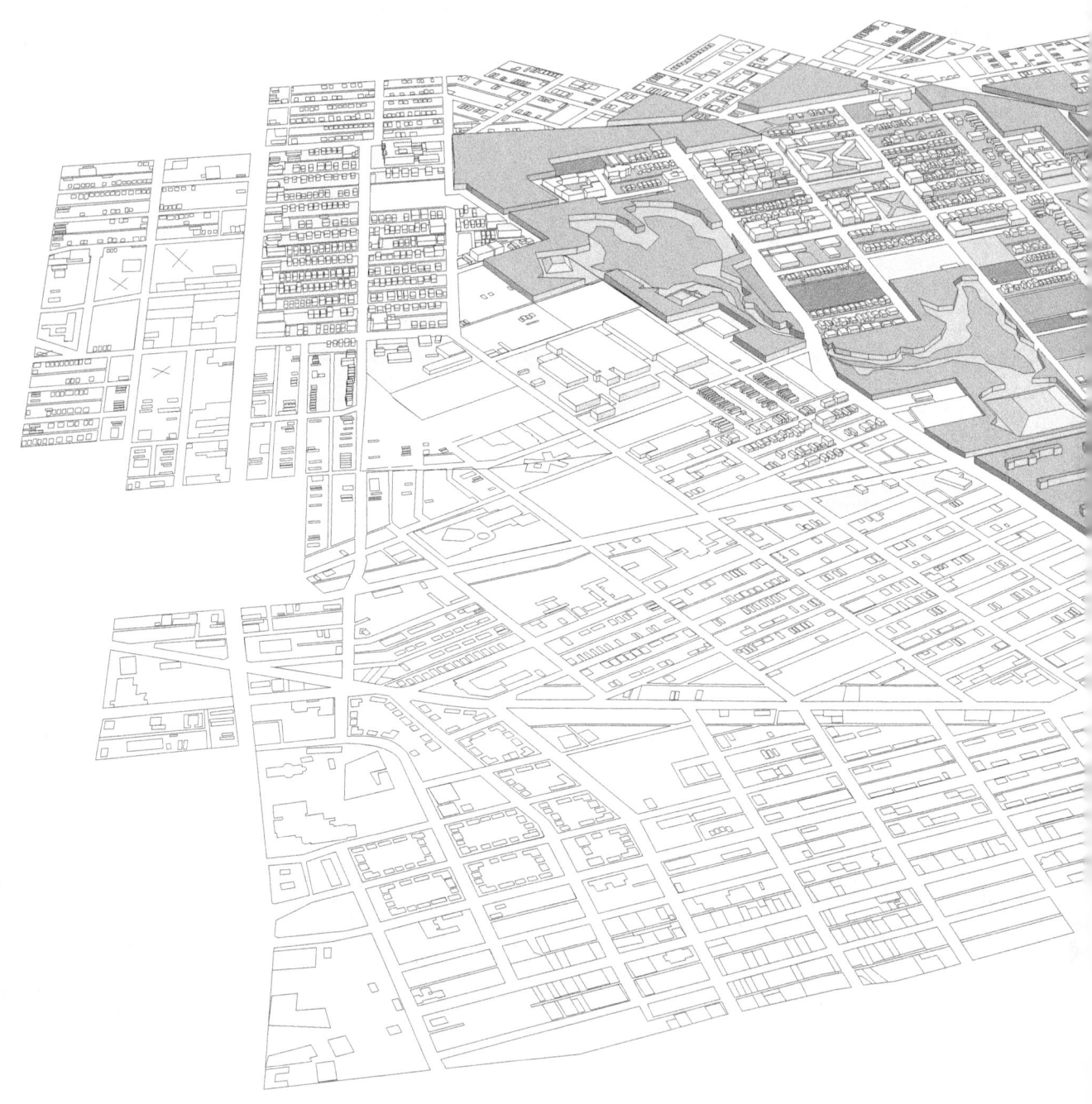

St. Louis Metro Villages 99

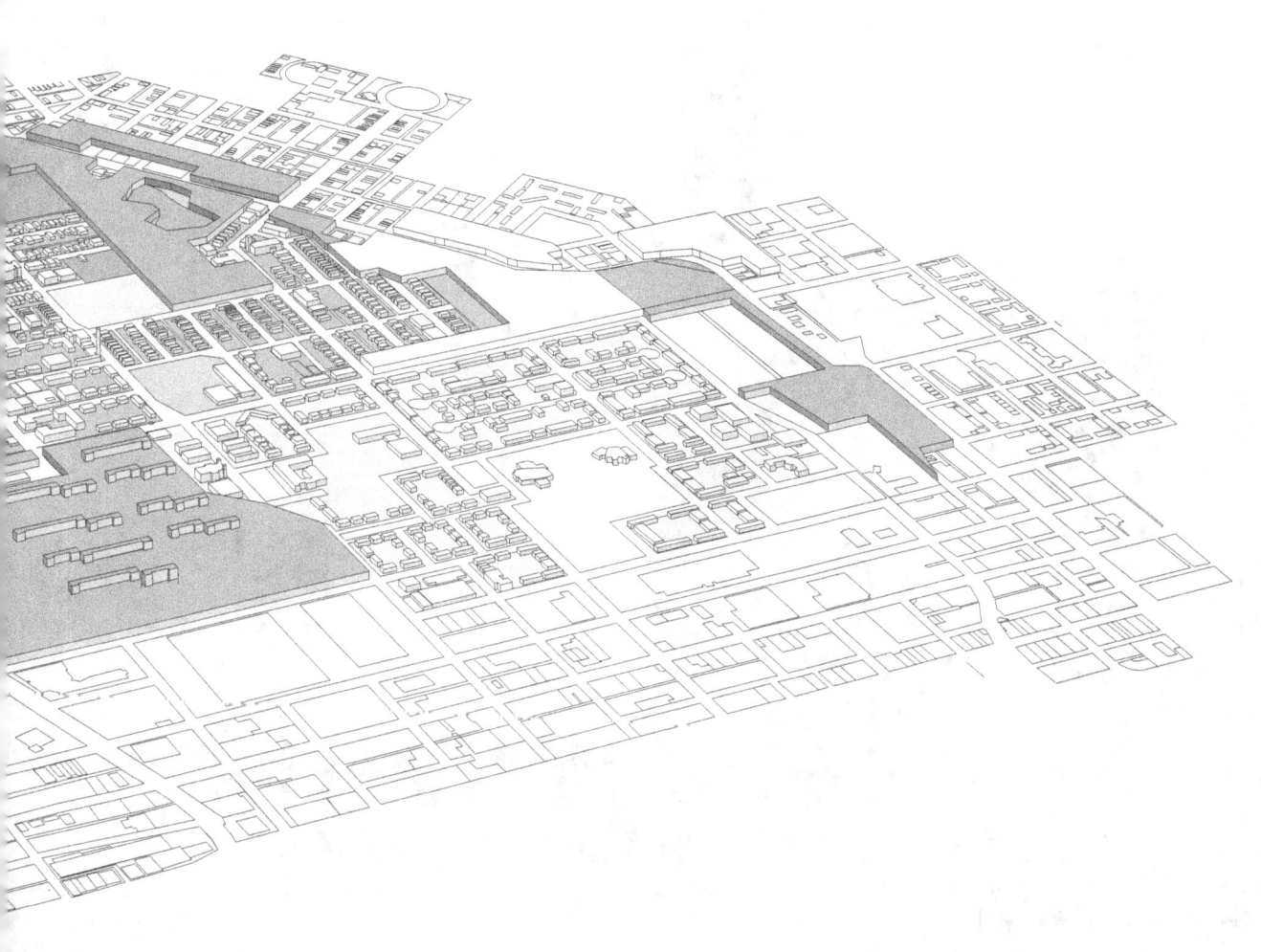

The Experiential Helmet

The Experiential Helmet
Nimet Anwar

The Experiential Helmet serves as an enclosure in which the subject's perception of space and environment is altered. The transition from an open-air norm to a constricting and deteriorating helmet contribute to the decline of perception of both realms.

After the deployment of parasites onto the thick enclosure, the surfaces were left in decay with varying thicknesses, transparencies, and textures. At points of excessive parasitic activity, the material was completely dissolved allowing limited accessibility to and awareness of the outside environment. The unaffected portions lacked transparency and obstructed interactions.

Once submerged in the helmet, there is no accurate understanding of the outside realm, because of the thin membrane which severs the public from the subject. Although the membrane allows light into the helmet at points of high parasitic activity, it subsequently interrupts any ability to see out of the helmet.

The helmet serves as a spatial device to define a heterotopic universe in which the subject is neither consciously engaged with their surrounding environment nor completely isolated and confined to the parasitic realm. The subject is able to occupy two contrasting spaces, while never able to fully reconcile both realms.

An & Interview With Meredith Miller

Assistant Professor of Architecture

& So the first question – and again feel free to interpret this however it makes sense to you – but how is your work engaged a site or sites of decline as a primary context?

MM I'm sort of curious what aspects of my work you guys are most interested in because I could answer it in regards to what I did as a fellow here and how that's kind of changed – my thoughts have kind of changed over the past four years. I could talk about Jakarta as a site of decline on a scale that I've never encountered before. But I can even conceptualize my Research Through Making project to be about decline and then the whole premise of that research is to work with materials that degrade.

Is that the bioplastics?

That's the bioplastics. So that's less about sites of decline, although I think embedded in that premise is the application of these materials that might be a way of drawing out aspects of decline and deterioration as a production rather than a destruction or as a creation of conditions or implications of conditions on the site – like through the interaction of the material with aspects of the site – whether that would include processes of composting and that kind of thing.

I think from my own interest let's start with bioplastics and if a question or two down it makes sense to revert to Jakarta or somewhere else we can do that.

They all seem very unrelated but maybe decline is a way of relating them.

Well I was going to ask what is the common thread? What draws you to the sites that you work on?

Well I think some of my work is site driven more than others and I would say the bioplastics was actually a different way of working for me. It started with an interest in working with a set of materials, and I would say that's not usually how I work. Usually something like a site is one of the earliest things that comes into the project, and I would say the work on the house in Detroit was definitely done like that – that was the beginning and everything else was a response to that set of circumstances. But with the bioplastics the hunch was that working in a hands on way with this material might reveal hidden capacities for how it could be applied in the world – less toward the way it is typically used in industrial or commercial applications where there's just this association with it being the responsible consumer choice, when there's actually very different studies and very different positions on just how biodegradable or compostable a lot of these plastics are. Because even if the constituent ingredients in the bioplastics comes directly from plants like corn or other starches the processes that render it into the plastic, that create the polymers, that give it strength and resilience, transforms the chemical nature of these materials in such a way that when they return to a natural environment and get thrown into a compost pile they don't necessarily degrade.

Revert that decline? (laughter)

Yeah let's just go back to the green pastures. Exactly.

How do you test degradation? How do you simulate that kind of…?

No, yeah, it's a good question – we probably won't get there with this project. So a lot of that side of the project is more just research and looking into it. But within the framework of Research

Through Making, having a budget, having a team of students, and having this idea to work with a set of materials – within that framework we're more focused on just trying things out. A lot of what we did over the summer was test different recipes of sugar and starch based bioplastics which range from hard candy to sugar, corn syrup, and water to recipes that have tapioca, starch, glycerin, and vinegar. What sort of ties these together is that there's a process of cooking which makes the chemicals react in a certain way that then produces these polymer genes and makes something more rigid. This maintains some pliability so that the cooking is what transforms the set of ingredients into a somewhat different material. So we tested a range of recipes just to see the variation and material properties that resulted. So behind you – these have been hanging there for a while. These are starch based bioplastics – some have potato starch, some have corn starch, some have a combination. It's been really interesting seeing how they've just changed over time reacting to the interior weather. What we ended up doing is a kind of field test where we took one of the recipes that we were working with over the summer and we found a way to scale it up. So that was another consideration, how do you take something that is otherwise the size of a pot or pan and translate it into a scale that can actually be spatial – and we wanted to do something that was even territorial. So there's this interest in linking the scale of making, in a very DIY manner with ingredients you can buy at Kroger, to something that could be out in the landscape and have some sort of presence. This was more difficult than we thought, because structurally the recipe that we used was candy. It's either so brittle that it wants to break, or if you cook it a little over temperature, it adds more flexibility and it just wants to melt. We were doing a lot of testing over the summer when it was very hot and humid but the installation happened in November, so it really is an interaction between our intention as designers and how the material is willing to react to the environment – not just outside but inside too. The bioplastics have changed a lot ever since the heat got turned on. There are so many variables and I think that was initially part of the project, to take on a design where you're not in control of all the variables.

It's a position of creating something agile in response to a set of conditions that you're working with rather than predetermining some shape or some performance or some aesthetic. Finding this through the process has been kind of fun, especially in the summer when we were just trying out lots of things. Some really ugly stuff came out of the kitchen, but it was delightful.

The last little bit you said seem like it might also be equally applicable to Jakarta, going in and not imposing an end result on it but rather focusing on process.

Sure. That's definitely true.

Can you talk a little bit about how you got to that place?

Yeah – why Jakarta? I think it was partially a shared hunch between me and Etienne. He had been thinking about doing research in South East Asia as a way of looking at some of the ideas he'd been working on concerning the irreversible effects of human activity on the Earth at a geological scale. So he wanted to look at it through the mega city in South East Asia, Jakarta being an exemplary South East Asia mega city that's undergoing enormous change especially in the past 10 20 years. There is the rate of population growth matched with the effect of climate changes, as well as the level of the ocean and how that's kind of creeping along the coastline of Jakarta. Meanwhile, because of the way that development in the city has happened, over the past several years there has been extreme population growth, and the ground water is being extracted at such a rate that the city is also sinking. So naturally, or in terms of its position in the regional landscape, Jakarta sits in a river basin where all the rivers from the surrounding mountains flow into the ocean. But of course the ocean is where all of the resources that are inland flow, mining, logging, all of these extractions that have formed the economy for hundreds of years. That same sort of flow is what made Jakarta a site for the city in the first place, and that would be where all these resources would be exploited. So there's this draining of the country through this intensified urban site and it's impossible to disentangle in a

sense – the economic interests, the uncontrolled urban growth, and the effects it has had on the natural systems. So we use the term postnatural to describe this hybrid condition between what might appear to be rivers and landscapes and what is actually a complex combination of human intervention…is

Man versus planet.

Yeah. So in a way, I think Jakarta is about both the site – there are many things specific to its culture and its geography that you wouldn't see in other cities – and also conditions that present a good case study for issues that are also very much a part of other things. I think that's important. There's something that's translatable from Jakarta to other cities, even back here. Last year was the first for the course and one thing that we commented on observing were these very resilient and robust economies that are difficult to formalize. Some people use the term informal economies, but I think it's kind of a problematic term because it's more that they just aren't familiar to us or we have a hard time reconciling them to our way of breeding a system. But they actually have their own logics, so the economies are these robust ground-up organizations that find ways of inserting themselves into the cracks between the more formal economic systems or informal infrastructures. It's very present in your experience of Jakarta and we're just wondering how much of that intelligence could translate into a way of reading Detroit. But there's an extreme difference between these two cities because of density…

But the opportunities are similar.

Maybe the opportunities are similar. Maybe they are there just harder to see because there's not the same intensification or density within that city.

That leads really well into the next question. What do you think are some of the common setbacks or pitfalls faced specifically by designers working within a context like that? And in terms of the setbacks or pitfalls, how they might be mitigated or avoided all together?

I mean that's a really difficult question – it's a good question, and it's a difficult issue because I think architects and specific architects with academic affiliations are expected to be experts and have some kind of answer to difficult questions. I think it's important to approach those issues with a high degree of humility on the one hand, but also with understanding that it's necessary to collaborate and work with others that have different forms of expertise or a different set of knowledge than you do. With our work in Jakarta, on the one hand there was this hesitancy on our part because we're coming to this place that we don't know at all, we're outsiders, we're coroners, we're a group of architects that are talking about issues that may appear to be outside of the realm of architectural expertise, and yet I think what might be seen as naïve or innocence in some ways served us well because people were interested in listening to what we had to say. There is kind of a position of power when coming from a foreign institution to study this city. We don't have the insights or the intimate knowledge of the place that people who live there and have been working there for a long time have, but we have an audience. And so, I think with that position of power comes a really important responsibility to make sure that we're not imposing some sort of solution. Again, it's not a solution-based process but that we're acting more like an intercessor. We're in GRUPA and this year we're hoping to work closely with the Urban Poor Consortium, so our role is more as an intercessor and as a translator of the issues we're researching into a format that might be legible to a different audience. I think that is how I would characterize our position, and I think that can apply to other types of projects where an architect or a researcher is inserting themselves into what might be called a difficult or complex set of issues. Rather than imposing or coming at the problem with the idea that there is some solution or that architecture is the solution maybe it's more that architecture is just part of a conversation. And hopefully this links things that might not otherwise be linked – or links people that might not otherwise matter.

This may answer my question about how this relates to the bioplastics research – because

it doesn't necessarily. It's not the first thing that would pop to mind, that architects would be working on something like this and at the same time be taking candy out and experimenting in the summer. So tell me about that with what you just said about why architecture is inserting itself.

I think that's an interesting way of connecting the two because I don't think that the bioplastics research I'm doing would be useful to a material science or someone who is working in industrial plastics production. I'm not developing knowledge that is going to be useful in that type of context, but I do think in terms of architecture as intercessor maybe, or as connecting things that wouldn't otherwise be connected. That might be part of what we're doing - just trying to imagine a possible application or possible situation in which these materials might temporarily transform a set of conditions or just exist in dialogue with a set of conditions. So the installation that we did in November was at Domino's Farms, which is like a corporate office park designed by Gunnar Birkerts, and I'm a big fan of Gunnar Birkerts' work. So they have a petting farm that's part of the educational component of the corporation, where you can visit and learn about animals and the farm. So I pitched it to them that this would be an educational installation that would be temporary and that they wouldn't have to worry about any permanent damage or trace to their property, and they were really receptive to it.

It was extremely temporary wasn't it? Like one afternoon?

Yeah. The candy panels we set up created a perimeter that enclosed half an acre. It degraded at a pretty fast rate but the idea was that it would be temporary, so a large part of the project was the performance of the cooking and installation. It was all disconnected from anything else; we brought in gas burners and had all the ingredients there on site. It almost appeared like a survivalist encampment. Again, we're always in dialogue with the weather and it's been very, very strange – maybe that's another link between Jakarta and this research – we had this crazy 70 degree weekend with winds up to 25 mph on the Sunday of our installation. We first thought it would be too cold and the candy would be brittle and break, but because it was warm the candy was cooling very slowly and the winds were just knocking things over. But it was a fun experiment, and I think that our role was less about the product or furthering knowledge about this material anyway, and more about offering an image or projecting forms of architecture. I would think of that as architecture when it may not otherwise be considered such – taking forms or formats as a way of linking these things that might not otherwise be linked.

I just finished reading David Shields' book Reality Hunger, and he talked about the importance of artists erasing the boundaries of what they are working on. He was talking specifically about writing and equating the genre of non-fiction with labeling a dress as non-socks, so it sounds like your work speaks to that. Like, you go in with no boundary, and you come out with no boundary, and at the end you say here is the thing that we didn't know before.

Right. I like that.

How would you characterize your design methodology with respect to contemporary architectural practice? Do you think you're pretty much in line, or are you and Etienne in opposition to that in particular ways of working?

That's a good question. And when you say design methodology you're talking about architecture?

I'll leave it open.

A question that has come up relative to the Jakarta research is why should architects be doing this and not urban planners, policy makers, or environmental scientists? Is there some kind of added benefit, or special expertise, or a special way of looking at these issues which comes from the architect who is coming from design? This may not be answering your question in terms of being in line with contemporary design. I think

the fact that this question comes up mostly in an architectural context is because it does appear to be outside of what architects are typically looking at or how they're working. But I've actually found that the students we took in the first year of the project have picked it up pretty fast. They have skills, and they have a way of observing, and a way of visualizing what they observe, and visualizing connections that aren't immediately legible in the world but can be made legible through representation. But that's something they were already skilled with, and it was just a matter of redirecting those capacities toward an unfamiliar set of circumstances. I think they found that they had an agency. And again, it was less about turning around and designing something as a response or as a solution and more connecting those observations in a way that could propose more focused questions, so that architecture in this case is a mode of inquiry rather than an answer.

That makes a lot of sense. I'm in the middle of reading Diagrams of Architecture, and in there the author says that architects have traditionally been responsible for knowing classical beauty and decorum. I immediately thought, "Okay, decorum seems like such an irrelevant word," but I don't think it is. I don't think it's in circulation, but maybe other things constitute decorum, like proper treatment of the planet, intelligent use of materials, things like that. And so, by that logic it makes sense that architecture would be approaching something – maybe approaching without being solution-based makes less sense to outsiders but it does make sense in general.

Yeah I think it does. It does make sense within our context, and it is interesting how much difference there is in what people require of architecture. I think it just depends who you're talking to.

Yes.

And I think that's true of my practice. I mean, I also have more familiar, traditional types of projects that I work on and I don't see them as any less important. It's not about more or less important, it's just different ways of exercising what I was describing to the students. We have these skills and they can be applied to different circumstances. Some more challenging and some maybe requiring more inventions on the part of the techniques or methodologies used, but it's all a way of positioning yourself in the world.

Bio taken from the *University of Michigan: Taubman College of Architecture and Urban Planing website.*

Meredith L. Miller is an Assistant Professor at the University of Michigan, Taubman College of Architecture and Urban Planning, where she entered as an A. Alfred Taubman Fellow in 2009-2010. She is a licensed architect and co-founder of MILLIGRAM-office, a design practice and research platform. Their recent projects include building additions in New York and Virginia and Site Double, a full-scale installation at the 2012 Venice Biennale, Common Grounds.

Through coursework and writing, her current research explores the influence of environmental thinking on architecture and its outcomes as a diverse set of forms and practices. Her urban research on the complex effects of inundation in the southeast Asian megacities of Bangkok and Jakarta, a collaboration with Etienne Turpin and students from Taubman College, University of Indonesia, and Hong Kong University, will be featured the forthcoming edited volume, Jakarta: Architecture+Adaptation. This interest in architecture as both an ecological agent and as a representational project informs her own design research. Her experimental design and fabrication project, (De)composing Territory was awarded a Research Through Making grant. The project considers the aesthetics and temporality of bioplastics in concert with environmental factors.

Meredith received her M.Arch from Princeton University and holds a BS in architecture from the University of Virginia. Meredith has previously practiced in design firms in New York and Boston, where she was a project architect with Höweler + Yoon architecture and contributed to various projects including Sky Courts and Hover. Within this office, Meredith also co-authored the book Public Works: Unsolicited Small Projects for the Big Dig on tactical design interventions within a new infrastructural landscape. Her writing has also been featured in MONU, Pidgin, Thresholds, and Another Pamphlet.

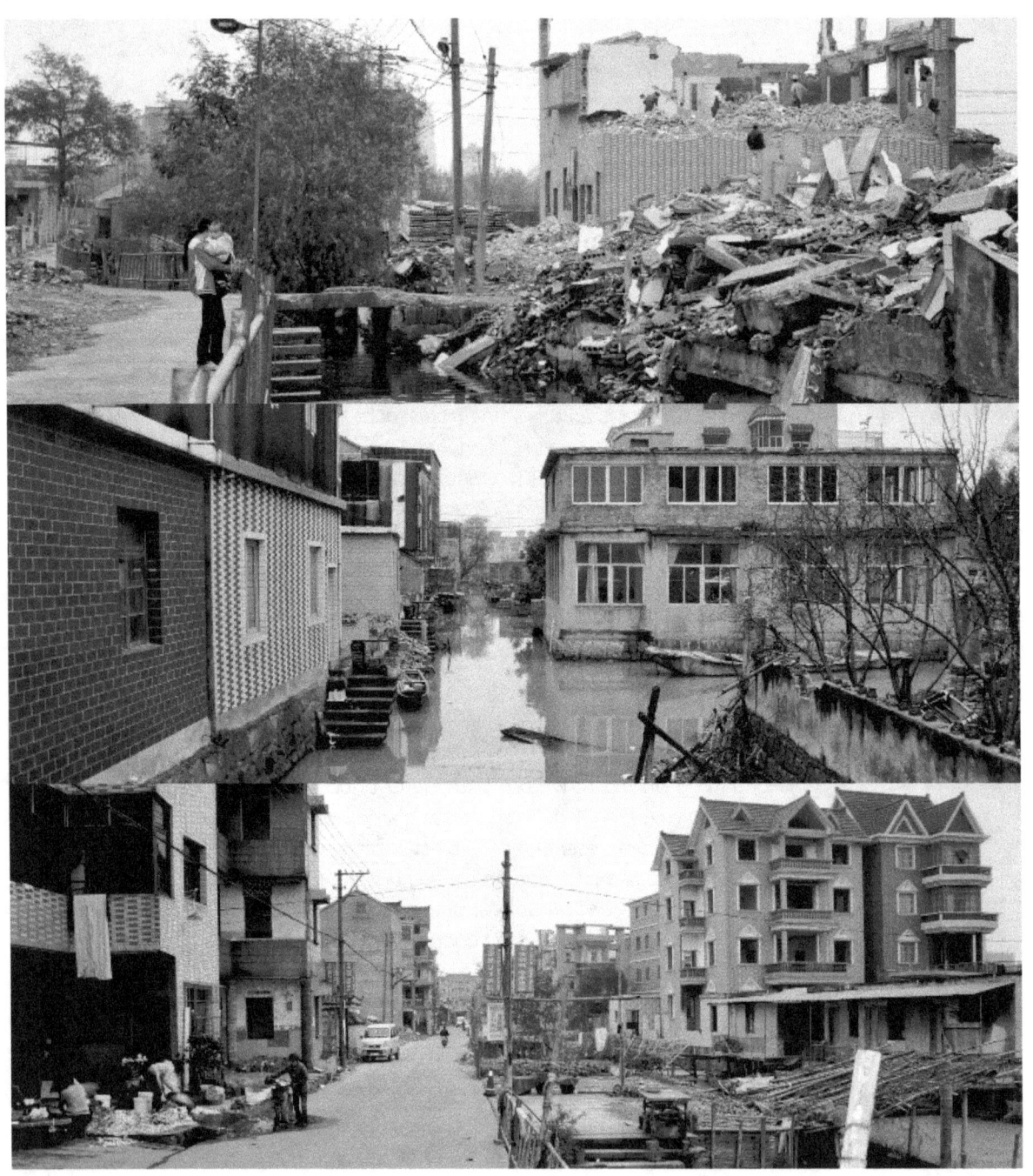

Field Trip to an Ephemeral and Unfulfilled Future

Field Trip to an Ephemeral and Unfulfilled Future

Bert de Muynck
Mónica Carriço

While taking the bullet train from Shanghai to Hanghzou, one can detect the transition from one province to the other by simply looking at the built environment. In Shanghai, the landscape is filled with rectangular and serial types of homogenous constructions, in Zhejiang province, the landscape turns into a setting of heterogeneous and individualized semi-rural housing typologies. In the past years, while taking the train from Shanghai to Hangzhou we documented this particular kind of temporal architecture and called it the Zhejiang Farmers' Architectural Style.

This architecture takes its advantage from the Chinese rural density and its countryside construction culture. But also from ready-made concrete skeleton structured that are adorned with seemingly off-the-shelf materials. Its variety still remains something of a mystery to us, but so are the motives behind this very specific architectural style. It is not something you can design, while it proves hard to decode the principles behind it.

The Zhejiang Farmers' Architectural Style can be quite fat and plump, or lean and lost, while it is an architecture that is aping each other. We see returning materials and elements incorporated in facades, on top of roofs, along staircases. Combined, they can be described as picturesque with princely architectural ambitions.

This territory is seemingly built without any critical agenda, but it is organized in such a way that a strange order emerges out of this density. MovingCities is fascinated by this specific form of rural regionalism: we wonder if these farmers' fantasies are a footnote in a yet to be written book about China's urban state.

Today these sites, high-density villages, are making place for growing cities. Soon, these villages – case in point is Hangzhou's Hutouchen village – will disappear and vanish. They have remained unnoticed, will be left undocumented (as appreciation for this type of architecture is rather non-existent) and soon will disappear in the folds of the future.

Despite a collective readiness to do away with sites of decline, we can only document, register the territory before the tabula rasa sets in.

Water Tower Kinetic Machine

Water Tower Kinetic Machine

Danae Manolesou

This project deals with an example of public architecture: a water tower situated in a residual space of undefined use. The water tower of Rio, a small town north east of the city of Patras, Greece, is interesting because of the contradictory relationship to the local community. Even though it is a building of an unusual form, of a privileged location and of a very important function, it seems completely absent in residents' everyday activities. The area surrounding the water tower is the outcome of recent urban planning changes between the 1970s and the 1990s: a new national road, a university and a hospital having been constructed during this time.

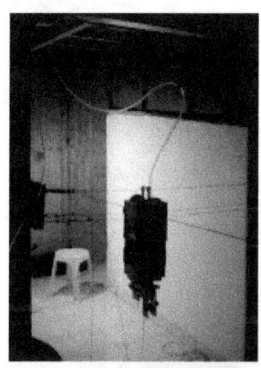

In close proximity, the water tower is framed by three elements hold together in fragile balance: a hidden garage whose activity occupies most of the space, a peculiar abandoned square that is used occasionally by the community during the national holidays, and finally, two immigrants that radically "redesign" the space as they convert abandoned cars to sheds and the space next to the square to a mini open market. As my research goes on, some connections reveal: the whole site was formerly used as the cemetery of the community - a property of the church that is built opposite of the square. Those days the site was a lively place, attracting the interest of the community, sometimes in a subversive way: residents' narratives speak about children making small explosive mechanisms to blow up the enclosure wall of the cemetery. Coming to the present state of the site, I notice that the two immigrants make use of the space in a comparably subversive way, while their national and religious identities contradict the established national and religious symbols of the community.

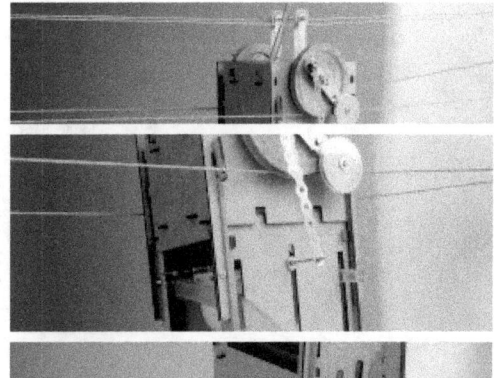

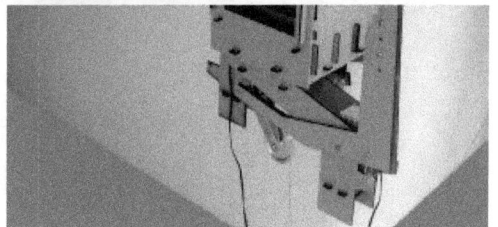

Above: snapshots from the video of the performance

Right: (from top to bottom) supplying with water, the wheel is beginning its rotation, the "arms" return back the vessel

I attempt to reconstruct the water tower as a kinetic machine. I experimentally apply a "machine vision" to the initial architectural object, so that it is converted into process. This transformation of the building into a machine/process originates from the disciplines of site-specific art, performance studies and mechanics. It is architecture as a sum of processes, preparations, repetitions, and executions, which interact with each other temporally.

While restoring the tower's function of water circulation, a new object is activated through a game; a process/performance apart from the initial architectural object. This could be performed at the playground of the community's school, engaging both children and tutors. Keeping the present physical state of the water tower and the site intact, the solution I propose is intentionally a function that can be performed in different sites.

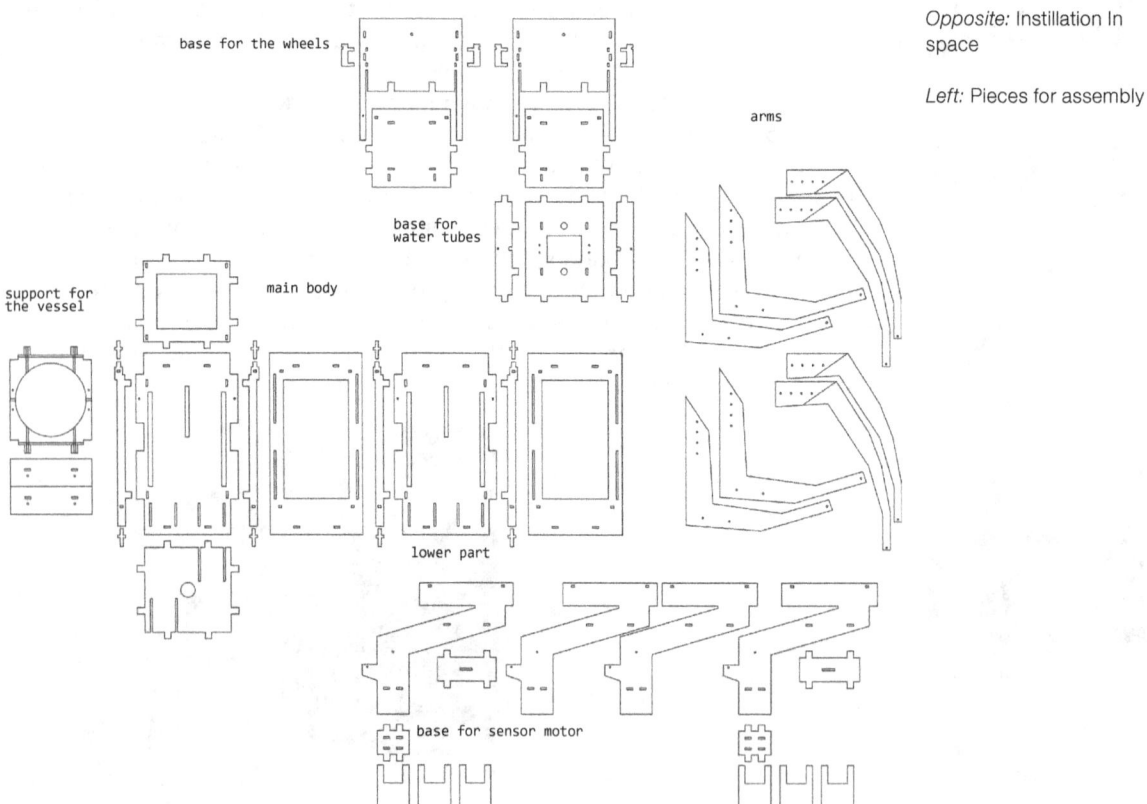

Opposite: Instillation In space

Left: Pieces for assembly

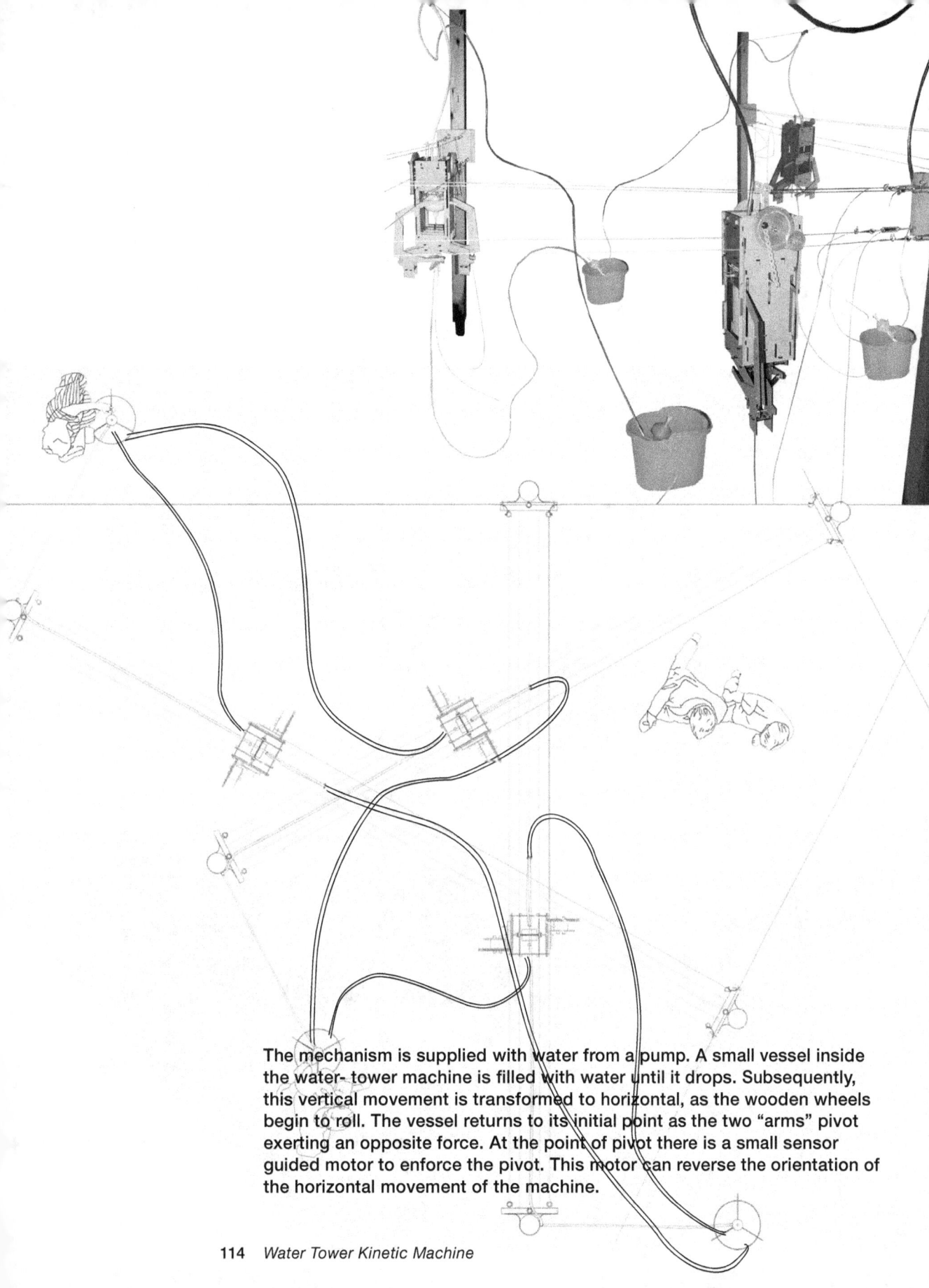

The mechanism is supplied with water from a pump. A small vessel inside the water-tower machine is filled with water until it drops. Subsequently, this vertical movement is transformed to horizontal, as the wooden wheels begin to roll. The vessel returns to its initial point as the two "arms" pivot exerting an opposite force. At the point of pivot there is a small sensor guided motor to enforce the pivot. This motor can reverse the orientation of the horizontal movement of the machine.

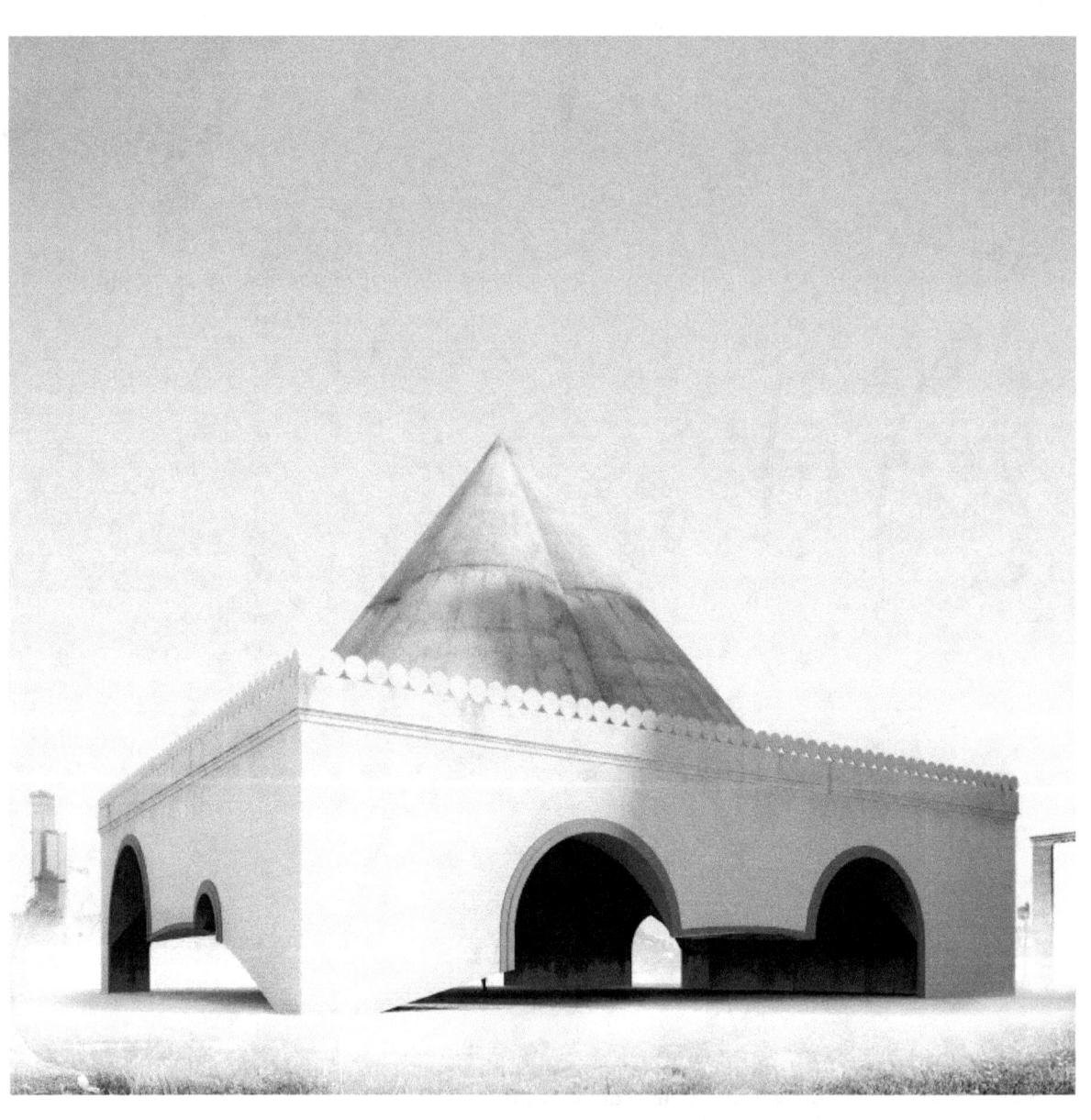

The Monument to Bruce: Save the Prentice ~~from the~~ Wrecking Ball

Design with Company

We refuse to rehearse the false choice as outlined by the University or the Chicago preservationists-- the demise of the Prentice Women's Hospital in Chicago, a Brutalist icon, is now a foregone conclusion.

This addendum creates a new narrative for the building's afterlife. Our images and text shouldn't be understood as a proposal in the traditional sense of the word. We present an alternative that combines literary and architectural narrative strategies. This is a design fiction that tries to recapture the building's narrative and produce the universe we need to steer us toward the conversations we want to have. This story is not a means to an end; it is the ends.

Below: (clockwise from top left) Swinging Pendulum, Arch Outline, Case-Out, Open Up

The last design for expansion had failed. They called it M.U.F.F.I.N. T.O.P.: Moving Up From Figural Icons Now, To Overcome the Prentice. The concrete shell proved too confining.

The high strength concrete of the Prentice Building required a special steel alloy ball to withstand the force of the repeated blows. An extraordinary ball was forged.

The Inscription Reads: "Proceed through concrete obstacles for health and prosperity in Chicago."

A case was constructed to protect and display the ball on its journey between the steel mill and its ultimate battlefield. People affectionately called the ball Bruce.

A parade was arranged and the ball lumbered through the Chicago grid. It was so heavy, the "float" could only turn left in loops. People changed "Bruce" but it sounded like "boooo...."

 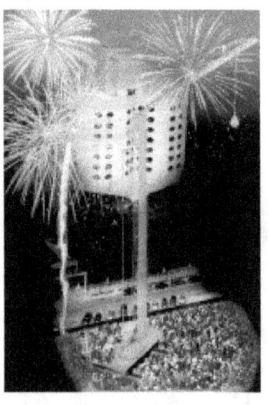

The celebration at the first hoisting of the ball. It was destined to become the greatest landmark Chicago had seen.

Monument to Bruce

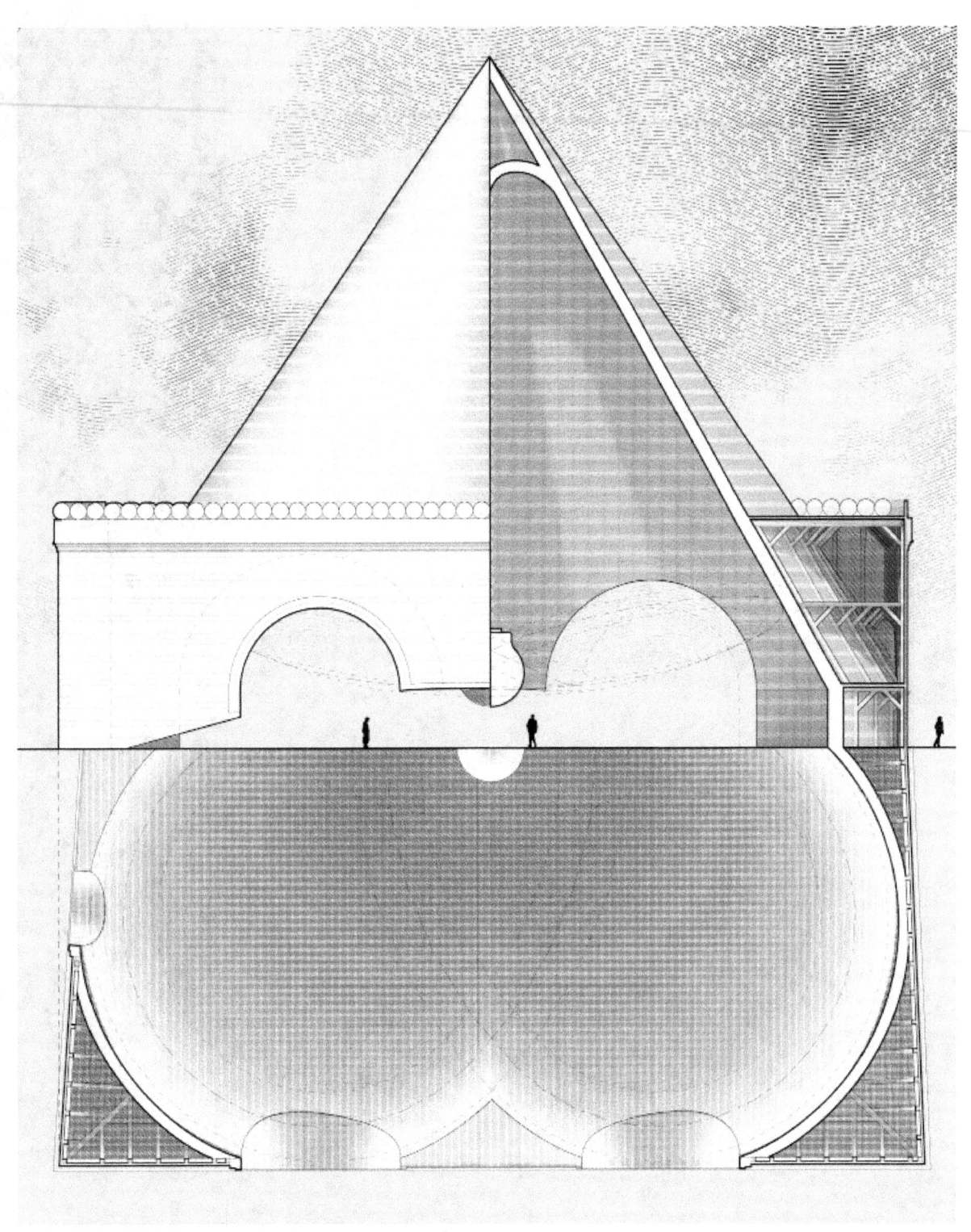

118　*Monument to Bruce*

Now, the retired wrecking ball rests in a monument on an empty Chicago lot. The timber-framed podium welcomes the occasional visitor. The ball swings, caught in perpetual motion. It traces and retraces the quatrefoil arcs of the Prentice footprint—coincidentally, the ancient Celtic symbol for luck.

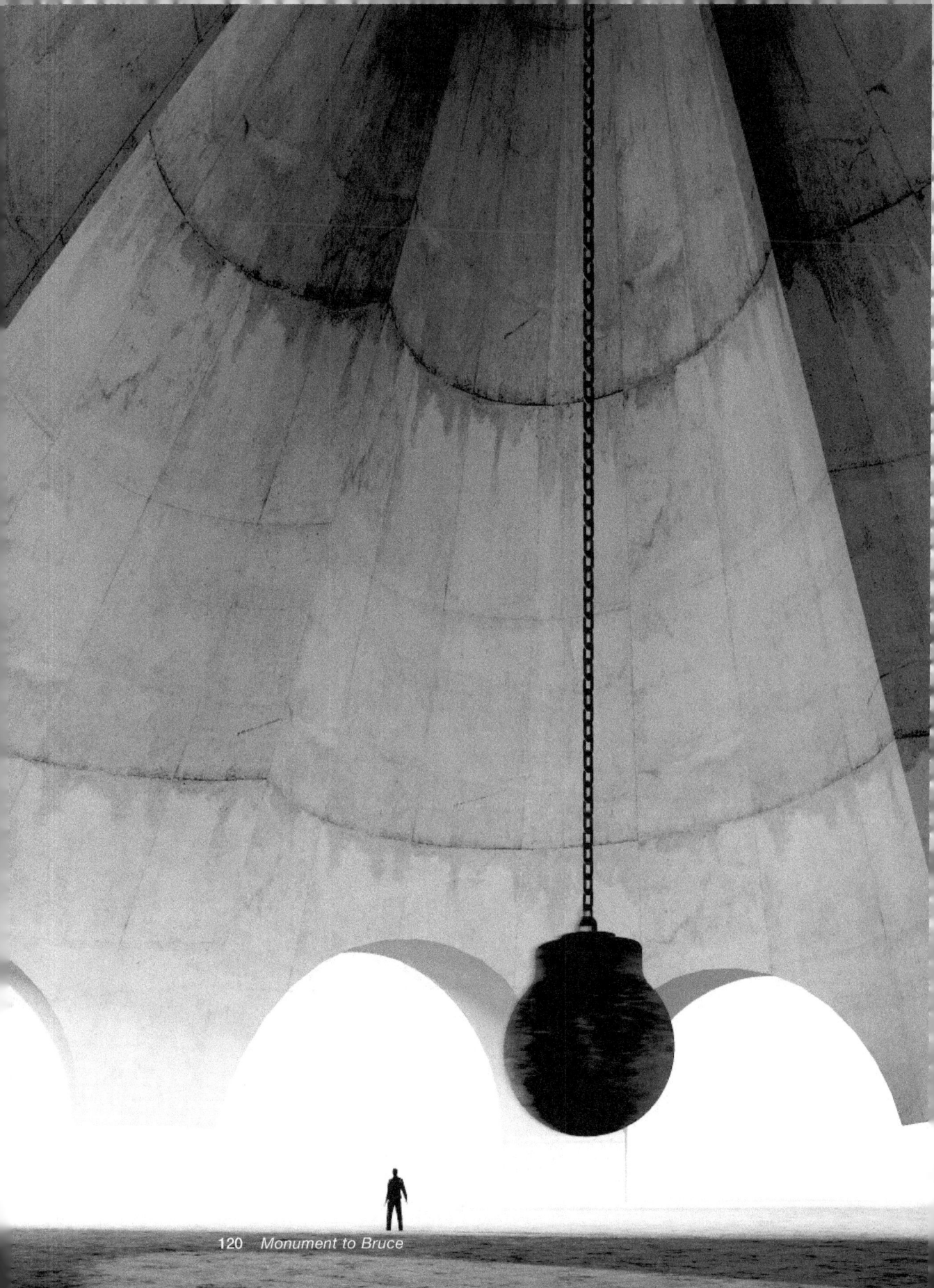
Monument to Bruce

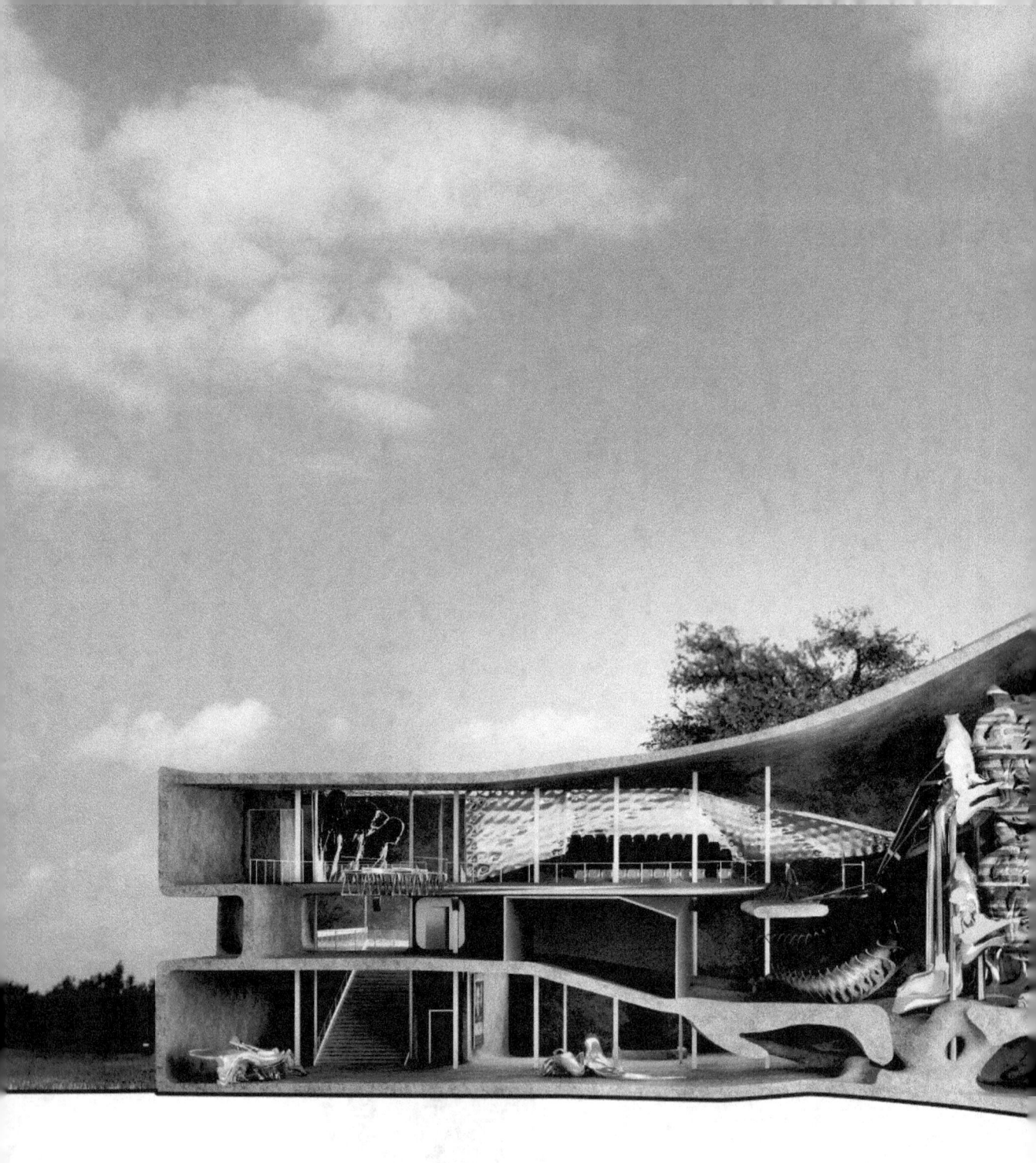

Popular Mutation

Popular Mutation
Miro Straka

The Experimental Music Hall Extension of an old power plant building in Bratislava. A fairytale of modern man. A cinematic cliché. How is figurative ornamentation reinvented in a way that engages our imagination? Greek mythology is no longer common knowledge. Instead, it acts as a collective memory of nostalgia. However, the gravity of pop culture has subsequently given way to new symbols and meanings. Wildly entertaining fictions comprise a new mythology – Optimus Prime as new atlas, carrying the weight of humanity on his shoulders, or Darth Vader as symbol of despotic power.

Straightforward principles of old building contrast with restless and surprising organization, where linear structure is replaced by unexpected spaces, and the austerity of reinforced concrete is twisted into a constantly changing mass without a singular, logical language.

The seemingly useless and unreadable object is opposed to repetitiveness and predictability of the present. With mass customization and large-scale printing, modularity loses its prominence.

This is where blending comes in, connecting unfitting or related objects, not based on their shape but their meaning, where bricks are used in modularity. Anything can be used in blending.

Grotesque assemblages reverse the ratio between function and ornament, radically dissolving relations between architectural object and reality. Objects gain or lose their beauty based on social circumstances, which predict how we read objects. Therefore, old figurative motives are no longer present - they are rather replaced with ornamentation known to modern man –from pop symbols to movie stars – to engage his imagination.

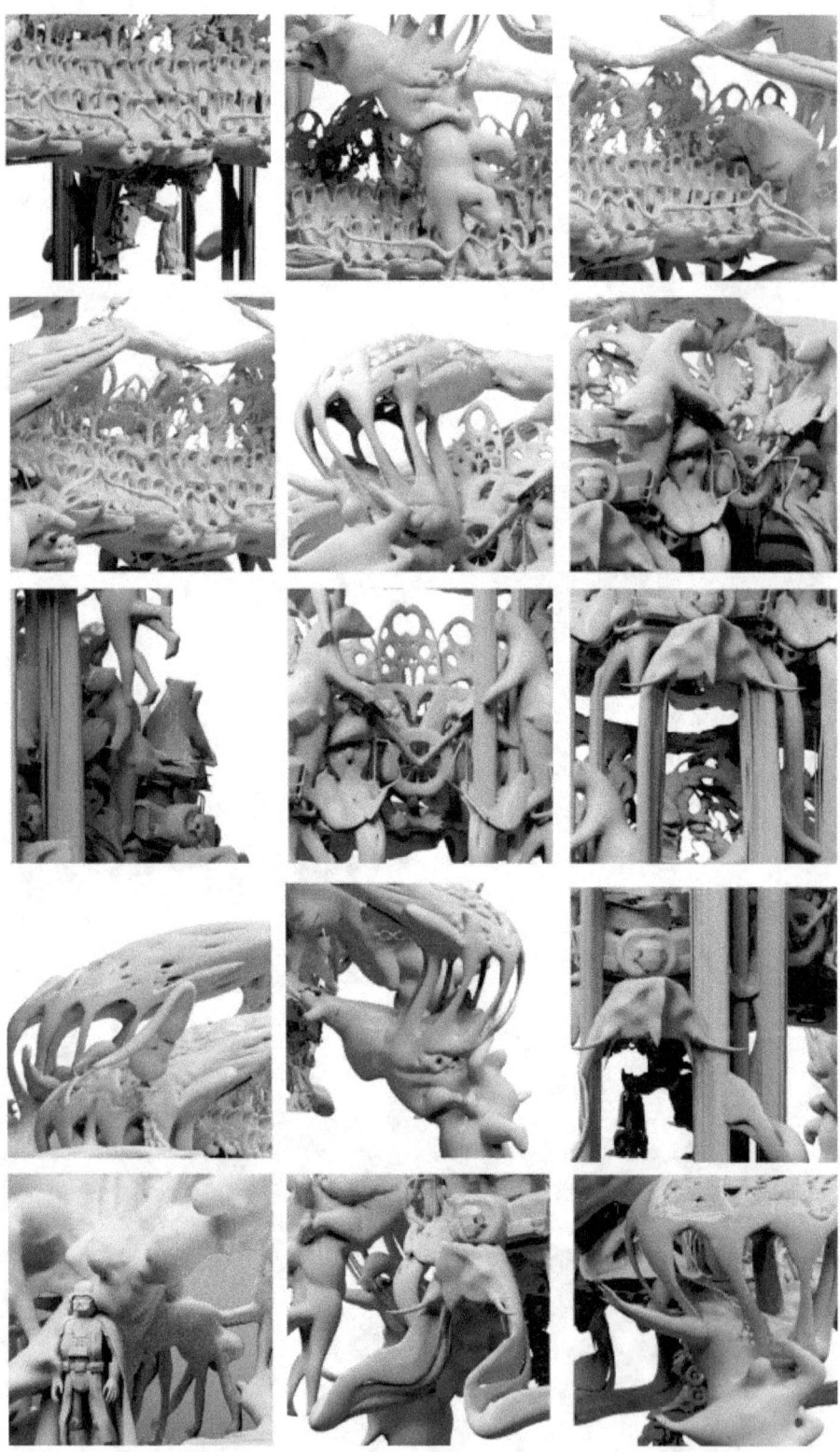

Popular Mutation

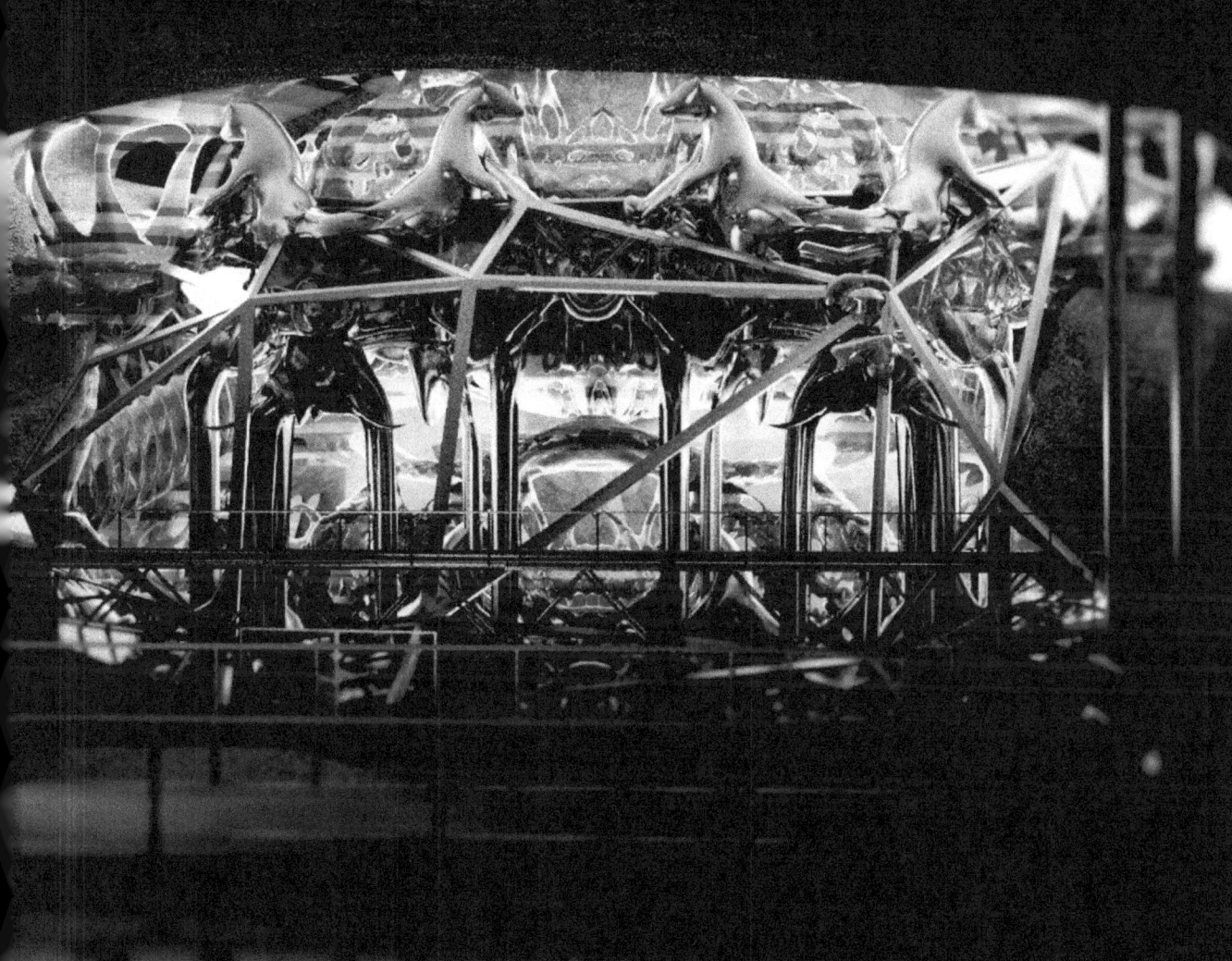

The Villa Simulacrum
Salvatore Dellaria

The myth of reuse implies a drift from perfection to compromise. It invokes an imaginary original which overwhelms all subsequent functions. In fact, there is no reuse, only use. The myth of ruination invents inevitability. It draws a false trajectory of decline, pointing forward toward entropy and backward toward a fiction of unspoiled beginnings. Ruins are constructs no less than the buildings from which they are derived. The myth of conservation contrives an ending. It collapses possibility in favor half-remembered and elusive truths. There are no endings to be written and no beginnings to be preserved. The Villa Simulacrum is an armature for mythology, a meta-fiction that rehearses and debunks privileged narratives of architectural endurance.

A hornless brown and white Hereford calf is at pasture in front of a clean-lined, but weathering gray, stuccoed concrete villa – a rough rectangular box with horizontal ribbons of windows raised on slender pilotis above tidy rows of artichokes, asparagus, peas, fennel, and leeks. A vegetable delivery truck idles in the gravel as its driver loads crates of produce onto a trailer. The villa's upper floor is a hayloft. Bales of drying ryegrass bulge through open windows. Bundled straw is stacked chest-high on the terrace. A table saw on horses kicks sawdust under the bedroom door. Below, the entrance foyer stocks hand tools: trowels, shovels, mowers, rakes, and pitchforks.

The villa is empty of domestic comforts. Its cupboards store no dishes; its closets store no linens. No beds, no sofas, no settees, it articulates a household in relief, an outline of an absence. The livestock, the garden, the sawdust, and the hay, the trailer slowly filling with vegetables, they are all overpowered by this false memory of domesticity. The villa was never a home. It was a model for efficient modern living, a manufacturer's showroom. It was a manifesto for mechanization. Citroen in the garage and Olivetti in the den. Yet, the vacancy of what it never was defines

the terms of endurance and obsolescence. The villa-as-farm is ranked always in relation to its fictional origin, and the degradation of each successive copy of a copy—it will be in turn a school, a church, a barracks, a bomb shelter—elevates in contrast and perfects the mythic villa-as-home.

At the Villa Simulacrum, a chronology of use is mistaken for a hierarchy of identity. Difference falsely measures distance from a procreative fiction. There is no prototype from which to deviate. Still, the imaginary home insists that eccentricities of use and adaptation are interference patterns lessening the clarity of its broadcast, but noise without a signal is a transmission of its own.

Windows are painted shut, and dusty yellowed glass blanches the landscape past the villa's empty sitting room. The fireplace vent is plugged with concrete. The air doesn't move, and the room is choked with dirt and ashy dust. Walls of peach and blue paint blister and peel. Plaster separates from concrete blocks and falls in pieces to the floor where the feet of vagrants and curious trespassers grind it, over time, to a coarse powder. Decay verifies the villa's substance, gives it texture and vulnerability. The nearer it draws to collapse, the more endearing it becomes. Persistence wins it affection.

Deterioration draws notice from rubberneckers charmed by stains and scars, keen to join in on the villa's demise. For them, the villa is its age; it is a fetish object that substantiates an inescapable mortality. They come with clippings torn from magazines, photographs taken at the building's completion against which to measure the degree of its decline, black and white proofs of an origin away from which the villa necessarily slides. A pair of students hop the fence and push quickly past loose sheets of plywood hammered across the front door. Shaking cans of spray paint, they write love letters to the villa on its crumbling walls.

Despite this romance, the Villa Simulacrum's ruins are not anticipated at conception, and it owes no debt to inexorable vectors of decline. Decay is not the inevitable cost of endurance; it is an architecture of its own. Trespassers come to witness the villa's anonymous failure instead author these ruins with vandalism. Owners ghostwrite an unsigned text of entropic loss with deferred maintenance and neglect. The arc of decline upon which the ruined villa follows naturally from its origins is a forgery. Neither state implies the other. Origin and ruin share a shadowy resemblance but are of discrete and independent provenance.

Patchy stucco is rubbed with soot, charred black in gestural streaks below the building's roofline. Fire has emptied much of the second floor and weakened its structure to near failure. Now, an armature of support turns the villa inside out. What the building can no longer manage from within is instead imposed from without. A latticework of canted steel beams digs into the earth and pushes back against the walls.

The props are deliberately unassuming. They do their job plainly. The villa's plaster has blackened, but the steel support is blacker by a shade. Too dark or too light and it would strike a note of contrast; too similar and it would veer toward mockery. Instead, the props defer to the villa as best they can, striving for neutrality, neither imitating its pilotis nor competing with them for attention.

Even in modesty, the steel can't help but spill some false rhetoric. It gestures toward weakness and disrepair. It retells episodes of injury and it fastens the villa to these narratives that it favors. The steel is the conclusion to the villa's speculations. All possibilities other than the one that it supports are forbidden. The props counter structural collapse with a metaphysical collapse of potential. The villa's desire to become something other than what it was vanishes. Its end is pinned to its beginning, and both extremities are knotted to these steel reinforcements.

The completion of the Villa Simulacrum is a fiction disguised as truth by the neutral candor of conservation's exoskeleton. There is no ending but that imagined by the props. The villa is not at its finale because there is no narrative that demands resolution. The steel and the villa together are a new composition, as incomplete as those that came before and undiluted in potential for those that may come after.

<center>***</center>

The villa groans under the weight of a heavy snow. Its pilotis labor to carry the load. Windows and doors long missing, unheated, snow is pushed in drifts across the living room floor, piled into corners of the bedrooms.

Outside, the villa is prepared for renovation. Every addition of lumber and wallboard is eliminated, every alteration erased. Its structure is reinforced; it stands again on its own. Walls are scraped clean of plaster and wood, stripped back to its barest substructure of steel and concrete block. The stuccoed surface is gone without a trace, save for neat mounds of rubble buried in the snow, waiting for a springtime excavation and removal by backhoe and dump truck.

In this state, the Villa Simulacrum is less than a ruin. It has forgotten everything—use and reuse, ruination and conservation—except how it was made. It explains itself now only in modest terms of concrete reinforced with steel, of infill bricks stacked one on another. Keeping no memory of its history and anticipating no particular future, it is released from the mythologies that enclosed it. The villa hibernates in limbo. A concrete framework for fictions written and revised, it has seen them come and go, and it waits, now, for the next.

No state in architecture is gathered from the remains of what preceded it. No origin echoes inescapably across its lifespan. No model conditions a degradation of copies, one following another, losing legibility, and fading eventually toward dissolution. Even when a linear, if waning, resemblance seems to bind architecture to an absent and prior model, or when the narratives it supports seem to corroborate that link, similarity speaks only toward deception. Likeness between a building and its ruins or between restored and original work is a superficial illusion, produced and reproduced anew at every turn.

Ampersand is a student-led publication working within the *Taubman College of Architecture and Urban Planning* at *University of Michigan*. Existing in the realm between a critical magazine and casual journal, Ampersand's primary focus lies with architectural productions, research, and discourse which express the state of the discipline from the recent past to the near future. Rather than respond to topics and methods that have trickled down through academic institutions, seasoned professionals and established ideologies, Ampersand is biased towards ideas in their infancy, projects which don't know what they are, and conversations that have no clear precedent.

Copyright © 2013 The Regents of the University of Michigan.
All rights reserved. No part of this publication may be reproduced in any manner without express written consent.

Made possible by the generous contributions of the *University of Michigan: Tubman College of Architecture and Urban Planning*.

Special thanks to *John McMorrough*

Cover Image: Visual Polemic by *Anastasisa Kostrominova*

www.ingramcontent.com/pod-product-compliance
Lightning Source LLC
Chambersburg PA
CBHW080919170526
45158CB00008B/2163